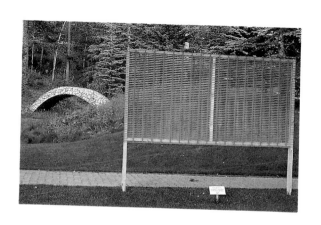

# QUEUES, RENDEZVOUS, RIOTS

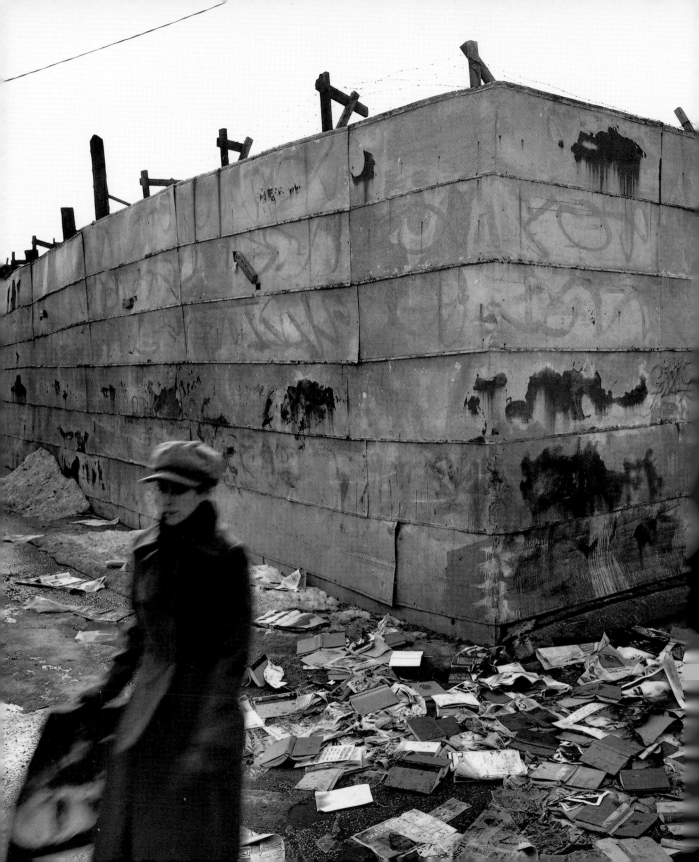

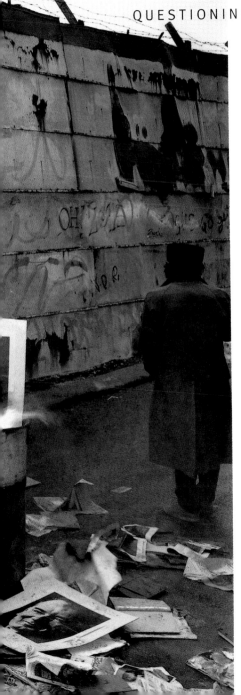

# QUEUES, RENDEZVOUS, **RIOTS**

## QUESTIONING THE PUBLIC IN ART AND ARCHITECTURE

EDITED BY

GEORGE BAIRD

AND

MARK LEWIS

WALTER PHILLIPS GALLERY

The Banff Centre
for the Arts

Walter Phillips Gallery
The Banff Centre for the Arts
Box 1020 – 14
Banff, Alberta
Canada TOL OCO
(403) 762-6281

Canadian Cataloguing in Publication Data
Main entry under title:

Queues, rendezvous, riots

Includes bibliographical references.
ISBN 0-920159-72-9
1. Public art. 2. Public architecture. I. Baird,
George II. Lewis, Mark, 1957– III. Walter
Phillips Gallery
N8825.Q48 1994     700     C94–910876–6

Reprinted from *Annales* 4 (July-August 1978),
Daniel Hermant, "Destructions et vandalisme
pendant la Révolution française," by
permission of Annales: Économies – Sociétés –
Civilisations, Paris, France.
Copyright © 1978 Annales: Économies –
Sociétés – Civilisations
Translated by Don McGrath

Design: Mary Anne Moser
Design Assistant: Mary Squario
Printing: Best Gagné
Colour separations: Colour Four

# CONTENTS

CONTENTS

# INTRODUCTION

George Baird

Some three years ago, Mark Lewis asked me if I would join him in curating an exhibition he was contemplating for the Walter Phillips Gallery at the Banff Centre for the Arts. He was interested in the idea that an exhibition on the difficult question of "the public" in art and architecture might include both artists and architects and hoped that I, as an architect, would also be interested in this possibility. Indeed I was. Some time later, we learned that the Gallery accepted the proposal we had submitted, and that the Canada Council and the Alberta Foundation for the Arts agreed to provide funding for the exhibition.

At that time, we commenced the process of finalizing participation in the exhibition, and were pleased to discover that the artists and architects we selected were all interested in being part of the exhibition. As a result, artists Dennis Adams, Marik Boudreau (with Martha Fleming & Lyne Lapointe), Vera Frenkel, Jeff Wall and Dan Graham, and architects Elizabeth Diller and Ricardo Scofidio, and Rodolfo Machado and Jorge Silvetti, all have works represented in the pages that follow.

In the summer of 1992, the exhibition opened at the Banff Centre – not just in the Walter Phillips Gallery itself but also in other locations on the campus. Works by Vera Frenkel, Elizabeth Diller and Ricardo Scofidio, and Rodolfo Machado and Jorge Silvetti were installed in the Walter Phillips Gallery; Marik Boudreau with Martha Fleming & Lyne Lapointe, and Jeff Wall and Dan Graham proposed works that were exhibited both inside the gallery and in satellite locations; while Dennis Adams created a work that was situated outside the gallery entirely – in fact he positioned his work, which was a proposal for a permanent installation, in the building next to the proposed site.

In addition to this, Lewis and I, as curators, developed our own proposals for curatorial intervention outside the scope of the gallery proper. Over the years, a series of artworks had been installed in locations on the Banff Centre campus, and it was our sense that they too had a bearing on our theme: hence we decided to devise conceptual "frames" and contemporary identifying labels for them. In this manner,

then, works by Barry Cogswell, Hugh Leroy, John McEwen and John Nugent also
became part of the public art of *Queues, Rendezvous, Riots.*

From the perspective of two years later, it is remarkably interesting to see how
interrelated the exhibition and publication components now appear.

The artist pages created for this book by Frenkel, Boudreau with Fleming &
Lapointe, and Diller and Scofidio pose the compelling initial question of "the public"
– not only to unmask the characteristic reifications which are so commonly put
forward in its name, but to disclose also its insidious powers of consciousness
formation. Frenkel alludes to the largest shopping mall in Europe to explore the
construction of consciousness in consumer culture. She both documents and
represents her installation in the exhibition, reproducing part of the video
commentary in the context of a series of photomontages that accompanied it. The
contribution to the volume by Boudreau, Fleming & Lapointe stands as a touching
and evocative epilogue to the poignant photographic intervention in the exhibition,
addressing urban change. Diller and Scofidio assemble an interleaved series of diverse
historical, descriptive, popular, analytical and deconstructive texts that deploy the
startlingly kinetic features of their installation on the tourism industry.

Machado and Silvetti, Lewis and Robin in turn reveal the sheer impossibility –
even inappropriateness – of architects and artists ever escaping accountability for
"representation" – as long as they engage in praxes considered to be social. Machado
and Silvetti's texts depict the complex mythological structure they developed for their
proposal and places it in the polemical context of current debates among architects
and artists in regard to appropriate public roles for artwork and architecture today.
Co-curator Lewis speculates in his argumentative text that the putative role of public
art continues to be intensely problematic, notwithstanding the boom in the field that
has been typical in recent years. In a comparison of Nikolai Kolli's 1918 proposal, *The
Red Wedge Cleaving the White Masses*, with Staten Island's 1989 proposal for a pyramid
of garbage as high as the Statue of Liberty, Lewis shows how astonishingly persistent
the condition of monumentality still turns out to be. In a text specially commissioned
for this volume, Robin provides a provocative bridge between my arguments and
those of Lewis and Payne – documenting with intense energy the painful paradoxes
of historical accountability and representation that have haunted the countries of
eastern Europe in the wake of the 1989 collapse of the Soviet empire.

In an interesting strategy of doubling back, Adams and Wall and Graham take the
very techniques of reification in the public realm that are implicitly debated by the
above two groups, and use them rhetorically against themselves. Adams reframes his

elegant contribution to the public art competition in the exhibition as an extended reflection on Mies van der Rohe's late 1930s project for the Resor House. This precedent-setting project lay so provocatively in the background of the proposal he made for Banff, and highlights the social context affecting the public praxes of artists and architects. A precise description of the two-part collaborative project by Wall and Graham explores the public considerations of an architectural playground. Details of the characteristics of the *Children's Pavilion* conceived by Graham begin their account; this is followed in turn by a parallel account of the photographs of children taken by Wall; the text concludes with descriptive comments on the logic of their joint intention to exhibit the photographs in the pavilion.

Hermant and Payne then place the "debate" as I have characterized it, between the other contributors, in an impressively broad historical perspective. In these essays, both authors initiate their arguments in the political and philosophical turmoil of the late eighteenth century, and trace their putative implications forward toward the present. Hermant's celebrated 1978 essay on destruction and vandalism during the French revolution was a key text that provoked the curators to formulate the exhibition in the manner in which we did. It is presented here for the first time in English, providing a strong intellectual underpinning not only to the intentions of the curators but also to other contributions to this volume such as those of Robin and Lamoureux. In another text commissioned specifically for this volume, Payne develops a complicated and extensive commentary on the response of French political philosopher Claude Lefort to Karl Marx's critique of democracy. In this text, Payne assays a subtle redefinition of both Marx's and Lefort's positions, relating both of them back to earlier work of Immanuel Kant. In the process, he works through important philosophical considerations on conceptions of the public for democracy.

My own essay gives an account of the challenges the curators made to the participants, first to invite them to participate in the first place, and then to participate in a full-fledged "public art" competition within the exhibition. This subsequently materialized with artist Dennis Adams and the architectural partners Rodolfo Machado and Jorge Silvetti producing works for the exhibition as proposals for a public artwork. I then give an account of the outcome of that internal competition and reflect on the issues that it raises.

Finally, Johanne Lamoureux effectively brings the focus back to the exhibition itself and to a consideration of its audience. Lamoureux kindly accepted the invitation of the curators to visit the exhibition at the Walter Phillips Gallery for the express purpose of writing about it. Her commentary not only encompasses the exhibition

itself, but also speaks with great acuity and intensity about the controversies that ensue surrounding art, architecture and questions of the public.

# PRAXIS AND REPRESENTATION

GEORGE BAIRD

## INTRODUCTION

For thoughtful social critics and cultural theorists, the "public" has been "in question" for some time now. In 1960, Jürgen Habermas published his influential "Structural Transformation of the Public Sphere," which characterized the notion of the public as having been in a process of significant degradation since the eighteenth century. In 1974, Richard Sennett published another much discussed text which cited "The Fall of Public Man."[1] Generations of commentators younger than Habermas and Sennett have tended to be even more pessimistic – not a few of them chastising these two predecessors for what came to be seen as, if only by implication, naïve yearnings for a lost era or as idealizations of a putative "golden age."[2] Indicative of the bleak current mood in these matters, a topical recent collection of texts by social critics and architectural historians has been subtitled *The New American City and the End of Public Space.*[3]

Still, this pervasive pessimism has not – except among the most unyielding current followers of Adorno and Lukacs – entirely extinguished curiosity and speculation in regard to the possibility of praxes that might still be able publicly to come into being. Indeed, thought-provoking possibilities can be discerned in the arguments and commentaries of the most probing current critics of Habermas and Sennett. It has been particularly interesting to watch this now three-decades-old discourse proceed from my own vantage point – that of an architect. In part this has been so on account of architecture's inescapable complicity in the transformations and degradations of "the public" identified by the various generations of critics discussed above, but also due to some of architecture's characteristic modes of proceeding within the overall social construct – modes that in my view have an emphasis significantly different from more purely "artistic production." This different emphasis was concisely expressed by Walter Benjamin in his famous statement: "Architecture is the prototype of a work which is consummated by a collectivity in a state of distraction."[4]

It is this "distractedness" of its audience which, as I understand it, accounts for much of architecture's social potency. Insofar as that audience is not – during the process of its consummation of the work – in a condition of high consciousness, architecture is readily able to influence its behaviour, without that audience becoming aware, let alone critical of, the social and political manipulations to which it may be subjected. Given the characteristic ambition of the "artistic" work precisely to command conscious attention, such a work tends necessarily to forfeit much of that insidious potency in favour of a more open appeal to its audience. As a result, it seems that contention in respect to the significance of a work of art – particularly a work of "public" art – will tend characteristically to focus predominantly on its iconography, that is to say, on the perceived ideology of its typical modes of representation, whilst that in respect to a work of architecture will characteristically focus primarily on disclosure of its subconsciously manipulative effects – or, to put it another way, on its discernible ideological relationship to a putative social or political praxis.

Against a backdrop of such considerations, a series of notes were prepared by Mark Lewis and myself as curators of *Queues, Rendezvous, Riots: Questioning the Public*, and circulated to the artists and architects who had agreed to participate in the exhibition. Theses notes focused on three themes, as follows.

## SHIFTING MEANINGS IN PUBLIC ART

In the centre of Queen's Park in downtown Toronto, on the site of a former nineteenth-century bandshell, sits a substantial bronze equestrian statue. So far as one can tell, the statue possesses little significance for Torontonians, either positive or negative, even though its subject is King Edward VII. The statue did not begin its historical life in Toronto, nor was it always so innocuous a public artifact. It was originally erected in 1919 in Delhi, India, and remained there – in its original location – until India's independence in 1947. Following that, it began to be seen as an unwelcome reminder of India's colonial past and was taken down and put into storage. Interestingly enough, even in the early days of India's independence, hostile public opinion did not run so high as to precipitate the demolition of the piece, only its placement out of public view.

Almost two decades later, the Toronto philanthropist H.R. Jackman learned of the existence of the statue and arranged to purchase it and bring it to Toronto. In 1968, he offered to donate the statue to the city, if it would pay the costs of re-installing it. Jackman's proposal was turned down by city council but the mayor of the

day succeeded in raising eighteen thousand dollars by public subscription, and with the agreement of the city's Committee on Parks and Recreation, the statue was erected on a grass mound – the subscribed amount would not cover the cost of a new plinth – where it has remained ever since.[5]

The successful public subscription for its installation undoubtedly stands as evidence of a tangible identification with the statue on the part of a particular group of Torontonians. Still, it does not appear to carry any identifiable significance for Torontonians-at-large nowadays, notwithstanding its prominent location. Indeed, one suspects that few contemporary observers realize who the statue represents, or how recently it arrived at its present location. They probably suppose that – along with the innumerable other British imperial monuments one finds throughout the older parts of Toronto – it has been there all along. Like the monuments of imperial antiquity which continued to stand in Rome into the middle ages, Edward VII is by now largely sapped of ideological intensity. His statue is reduced to an abstract visual focus for the open space of the park.

But, of course, much of what we now know as "public art" is far from being so innocuous. The fascinating text of Daniel Hermant, which has been translated into English for the first time in this volume, discusses the extensive and diverse destruction of monuments of the Ancien Régime, which was perpetrated by "vandals" during the French Revolution. Statuary and paintings of notable figures of the régime, as well as the tympani of many major cathedrals were destroyed or defaced by the so-called *enragés*, seeking to obliterate the monuments of their overthrown oppressors. The incidence of such destruction is not limited to distant historical periods. Almost exactly two centuries later, in the fateful summer of 1989, many of the capital cities of eastern Europe saw similar events. In city after city, there occurred the removal or the destruction of statues and images manifesting the "cult of Lenin" that had been such a strong feature of Soviet socialist cultural programs after World War II.

One might suppose that such intense public reactions to artifacts in the public realm as represented by these varied historical examples would be an unknown phenomenon in the "peaceable kingdom" of Canada. The wide public indifference to the statue of Edward VII, which was so recently dropped into Torontonians' midst, would seem to be evidence of this. Yet counter-evidence exists, even here. One remembers, for example, seeing newspaper photographs some years ago of the notable Toronto social reformer and fundraiser June Callwood, attacking the old Don Jail with a sledge-hammer! The circumstances of the picture-taking were as follows: the jail, a building that had originally been erected in the middle of the nineteenth

century, had continued to serve as part of a Toronto jail complex, right up until the 1970s. Knowledgeable and concerned observers, such as Callwood, had been campaigning for some time for improvements to the conditions to which prisoners in the old part of the complex were being subjected. Thus, when the authorities capitulated, and agreed to end active use of the oldest part of the complex, the reformers amongst whom Callwood was so prominent, chose to celebrate their victory by posing her for the photograph, sledge-hammer in hand, attacking the dramatic stone surround of the front entrance. Of course, the building, having been designed in the first half of the nineteenth century under the influence of "associationist" psychology, projected a romantic aesthetic *terribilita* that played into the hands of Callwood and her colleagues, in their having turned "vandal" for the occasion. It is worth noting here also how a "mere" building – usually so much less inflammatory an icon than, say, a statue of a historical figure – nevertheless succeeded in precipitating so palpable a physical response.

The hostility and anger that has so often greeted the installation of memorials and statues in various cities recently is testimony to the tendency of public artworks – and sometimes even architecture – to highlight the bitter contestation of meaning that occurs in relation to the semiotics of the existing public sphere. Public works may not inaugurate this contestation but perhaps – not least because of the complex history of the public monument – they uniquely precipitate the identifications and projections that allow debate to surface. It was a hope of the curators of *Queues, Rendezvous, Riots* that the exhibition would launch an exploration of the processes whereby the manifold and heteroclite meanings of "public art" are formed, the equally consequential process through which they sometimes seem to dissolve and perhaps even the disturbing ways in which they often appear susceptible to manipulation for political purposes.

Evidently, large territories of once-intense bodies of social significance lie quietly, just beneath the surface of quotidian discourse, awaiting possible rediscovery – or even contentious reinterpretation.

## THE DILEMMA OF ASSIMILABILITY

Reinterpretation brings with it the difficult question of assimilability. Insofar as extant monuments surviving from the past are susceptible to reinterpretation, this opens the door to the possibility of their being assimilated in new social and political contexts. Indeed, Hermant's text also indicates how it became a major challenge for the

contemporary intelligentsia of the French Revolution to formulate some such credible reinterpretation of the cultural production of the Ancien Régime, during the same period of time that the revolutionary vandals were at work on their programs of destruction. By means of a very early form of "bracketing," the intelligentsia sought to formulate a distinction between the "political" and the "aesthetic" dimensions of that production, which would enable a politically credible defence of its preservation. Perhaps not surprisingly then, one of the first cultural purposes of the modern European "museum" was to constitute a sufficiently de-politicized zone as to be able to create a neutral repository for the politically contaminated cultural production of the Ancien Régime.

A more contemporary example of such a process has been the "bracketing" and reinterpretation of the works of Stalinist "socialist realism" in the works of the émigré Soviet artists Komar and Melamid.[6] Even though their highly rhetorical displacement of the characteristic tropes and motifs of socialist realism constitutes an almost heretical reinterpretation, the two artists nevertheless do not deny an inescapable psychological identification with the recent originals, amongst which they both spent their youth. As a result, the mock "realist" works that the two artists created during the early years of their exile, exhibit a particularly complex form of assimilation.

## THE ARBITRARINESS OF THE SIGN, AND THE LABILE STATUS OF THE PUBLIC ICON

It is, of course, the fact that public symbols are "arbitrary" – semantically speaking – that renders them susceptible to "reinterpretation" in the first place. We owe it to the pioneering linguist Fernand de Saussure, and to the semioticians of the 1960s and 1970s, that we now understand to what degree semantic signifiers – especially highly iconographical ones – can shift in subtle, and even in highly unexpected, ways. In fact, the same methodological "arbitrariness" that facilitates the processes of reinterpretation, at the same time also allows the possibility of deliberately calculated meaning shifts that are manipulative.[7] A familiar example is the long, slow process during the twentieth century by which such figures from American history as George Washington and Abraham Lincoln have been gradually schematized into homogeneous public icons, capable of rhetorical political usages that far exceed the historical evidence available to the framers of any reasonable historical interpretation.

A very recent and dramatic instance of such manipulation has been documented by the émigré Iraqi author Samir Al Khalil in a startling book on the calculated political usages of art that have become typical in Saddam Hussein's Iraq. In a

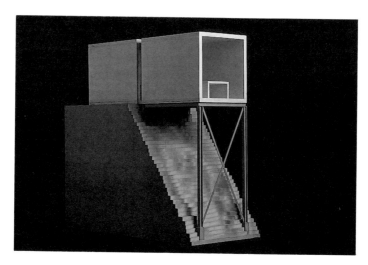

Dennis Adams *Break-Out Room* (1992) maquette

particularly telling account, Al Khalil described how, at a strategic moment during the mid-1980s, Hussein decided to attempt to consolidate his historical position in the eyes of the Iraqi population at large. As one means of doing so, he arranged to re-erect a statue of the former King Faisal, who had been overthrown by his own Ba'athists – by then, not a recent event and not at the top of people's minds. In such a circumstance then, the level of public consciousness in Iraq was sufficiently "distracted" to permit Hussein's efforts to assimilate the legacy of the admired historical figure of Faisal to his own, so as to seem to create an evidently seamless web of modern Iraqi history, culminating in his own ascendancy.[8]

## PUBLIC ART PROJECTS FOR THE EXHIBITION BY DENNIS ADAMS AND BY RODOLFO MACHADO AND JORGE SILVETTI

Midway through the planning of *Queues, Rendezvous, Riots*, an opportunity arose for the guest curators to test out such historical and theoretical speculations as I have just been recounting, in a decisively tangible fashion. At that time, the chief curator of the Walter Phillips Gallery, Daina Augaitis, informed us that certain funds unrelated to the exhibition happened at that time to be in hand, earmarked for the purpose of the creation of an artwork to embellish a recently completed nearby building for conferences and seminars at the Banff Centre. Augaitis and her colleagues at the gallery proposed to Mark Lewis and myself that we might wish to incorporate the commissioning of a public artwork for the new conference centre (called the TransCanada PipeLines Pavilion) into the exhibition. Such an invitation offered the possibility for the exhibition to focus very sharply the provocative social and political propositions suggested by our curatorial intention. It was true that the sum of money available for the work was modest – less than thirty thousand dollars – which would have to cover all administrative costs as well. Nonetheless, the challenge seemed irresistible, and we decided to accept the offer.

We then asked each of the artists or groups of artists who had agreed to participate in the exhibition whether or not competing for the commission for a permanent artwork in the Pavilion, under the umbrella of the exhibition proper, was of interest to them. Two of the exhibitors – Dennis Adams and the partnership Machado and Silvetti – agreed to conceive their pieces for the exhibition as proposals for a permanent public art installation for the TransCanada PipeLines Pavilion. During the spring of 1992, Adams and the two architects visited the site, and prepared their proposals that – together with the gallery installations of their colleagues – comprised the exhibition, which opened on June 12, 1992.

The two proposals comprised a provocative pair. In an interesting artistic "cross-over," the artist, Adams, made a decidedly architectural proposal, while the architects, Machado and Silvetti, saw fit to develop a proposal whose principal focus was its public iconography. Adams' proposal was called *Break-Out Room*, following terminology already used in the pavilion to describe a series of secondary rooms designed to accommodate small group discussions that typically followed large group presentations. Both a model and drawings for his proposal were placed on display in the very space within the pavilion from which the actual executed project was intended to be seen. An excerpt from Adams' description reads as follows:

> Break-Out Room *is a proposal for two rooms of identical proportions that in tandem frame a view along the axis of a line that radiates from the centre of the TransCanada PipeLines Pavilion. Approaching the project along this axis, one room is situated directly behind the other at a distance of twelve inches. The front room sits on grade level and is accessible through its open face. The back room is suspended out over the steep drop of the mountainside by a steel I-beam structure and is completely closed to public access. The back walls of both rooms are glass and the front wall of the back room is a simulated black and white photographic negative between glass. Both rooms contain an identical table and bench. The viewer/user can look out from the front room through the photographic image into the back room and beyond to the landscape.*
>
> *The form of the work suggests the lens/glass negative structure of the early box camera that is associated with nineteenth- and twentieth-century photographic representations of the western landscape. By translating this historical icon into architectural form, photography is represented as a matrix of "captured territory," an agent for western expansion and colonization.*
>
> *The photograph was taken by Robert Galbraith during the 1990 Mohawk revolt at Oka. It shows four warriors behind a barricade on the Mercier Bridge.*

In short, Adams' proposal was an extension of the minimalist architectonics characteristic of a number of his earlier urban projects. Spare and inscrutable from one point of view, yet characteristically matter-of-fact from another, it only gradually disclosed its varied significances to an observer who lingered in its presence. Positioned as it was, it also brought the quotidian space of the conference centre's lounge into a newly acute relationship with the spectacular view of the valley beyond, not to mention with the larger politics of its inhabitation and occupation, throughout a century of Canadian history.

Machado and Silvetti proposed a piece to be located in the open space framed by the TransCanada PipeLines Pavilion and the older Donald Cameron Hall building to the north and east of it. Their proposal was exhibited both in drawings and in a dramatic maquette inside the exhibition proper in the Walter Phillips Gallery. As they describe it:

> *Machado and Silvetti Associates Inc., proposes a recreational facility adjacent to the TransCanada PipeLines Pavilion. It is a public "fire place" to be built according to the drawings and specifications on display. It is called* Banffire. *Its location allows the viewing of the spectacle of fire from all nearby buildings and by groups of people sitting around it on a cool summer night, for example . . . Since the* Banffire *is intended to be a permanent structure, we propose to build a well-crafted object, correctly located, iconographically clear, functionally seductive and desirable, and quite open to interpretations. We cannot predict its future meanings . . .*

Machado and Silvetti employed an almost cinematographic representation of their proposal for *Banffire*, to depict its very intense form in its own blacked-out space within the exhibition. They also scripted a "possible social interpretation" of it as it might exist "one hundred years from now," and presented it in textural form, together with the cinematographic representation of *Banffire* itself.

Proposed to be situated so as to intensify the existing social focus of the outdoor space formed by the venerable Donald Cameron Hall together with its new companion, the TransCanada PipeLines Pavilion, *Banffire* would have brought the characteristic summer social ceremonies of evening in Banff into a clearer focus for its residents, at the same time that it engaged the curious paradoxes of the Centre's uneasy, shared inhabitation of the valley by people and by wild animals.

## INITIAL REACTIONS

During the early weeks following the opening of the exhibition, it appeared that visitor reaction to the proposals by Adams and by Machado and Silvetti was proceeding similarly to that for the exhibition as a whole. To be sure, visitors were obliged to go outside of the exhibition proper to see the Adams proposal, but they also needed to do so to see other parts of the exhibition as well. These included a part of the installation by Marik Boudreau, Martha Fleming & Lyne Lapointe; a part of Jeff Wall and Dan Graham's collaborative work, as well as the guest curators' own

Rodolfo Machado and Jorge Silvetti *Banffire* (1992) installation detail

interventions on a number of existing outdoor artworks on the Banff campus. Indeed, initial visitor curiosity appeared to extend to all the works in the exhibitions, albeit, seeming to this observer, frequently to focus on the particularly animated aspects of Machado and Silvetti's rhetorically dramatic "black box" presentation, and Diller and Scofidio's clinically aloof dissection of tourist mythology at Niagara Falls. Indeed, during the early weeks of the show, there was only one controversial reaction to the show, and it focused on certain images amongst the series of backlit photographs by Jeff Wall, some of which had been mounted outside the gallery proper, in the dramatic public atrium of the adjacent Jeanne and Peter Lougheed Building.

As time went by, however, the status of the two "public art proposals" as possible permanent additions to the landscape at Banff began to be more evident, and perceptions of these two pieces in the show began to take on correspondingly greater precision.

## THE SELECTION PROCESS

The chief curator of the gallery had proposed that a small committee of representatives of various constituencies within the Banff Centre be formed to consider the two proposals, and to frame a recommendation as to how to proceed. However, before the committee had even met, undercurrents of concern about the artworks began to be heard. Costs incurred by the process up to that point had left a sum of approximately twenty thousand dollars to execute the work selected, and some committee members feared that was insufficient to erect either project. Then, other less pragmatic concerns also began to surface.

The placement and bulk of the Adams piece troubled some. Proposed to occupy a part of the brow of a hill that was also a major outlook down the valley, Adams' proposal for the *Break-Out Room* began – paradoxically enough – to generate unease not atypical of that which conventional architectural projects often confront nowadays – especially in communities such as Banff which, during the 1980s, had seen a development boom extensive enough to cause grave local disquiet. Blocking even a small portion of the extant view of the valley began to seem troubling to some. Then too, it was also possible to discern distinct local unease with the prospect of living day-to-day, indefinitely into the future, with the iconography of the photograph of the Mohawk Revolt at Oka.

In a perhaps surprisingly symmetrical fashion, the art/architecture cross-over also bedeviled the reception of the piece by Machado and Silvetti. Too small to block any

extant views, it nevertheless aroused other concerns. While it was true that bonfires had long been a tradition at the Banff Centre, it was noted that they were becoming less common than they once had been – indeed, some expressed concern that increasingly restrictive policies being put in place by the Parks Canada authorities might well eliminate the use of the proposed Machado and Silvetti fireplace in the future altogether. But this still sets aside consideration of the dramatic iconography Machado and Silvetti had selected for their fireplace – that of elk antlers. It seems to me that their choice of this subject as the primary vehicle for expression in their piece created an uneasy dilemma for observers at Banff. Unable to deny the symbolic pertinence of Machado and Silvetti's choice, they nevertheless appeared deeply reluctant to consent to see themselves represented by such a symbol – particularly given that it was one presented to them by outsiders.

## CONCLUSION

In the end a decision was made to choose neither proposal for implementation. As a result we were faced with a situation in which the experimental challenge to incorporate a public art competition into *Queues, Rendezvous, Riots* led at the end of the day to an impasse. Yet, perhaps, we should not have been too surprised. After all, we had argued that permanent art installations were far more contentious than "temporary" ones, that architecture's symbolic potency was likeliest to be strongest when its reception was not conscious, that public symbols themselves – especially when rhetorically presented – were highly labile, and that public consensus about meaning was very slippery.

Perhaps the greatest lesson we learned at Banff was how accentuated all these known conditions of political art praxis became at an institution such as the Banff Centre. On the one hand, it is of course true that the members of the Centre were a highly literate audience, far more attuned to the nuances of art discourse than any typical cross-section of the "public" could possibly be. Yet the same particular grouping was far more self-conscious in respect to cultural issues than an audience in a putatively normal municipal social setting when faced with a decision as to whether or not to proceed with either of two declaratory proposals for a permanent public art installation, proposed to be located in their midst.

In the end, it would seem that notwithstanding the evident strengths of the two provocative proposals submitted to the Banff audience for its consideration, the characteristic dilemmas of "public art" in our time were all too well reprised in that

audience's response to the two contributions to *Queues, Rendezvous, Riots*. Evidently, the "public," as before, at Banff and elsewhere, remained, and remains, "in question."

NOTES

1   Habermas' *Structural Transformation of the Public Sphere*, long available only in German, was finally published in an English translation in 1987 by MIT Press. My edition of Sennett's *Fall of Public Man* was published by Random House, New York, in 1978. In different ways, the two authors see the activities which they call quintessentially public – various modes of discourse among bourgeois peers in a shared space – as having risen to prominence in the eighteenth century, and as having declined in later years, due to the rise of modern mass societies and to the influence of modern mass media.

2   Some opinions of this kind appear in the collection of essays in honour of Habermas edited by Craig Calhoun, *Habermas and the Public Sphere* (Cambridge: MIT Press, 1992).

3   Michael Sorkin, ed., *Variations on a Theme Park: The New American City and the End of Public Space* (New York: Hill and Wang, 1992).

4   Walter Benjamin, "The Work of Art in the Age of Mechanical Reproduction" in *Men in Dark Times*, ed. Hannah Arendt (San Diego: Harcourt, Brace & World, 1968), 241.

5   Part of this history is recounted in Dennis Reid's historical overview of public art on University Avenue in Toronto, which was included in the June 1989 report "The Art of the Avenue: A University Avenue Public Art Study" prepared for the Municipality of Metropolitan Toronto by consultants DuToit, Allsopp, Hillier.

6   See *Komar and Melamid* by Carter Ratcliff (New York: Abbeville Press, 1988).

7   See George Baird, "La dimension amoureuse in Architecture," in *Meaning in Architecture*, ed. Charles Jencks and George Baird (London, England: Barrie & Rockcliff/The Cresset Press, 1969).

8   This episode is recounted in Chapter 10 of Al-Khalil's *The Monument* (London: Andre Deutsch, 1991).

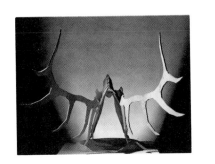

# BANFFIRE

RODOLFO MACHADO AND JORGE SILVETTI

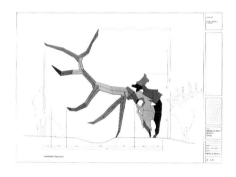

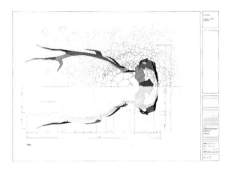

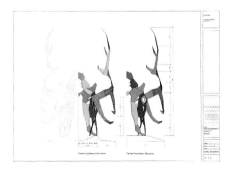

BANFFIRE — A BIT OF THEORY

For more than twenty years, architectural and art theory have had to deal and struggle with the devastating consequences of the definitive realization that the structural relation between form and content is arbitrary. It is particularly true in the politicized production of the "public," given the permanence and ubiquity of its products and its inevitable shifting meanings over time. Worse even, in realizing that the structural relationship is arbitrary, we have learned that such relationship is inevitable and, as a consequence, "meaning" is unavoidable. No one can entertain the idea of a naïve return to modern "formal abstraction" in order to escape the "dangers of meaning."

Postmodernism re-proposed the production of "critical" (or "deconstructive") objects. They have proven to be good for specialized audiences but hardly acceptable as public art: their "subversive" nature becomes either a public nuisance, an incomprehensible discourse or a fetish readily packaged for consumption. Lately

designers have been intrigued by the possibilities of producing "weak forms" only to be disappointed because they cannot hide their authorship and ideological and stylistic affiliations. Finally, there has been the further realization that, although structurally arbitrary, the relationship between form and content is historically motivated. Thus it brings back the inevitable polarization of the object, and it only assures, at best, the "dating" of the project and, at worst, the ridicule of future generations.

This dominant line of reasoning (paradoxically trying to control meaning while asserting that it is arbitrary and shifting) has lead to the cul-de-sac where mainstream/avant-garde art and architecture find themselves today. We accept the fact that controlling meaning is a losing battle. We believe in opening up other, fresher fronts such as those that pertain to more socially engaging aspects of public art: sensuality, desire and mythos. In so doing we refuse the complacent conservatism of the mainstream postmodern avant-garde, with its still condescending (as it was more than a century ago!) idea of educating the public, of producing shocking pieces that will make people aware of their exploited conditions in post-capitalist society, etcetera, etcetera. In other words, we reject the self-serving clichés of "critical art" that pervade today all the disciplines involved in the design of the public realm.

## THE ENTRY TO THE COMPETITION AND THE INSTALLATION AT THE EXHIBIT

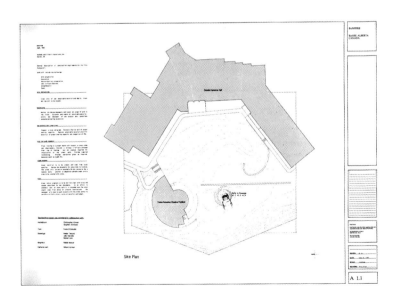

With this position in mind we approached the production of our entry for the *Queues, Rendezvous, Riots* exhibition, whose explicit intent was to "illuminate the various modes of the social formation, dissolution and manipulation of symbols in public art . . . [and to provide] . . . a context for a rigorous intellectual investigation into the notion of "the public."

THE ENTRY TO THE COMPETITION

The invitation to enter into a design competition as part of the exhibition offered
several choices as to how to approach the task, since there were at least two projects
(one for the competition and another for the exhibition) and the aims of the exhibit
could be applied to either or both of them.

Of all the possible combinations, we chose to enter the competition with the
design of a piece of public art that did not respond to the explicit intent of the
invitation, leaving this particular task for the installation accompanying the display of
the project in the gallery exhibition. It is clear that for us the short life of the
(meaning of the) "critical object" belongs to the gallery, while the intention of public
art should address more complex and subtle issues, which may result in works that
would rise above public ornament, purely programmatic concerns or strict political
motivations. We believe that public art that shocks and antagonizes people or, worse,
makes unaware lay people part of a "work of art" which in turn is watched by
experts, has had its day and it has failed.

Our aims are those of producing a piece that may be more related to the
subjectivity of a culture, which elicits desires that can be widely shared and produces
direct experiences that are unique to the site. But also, and importantly, our aims are
to produce a piece of public art that refuses to be a political statement not just by
distancing itself from an avant-garde position (to shock the public) but from a populist
one as well (to give'em what they want). Our proposal for the public art competition
is neither critical/deconstructive nor patronizing. It is about creating an object of
cultural and aesthetic appeal, and to make explicit our consciousness of its real social
and historical possibilities.

The proposed piece is based purely on issues emerging from the site itself:

| | |
|---|---|
| Landscape | The cliff, the forest, the mountains beyond |
| Fauna | The elk, who reign sovereign and sacred in the area |
| Weather | The cold, the snow |
| Local mores | Paranoia of (and fascination with) fire |

It consists of a stone fire pit at the border of the cliff in front of Donald Cameron
Hall, marked by a metal sculpture representing the skull of a colossal elk, which is
silhouetted against the imposing mountains. It is a communal gathering spot in one of
the most used areas of the campus (near cafeteria, dorms and administration). It attempts

to create a strong emotional communal
experience for guests, artists, faculty and
others at the Banff Centre for the Arts, as
they gather around a bonfire on the coldest
nights of the Canadian winter. Such an
experience is heightened by the attraction
and fear that fire produces in the context of
a national park. The piece is called *Banffire*.

## THE EXHIBITION

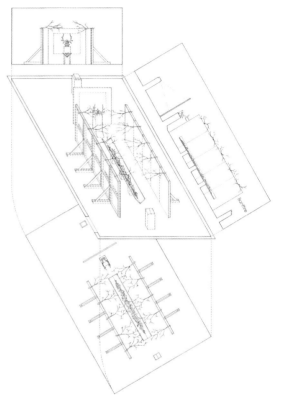

In the exhibit in the gallery we attempted
to deal with the issues raised by the
organizers by juxtaposing two moments in
the life of the proposed piece: first, a set of
descriptive drawings of the proposed piece
(plans, sections, elevations, etcetera) and,
second, an installation that shows a
moment of the imagined future history of
the piece. Both are narratives of events
that have not happened but are possible.
Both are verisimil descriptions of a
proposed piece of public art – one a technical narrative that would permit its
construction, the other a fictional narrative that would permit an understanding of
larger issues involved in public art. We could not predict the history of its future
fortunes but we know already the unfortunate history of its future meanings.

The installation consisted of a mise-en-scène of the ideas explored. The visitor
enters the large room and is confronted by the outside of a precinct defined by
vertical plywood panels. Directly in front he/she enters the precinct, stops and stands
at a precise point where he/she reads a text on a lectern. The text "Bonfeu, le 1er
mai, 2092," tells the story of an event taking place in 2092 at the site of the *Banffire*,
which is still standing. Directly in front, at the end of an axis is a background of
flames, the sounds of crackling wood and the smell of burnt things. The vertical
wood panels are marked by vertical black stripes, the traces of actual plywood burns
and, at the top of each strip, a carbonized tree branch emerges. Along the central axis
he/she sees a trough where there are burnt human artifacts: hiking shoes, bottles,

underwear, condoms. Outside the construction of the *Banffire* (the plans, sections, elevations, perspective) are Polaroid photographs of the production of both the project and the installation, and a short descriptive text.

THE OUTCOME OF THE COMPETITION

Perhaps the most illuminating event of the exhibit/competition, as far as the nature of public art is concerned, is the fact that while we were chosen as architects/artists, the project itself was questioned by the jury because of its "meaning" and its associations. While the fire-pit idea was approved, the iconography of the elk was considered inappropriate for the institution. After this we were asked to reconsider the design, which we were willing to do, but by the time we could have started we all realized there was not enough money to do it anyway, a factor that more often than not gives meaning to art today.

MACHADO AND SILVETTI ASSOCIATES INC., PROPOSES A RECREATIONAL FACILITY ADJACENT TO THE TRANSCANADA PIPELINES PAVILION. IT IS A PUBLIC "FIRE PLACE" TO BE BUILT ACCORDING TO THE DRAWINGS AND SPECIFICATIONS ON DISPLAY. IT IS CALLED BANFFIRE. ITS LOCATION ALLOWS THE VIEWING OF THE SPECTACLE OF FIRE FROM ALL NEARBY BUILDINGS AND BY GROUPS OF PEOPLE SITTING AROUND IT ON A COOL SUMMER NIGHT, FOR EXAMPLE. THE PIECE IS NOT INTENDED TO BE CRITICAL OF ANYTHING (ART, ARCHITECTURE, ETCETERA), AND IT CONSCIOUSLY AVOIDS BEING PART OF ANY AVANT-GARDE. WE VERY MUCH AGREE WITH THE THEORETICAL PREMISES OF THIS EXHIBITION AS PRESENTED BY THE ORGANIZERS, CHIEFLY THAT THE MEANING OF PUBLIC ART IS HISTORICALLY DETERMINED AND VARIABLE. SINCE THE BANFFIRE IS INTENDED TO BE A PERMANENT STRUCTURE, WE PROPOSE TO BUILD A WELL-CRAFTED OBJECT, CORRECTLY LOCATED, ICONOGRAPHICALLY CLEAR, FUNCTIONALLY SEDUCTIVE AND DESIRABLE, AND QUITE OPEN TO INTERPRETATIONS. WE CANNOT PREDICT ITS FUTURE MEANINGS. WE HAVE WRITTEN A FICTIONAL STORY OF A "POSSIBLE" SOCIAL INTERPRETATION OF BANFFIRE, ONE HUNDRED YEARS FROM NOW, AND REPRESENTED IT IN THIS EXHIBITION.

Proposal by Machado and Silvetti for the TransCanada PipeLines Pavilion
public art commission in 1992 at the Banff Centre for the Arts

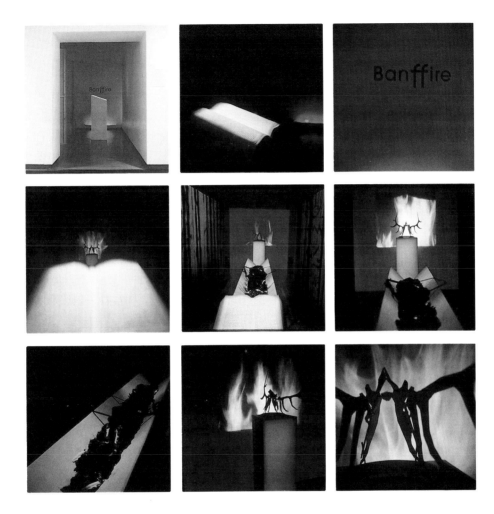

BONFEU, LE 1ER MAI, 2092

The choreographies of flames are never identical and their changing formations must continuously mean something else. So too can a variety of inflections alter the meaning of equal sentences. It is a question of tone rather than speech. Fire, I thought, was a language phonetically based on cracks, whistles and hums; it is either explicit (heat) or implicit (warmth). Intrinsic is its combustion, extrinsic are its gases. While we lick the words we utter, they can bear degrees of wetness: fire does the inverse; its tongues dry the air of its language.

It has been a practice of mine to chronicle the events of Bonfeu, and today's ceremony managed to unravel much more than this book has ever compiled. A woman had collected the local paper for decades. Her collection of daily infractions could not be left unpunished (recycling *obligé*), she was thus placed flat on her back, with her hands and feet extended, while the documents of her papyromania were set ablaze. With the wind blowing in the direction of those who silently watched, pieces of headlines flew about partially burned: the linguistic foundation of snowflakes literalized. The flaming fragments helped reconstitute an entire history: the missing dimension to our spectacle. Today's ritual was a purely solipsistic activity practiced by the more able out of "love for public art," while the less able persist in the belief that such displays actually mean something. Fires on the other hand are very suggestive, they attract a great deal of adjectives, yet only the punishment of this woman's folly could reveal at what exactly we were looking.

Most of the fragments I could read were somehow related to cultural events: *Sayonara, Again and Why Not* was an opera much performed here and *Banffire*, back in 1992, was the name of an exhibit out of which this structure emerged. This contraption, once considered "a neo-Semperian attempt at architecturalizing fire," even inspired claims such as "humanism is back." Architects and artists were often commissioned to display their installations in Bonfeu: S/M, Richard Forest (whose "weaving of metal alloys stood as vertical carpets providing elemental shelter") and Gladys Oppenheim, among others, exhibited on this site. The impression I could gather of Old Banff was that of a small yet elegant town living around a bankrupt Grand Palace Hotel whose casino was closed thus condemning the once posh to perpetually reminisce. The flying quotations, however, became less about "today's *vernissage*" and more about fire; its "ills" or "benefits" were measured; "ideological biases of more than a century of fire suppression" were deconstructed; someone was convicted of "animal torching"; and mysterious "running fires" were linked to a resident artist's madness ("found guilty of elk slaying"). The artist was a pyromaniac whose happiness consisted of setting antlers ablaze. More importantly, the town was slowly ravaged by "controlled burning." The slippage from Banff to Bonfeu

now made sense: a scriber's morbid irony when told to translate Great Fire.

Fires became the town's regular spectacle and some editorials even fatalistically implied nature's necessary rejuvenation and legitimized the fabrication of lightning. The place where the woman lay was the privileged seat from which the burning mountains could be viewed. No one believed a "Fire Control Programme" could fail. Elk too were often featured in burning headlines: "Growing Bolder Every Year," their violence was impossible to quell. One evening in September of 2013, a most horrific event occurred on this exact spot, around this very monument, during "happy hour" where one brought one's own steak (BYOS). Four curious male elk found themselves within the confines of this place and Forest's Core-Ten steel walls. Panicked by fire, they charged. The hour was no longer felix.

I could see the same spectacle, lightning repeatedly striking the mountain and accentuating the monument's steel spikes. The calligraphy of its contours framed the mountain beyond (both monument and landscape punctuated by flames). This once "domestic" fireplace has always served as a site for sacrifice (may it be for the warming of dogs, the massacre of elk or the burning of newspapers). It was sadly transformed into a memorial for  the dead; a mnemonic device whose purpose was to remind of the four elk here slain. Elk, however, soon disappeared (no one really liked horned squirrels anyway) and the weather was blamed. Other burning fragments later alluded to a short-lived era of environmental terrorism. Bonfeu was the ideal mountain guerrilla's fief (this monument was their symbol). Greenpeace was implicated with the OLF "in a joint operation connected with 'August Spills.'" Water pipelines were sabotaged and nature's cataclysms were instigated; their natural status became a national debate. Green became an intolerable color and violence an ambivalent practice. Violence had by now been institutionalized (not without its misogynies) and the woman whose fingers and toes of both hands and feet could touch the outer rim of a circle described therefrom was finally set ablaze. The nature of her infractions was irrelevant, only the choreography and inflections of rituals mattered; "it is a question of tone rather than speech." The flames licked her body while they cracked, whistled and hummed. Her screams shrieked and solidified as steel antlers. The newspapers she had saved, fueled her death. Elk might have once been sacred, it was even a crime to kill them, yet their sanctity relied on their being killed. They lived at a time when murder insidiously resembled sacrifice: crime entailed serious perils while it appeared as a sacred obligation which could only be neglected at grave peril. Like elk who once found surrogate victims to appease their rutting-induced violence, or men who "controlled" their numbers, monuments now serve the same purpose: they serve as official outlets for our hostilities.

Installation: Christopher Kirwan, Stephen Atkinson
Project team: Robert Linn, Julio Salcedo, Nader Tehrani
Fictional text: Fares El Dahdah

# RESOR HOUSE
## A ROOM BETWEEN VIEWS

# BREAK-OUT ROOM
## PROPOSAL FOR THE BANFF CENTRE

### DENNIS ADAMS
### 1992

MIES VAN DER ROHE
*GLASS HOUSE ON A HILLSIDE*
(1934) ELEVATION

In late August of 1937, Alfred H. Barr Jr., Director of the Museum of Modern Art, urged Mrs. Stanley B. Resor, the wife of the director of a large advertising firm in New York and one of the Museum's trustees, to invite Mies van der Rohe to visit the United States. He was to study a site on the Resor Ranch in Jackson Hole, Wyoming, and prepare a proposal for a vacation home on it. The commission, Mies' first in the United States, was initiated in the wake of his forced resignation from the Prussian Academy of Art in Berlin during July of that year, under threat of the escalating anti-modernist cultural policies of the Nazi regime. En route to the Resor Ranch, Mies stopped in Chicago to discuss an offer to chair the School of Architecture at the Armour Institute of Technology and on his return he stopped again to formally accept the position. Over a period of several weeks during his stay with the Resors in Wyoming, and throughout the next winter in New York, where he worked out of the office of his ex-Bauhaus students Barney Rodgers and William Priestly, Mies developed numerous permutations for the design. In the following spring he returned to Germany to close out his affairs before assuming his new duties in Chicago at the beginning of the 1939–40 academic year. During this return voyage, for reasons that are not entirely clear, Mies received a telegram from Stanley Resor cancelling the entire project. The house was never realized.

Outside of any claims about its architectural merits, the Resor project, then, represents a psychological station between Mies' resettlement, a charted delay between two cultures and two careers that consolidated his separation anxiety into a stark image of modernist ambivalence, a house displaced between two competing views of the rugged western American landscape.

# RESOR HOUSE

Specifically, the Resor commission was initiated to finish a partially constructed two-story service wing and add a westward extension that would define the central living quarters and bridge a small tributary of the Snake River. The original architect, Phillip Goodwin of New York, had terminated his role in the project after a dispute with the Resors. Mies was obligated to work with the fragments of Goodwin's design which, in addition to four concrete piers that were already in place to support the projected expansion across the river, included the elements of the service facility: a kitchen, pantry and servants' living area upstairs, and servant bedrooms and utilities downstairs. Mies' basic idea for the extension was to span the river with a long rectangular living room bracketed along its length by two glass walls that extended from floor to ceiling. This "observation bridge," from which one would have been able to view spectacular scenes of the Tetonic mountains, was intended to connect the pre-existing east wing that Mies had inherited, with his own design for the west wing, which was to house an entry, office and garage downstairs, and three bedrooms upstairs.

Mies produced a total of 844 drawings for the project. The design went through many modulations – sketches, plans, elevations, perspectives, details and photo collages – which eventually led to the development of three maquettes. The first maquette attempted to solve the problems of the inherited site and architecture and, therefore, unavoidably has a hybrid look. The last two maquettes dispensed with Goodwin's existing two-story

wing altogether, distilling the form of the house into single-story design. The east wing and west wing were here treated identically in volume, enclosed in cypress planking wrapped around both ends of a long glass rectangle. The last of these three maquettes went so far as to eliminate the bridge concept completely, anchoring the entire rectangular form of the house to a solid base.

The Resor project, then, exists as a series of visual propositions resisting final form. The sheer output of Mies' drawings, never to be equalled in his American phase except when he worked on the Library and Administration Building of the Illinois Institute of Technology, may have mirrored the restlessness of his mind, his immense anxiety on the eve of his resettlement in America. Even his archivist, Franz Schultz, concedes that the importance of the Resor House to Mies' overture is more biographical than architectural. This anxiety was no doubt intensified by his complete isolation on the Resor's Wyoming ranch as the project took shape. Nothing could be further from the turbulent streets of Berlin than the majestic solitude of the western American landscape. This was compounded by the fact that his hosts spoke no German and Mies spoke hardly a word of English.

One can only imagine this displaced German en route by train to Jackson Hole, Wyoming. Perhaps he was filled with fantasies of the American wild west, spawned by Karl May's popular adventure stories for German adolescents that were part of the collective memory of his generation. There is, in the dramatic rendition of Mies' photo collages for the Resor project, a utopian dimension, a metaphor for escapism in the image of a heroic landscape paradise. However, the subjugation of the house's interior to its exterior views proposes a radical imaging system that confounds the proposition of "wall as window" in the service of observation. The transparent boundary between the inside and the outside of the house would be compromised, seemingly capturing the "view" on the surface of its glass walls, in the sense of a photographic image. As Manfredo Tafuri and Francesco Dal Go have written in discussing Mies' glass walls, "The interpenetration between indoors and outdoors were treated as illusory: with no trouble at all, nature could be replaced by photomontage." Or as Kenneth Frampton has demonstrated in distinguishing the "tectonic" effect of the Miesian glass wall from the "scenographic" effect of Phillip Johnson's glass house, "Like Casper David Friedrich, Mies regards nature as an ambient mirage of light and verdure, a distant fusion of haze with the landscape or the near appearance of fossilized foliage miraculously suspended between floor and ceiling." To the degree, then, that the house's interior embodies its exterior views, it implies a perverse masking operation. In this sense, the glass walls would not only function as transparent planes to look through, but also as "blinds," decorative screens in the service of Miesian denial which, in turn, presuppose "another view" – hidden – outside the scope of the house as an "instrument of surveillance."

Among the vast number of rough sketches that Mies produced for the Resor house, there exists an interior perspective study – looking down the length of the living space – that depicts the glass walls on one side as transparent and on the other side as black. How do we explain the meaning of this stark opposition? Even Franz Schultz makes special note of it in his introduction to the Resor Project archive, labelling it as one of a handful of

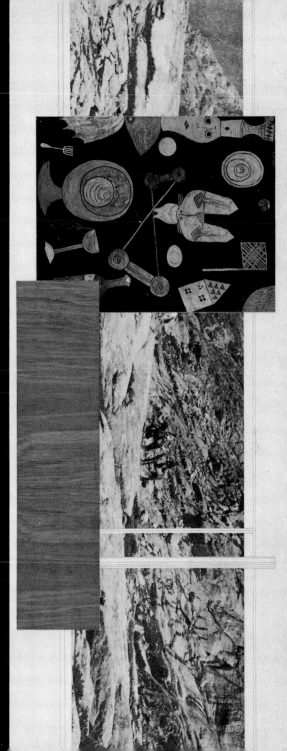

"bizarre, sometimes mystifying" proposal sketches that Schulze explains as the result of Mies' experimental mood during his stay at the Resor Ranch. Whatever its motivation, one thing is certain: from the inside, at the centre of the house, one view would be turned against the other. There would be no privileged vantage point. Sandwiched between two views of the rugged western American landscape, the occupant would be visually blackmailed. Commitment to one view or the other would set up an economy of denial, regulating this "blind side" in a system of exchange. The "unseen" would become the subject of the house. A utopia of exclusion would be set in motion. Supplementing this effect, the private and service rooms that were to have been enclosed by cypress planking on both ends of the house would be situated on the periphery of vision, at the limit of this double view. Beyond a concession to the function of "home," they would operate as blinders, guaranteeing the strict framing of views and the interval between them.

Of all the visual propositions that Mies produced for the Resor project, the most revealing of his conceptualization process are the two seminal photomontages that depict the house from an interior vantage point, along the exact bisection of its width – each looking out at the rugged western landscape through opposite glass walls. Both perspectives radically reduce the interior of the living room to little more than a framing device for a view. The north view is pared down to four vertical bars that overlap the landscape, depicting two structural columns in the foreground and two window frames at the limit of the interior. In the south view Mies added two visually startling decorative planes that crop the structural columns and window frames. These represent free-standing murals that were proposed as dividing screens to partially bisect the length of the living room. What is disturbing about Mies' use of photomontage is the extent to which it exceeds its function as a transparent representational medium in the service of landscape depiction, rendering the house an agent for photographic production itself – analogous to the viewfinder of the camera. In the north view what is, in fact, a representation of Mies' historically radical separation of structural support and wall, on first inspection gives the impression that one is outside the house looking completely through its interior to the view on the other side. This horizontal corridor, then, becomes a kind of collapsed version of the house itself, a model of its camera-like structure.

Hypothetically, standing inside at the centre of the house, a commitment to one view or the other would open up the possibility that the occupant might be viewed from behind, outside one of the glass walls of the house. This paranoiac proposition confirms the presence of this "blind side." The "unseen" would be mentally imaged by the viewing subject as its own double. The site of voyeuristic privilege would be displaced, recast into a serial exhibitionism in which the viewing subject/object relationship would be threatened. The very boundary of the house would be dissolved and absorbed into the ego boundary of the occupant.

The proposition of the free-standing screens that were to bisect the length of the living room confirm the anxiety of the house – its agoraphobic disposition. They would intervene along its fault line of distress at the exact centre between views, mapping the ego boundary of the house and, by extension, that of the occupant; they would become a kind of stand-in for the ego boundary. In this way, they would index an interior wall, the trace of a backside that would in turn set up a sense of frontality, directing the occupant's gaze outside the corresponding glass wall. From this perspective they would also deflect paranoiac imagery, screening out unchecked visual scrutiny from outside the house through its opposite glass wall. The voyeuristic privilege of the living room would be refortified as a platform of observation – a site of control. From the opposite perspective, these screens would crop the given views of the landscape, extending the violence of exclusion already in place in the image of the house as a viewing instrument. If the glass walls are suggestive of the viewfinder of a camera, then these screens would operate like the cropping bars of the darkroom easel, demonstrating an excessive control over the pictoralization of nature – its final dissolution into the composition of two-dimensional form.

To the extent that the symmetry of the house reinforces a fixed viewing point, from inside at the centre of the living room, it recovers traditional perspectival representation, breaking from the free-play of modernist experiments already pioneered by Mies in such radical decentred compositions as the Barcelona Pavilion of 1929. In this manner, the Resor House is a direct descendant of Mies' competition entry for the German National Pavilion proposed for the 1934 Brussels International Exhibition. This design was initially planned as a square, single space pavilion, glazed on two sides. As in the Resor House, its enforced symmetry registered a desire for a privileged viewing subject in the form of a central platform from which the gaze would be directed, if only to subvert it with the option of a second view. This ambivalence is further compounded in the Resor House to the extent to which it would have compressed the volume of its central open space between two walls of glass. The identity of inside and outside would be problematized by the overall image of the house as a camera-like structure to look through. From this abstracted vantage point, the occupant would be neither the subject nor object of viewing, but rather relegated to interference along the sight-line of a sacred modernist eye.

The proposition of the Resor House's central glazed volume with its undifferentiated space anticipated Mies' "freezing down in America." Like a vacuum, it would have been insulated from connotations of "free space" capable of generating new social formations. To what degree this was conditioned by Mies' separation anxiety on the eve of his resettlement in America can only be speculated. What is more certain is the extent to which the house would have operated as a "blind" in the name of transparency, inaugurating the subject of Mies' American career, a dark matrix where early modernist ideals would be absorbed and transformed into a new image of corporate power.

This proposal takes its lead from the small conference rooms of the same name in the TransCanada PipeLines Pavilion. These rooms represent an extension of the conference program – the possibility of "breaking-out" from the formal classroom situation into more intimate spaces for discussion. Taken one step further, these rooms might suggest an architecture for dissent – a "break" from conventional social discourse.

Break-Out Room is a proposal for two free-standing rooms of identical proportions that in tandem would frame a view of the majestic Banff landscape. The rooms would be sited along the axis of a line that radiates out from the centre of the TransCanada PipeLines Pavilion. Approaching the project along this axis, one room would be situated directly behind the other at a distance of one foot. The first room would rest on grade-level and would be accessible through its open face. The second room would be suspended out over the steep drop of the mountainside by a steel I-beam structure and would

# BREAK-OUT ROOM

be completely closed to public access. The rear wall of the first room and the rear wall of the second room would be clear glass. The front wall of the second room would be a black and white photographic negative screened on glass. Both rooms would contain an identical table and bench. The occupant would be able to look out from the first room – through the photographic image on glass – to the second room and beyond to the mountainous landscape.

The form of the work references the early box cameras and glass negatives that were associated with nineteenth- and early twentieth-century photographic representations of the western landscape.

The photograph was taken by Robert Gabraith during the 1990 Mohawk revolt at Oka. It shows four warriors behind a barricade on the Mercier Bridge.

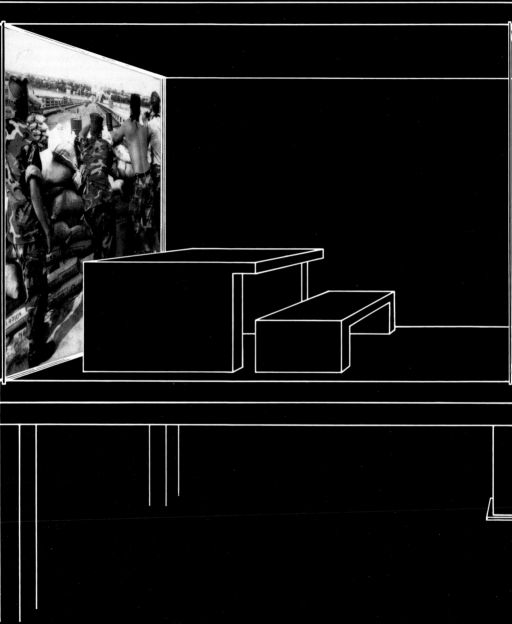

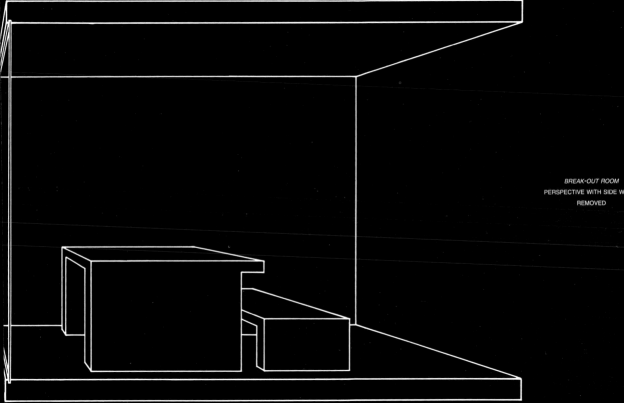

BREAK-OUT ROOM
PERSPECTIVE WITH SIDE W
REMOVED

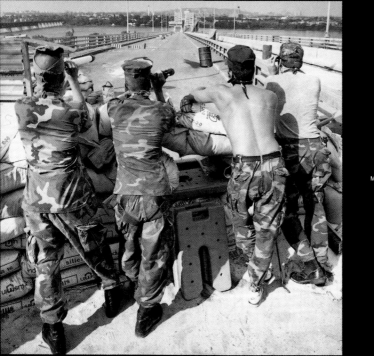

MOHAWK REVOLT AT OKA (1990)

# PUBLIC INTEREST

mark Lewis

The *public* art of our cities. Is it simply a token investment (in every sense of the word) in the city's architectural organization? Or is it an acknowledgment of the aesthetic experience necessary to make citizenship meaningful? And if so, what are the models, utopian or otherwise, that a modern city might set its sights on emulating? Can we imagine a place where, or time when, the occupation of the city and a certain aesthetic experience were commensurate?

The citizens of ancient Greece, the citizens of Rome and, more recently, the citizens of Paris, and even of New York, experienced the city in many ways as a place to be enjoyed. We are familiar with the limits of this experience, indeed the limits of citizenry; we know full well that even to talk of the aesthetic experience of these places and these times is at once to acknowledge the barbarism upon which they were built. But nevertheless it would be foolish to deny that for those who could enjoy it, the construction of the city, of the public realm, was studied in part with a mind to what we could call the aesthetic rights of those privileged few. Citizenship today is more universal, and we might have reason to expect, then, that the aesthetic experience of the city, previously reserved for the privileged few, would be a central part of this new extended franchise. Posed simply, we could ask if our cities today are organized with aesthetic rights in mind? Or, to ask the question a little more rhetorically, is there any continuity between Athens, Rome, Paris and New York, on one hand, and the city that increasingly most of us are forced, by reason of work or love, to reside in – the city of the shopping mall and the extended suburb, the city of Toronto, Edmonton, Vancouver, Minneapolis, Houston and Columbus, Ohio? Indeed, should there be?

We hear a lot today about the importance of public art. An abundance of exhibitions, conferences, books and essays testify to the fact that it has become the lingua franca of curators, museum administrators and all those who are concerned to enlarge art's franchise. Increasingly public art has also become a small but integral part of the plans for large scale developments in our cities, and in this respect developers

have responded to pressure brought to bear by administrators, government officials, and even artists. This imperative to build and create public art presupposes that there are indeed places that are meaningfully public, that today's city is, in other words, capable of delivering a certain public experience. We need to be certain that this is the case (or certain of the degree to which it is not the case) before we simply deliver to the city objects and markings whose meanings depend greatly on the framing effect of their occupation, public or otherwise. Increasingly we learn that the possibility of aesthetic involvement in the city is seriously atrophied and, if it exists at all, it is only in the most tangential and inconsequential forms, forms that de Certeau and the Situationists felt obliged to identify as the aesthetic practices of everyday life. We might feel entitled to ask if the crossing of a road against the red light or returning home in a way not detailed according to economics and ergonomics really counts as a significant aesthetic experience.

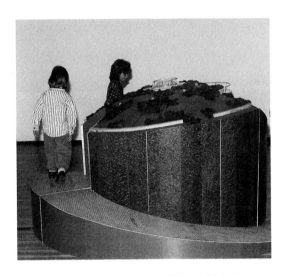

Jeff Wall and Dan Graham, *The Model for the Children's Pavilion* (1989–1992)

It would probably not be too difficult to argue, then, that in its most general formulation, what is being proposed with public art projects and programs is less an aesthetic *of*, and more an aesthetic *for* the public realm – a sort of last minute addition that unwittingly acknowledges the increasing failure of the so-called public realm to entertain the possibility of an aesthetic experience. If this is the case, the rhetoric of art's public involvement might run the risk of passively colluding with this denuding of public life, for in extinguishing their responsibility of protecting absolutely that utopian experience of public life (a responsibility that we might suggest has been the provenance of the enlightenment museum) our "cultural guardians" might end up introducing the diminished possibilities of *today's* public life into the museum. Would the space between Disney and aesthetic rights even be worth measuring?

Central to the experience of the work of art is the dialectical relationship between form and content. Historically the relationship between these two has been

experienced as an impossible reconciliation (this would be art's difference, so to speak). Expressions like "form follows content" and "no content without form" are correct only to the extent that they recognize the difference with which aesthetic judgement must proceed. They are incorrect insofar as they might judge that that difference will be reconciled to the benefit of one term or the other. The commission of a work of art for public display, the desire for such a work, is often predicated on just such a reconciliation of art's dialectic. For this imaginary work must commit itself in advance to exigencies that have the effect of radically diminishing the aesthetic dimension of its experience. For instance, most public works are required to engage with specific interests (community or corporate, for example), interests that are defined before the interrogation of what art's publicness might be, an interrogation that, according to the inner laws of art cannot precede its formal experimentation. To talk of interest here is not simply to acknowledge the whole slew of laws and edicts that in turn forbid and allow certain expressions and images in the "public realm." These restrictions are simply a matter of an absolute content and art today really has no commitment in this direction.

We need to be clear here, or we risk chasing the tail of a fast disappearing but nevertheless reassuring lure: censorship in art does not exist. Of course it exists in atavistic forms, but today in the west there is nothing that cannot be said, nothing, that is, that when released (as everything eventually is) can in any way mitigate an assumption of liberation, revolution or victory. And this is not simply to affirm the pithy truism that art is no longer *the shock of the new*. Rather it is to underline the fact that the intimate bond that once tied interdiction to art's *modus operandi* (its historical and delicate attempts always to circumvent the laws and protocols that forbade its invasion into certain territorial subject matters of the state, the church or the privileged) has long since expired. Art is free to represent what it likes with regard to subject matter. This is its obligation, an obligation that will not be extinguished simply by local legislation or even by imprisonment. To talk of art being banished or censored, or at least to speak of that as art's primary engagement, is strictly speaking, wrong. To argue otherwise is perhaps reassuring (if your stake is in interdiction and in trying to recreate the possibility of *shock*) but it is a conceit of increasingly obvious proportions.

No, the interest that we might find to have so undermined the possibility of a truly public art, or at least undermined the possibility of properly investigating its definition as such, is one that has, in advance of any real production, been imposed upon this art – a functional a priori. In other words public art must have a function,

and its total operation must be on behalf of that functionalism, a mimetic relation that will guarantee that this art of the public domain will never simply be itself. With regard to this functional a priori, there seem to be at least two common sense imperatives which guarantee that the former remains the putative content of so much of the public art that institutions and officials have championed, indeed allowed.

The first imperative is that this art, a public art outside the museum, must function differently. Why? Because it must answer to the expectations of those for whom the experience of the work of art is an alien concern (they do not, for instance, visit museums regularly). But then do we not run the risk of simply reaffirming that very alienation, assenting to the division of labour that allows some to engage (and others not to engage) with art's essential propositions? At the very least it underlines the difference between the museum and its other, indeed designating an "out there," the public realm as *being* the other of the museum. This imperative not only demands that alienation be taken into account (and presumably overcome), but because it establishes *alienation* as a central preoccupation of the work of art, it also insists that the work (or the process of its production) attend to what is often called "accountability." To wit: this art, outside the museum, but in the place that local people have their history, must respond to that history and recognize the place where it is made. Why? Because the people who live and inhabit that space have the right to determine what its organization, aesthetic or otherwise, should be. While it would be difficult to argue, *inter alia*, against that right (indeed the idea of an aesthetic right to the city would seem to include just this sort of franchise), we might want to know how these rights are to be adjudicated and represented. Further, what kind of occupation would determine if one person's stake in that adjudication was more immediate, more pressing than anyone else's? It is worth remembering that accountability, historically mandated by the state through and by its various national and local interests, gave to us the commemorative monument. Today, with accountability still the test of much public art, we risk being the grateful recipients of even more monuments, "democratic" monuments perhaps, but monuments all the same.

As soon as anyone or any group begins to speak on behalf of a given community, what is revealed (often because of the need to keep it repressed) is an acknowledgement of the contamination of public rights by private interest. This is not to suggest that private interest is alien to the aesthetic experience of the public sphere; on the contrary, it is to acknowledge the dialectic of public and private that makes the experience of the public realm so significant, so radically public. Think here of the

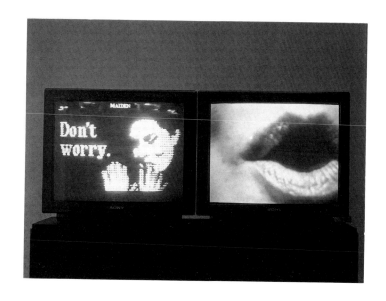

Vera Frenkel *This is Your Messiah Speaking / Allo, Votre Messie Vous Parle*
(1990) photo/video installation details

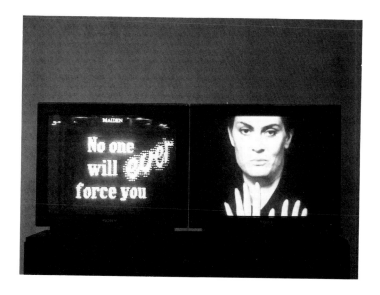

many historical public figures, including the much maligned *flâneur*, who have peopled the public realm and indeed brought it to "life." For these figures to enjoy the public realm, it was necessary to both feel the ineluctable draw of anonymity, to become lost in the crowd, so to speak, while at the same time experience the public, or the crowd as spectacle, as cinematic frieze seemingly organized for their or *your* private contemplation. While we might be able to describe this contamination of public and private, this precarious sense of publicness, we certainly cannot design it. This is the achilles heel of the modern, or perhaps we should say, the hypermodern city: it needs to plan, to design, to have everything in place before it dares even to call itself a city (and the mega development projects are just one sign of this desire for an urban *gesamtkunstwerk*). At the risk of introducing yet another problematic history, we could say that the hypermodern city – the city of Vancouver, especially with its development of the former Expo lands, is exemplary here – would like to stage-manage montage, or at least assemble in a totalized form what heretofore had been brought together without the conceit of a total vision. It is nothing radical to insist upon montage, or at least the montage of public and private as what has provided the modern city with many of its public possibilities. It is important, then, to acknowledge the fundamental relevance of the dialectic of public and private in what, strictly speaking, it is now difficult to call the public realm. Moreover, if we resist the temptation to believe that these conflicting interests can or even should be reconciled, it will bring us one step closer to releasing public art from its own obligatory interest.

The second imperative is that this art, outside the museum, but inside a place where people come to work, rest and play, must practically serve these forms of occupation. Chairs, tables, signs, drinking fountains are only the most obvious exemplifications of this art that has a functional form, though architectural decoration and other public markings could just as easily be imagined.

These two imperatives, then, often burden the public work of art with the obligation to deliver formal solutions to a content already defined, and these solutions can be caricatured as having two very general models: the commemorative monument and the architectural or functional form. In so far as these are the expectations for a public work of art, they are also its historical antecedents and the extreme limits against which it must at least expect to be read and judged. There are a number of ways in which these obligations can be resisted. Perhaps the least obvious, but certainly not the least interesting, might be to embrace these obligations without pretence, and to embrace them less as contents to be refracted formally, but rather as formal propositions to be transformed dialectically. With obligatory contents

(accountability, public alienation, functional models) rhetorically restaged as formal propositions, the irreconcilable dialectic of the work of art within the public domain may be allowed to reemerge as a problem. It may be that the public realm does not exist; it may be, in other words, that the complicated and dialectical relationship between public and private necessary for an experience of the public sphere is disavowed or even impossible in today's cities. But this should be no reason for art, when sited in this non-public place, to give up on its responsibility to refuse those very interests that would guarantee the disappearance of the dialectical relationship that is essential to both art and, for the want of a better word, publicness. Two examples of an engagement with the dialectic of art and its publicness can be found in the following.

## THE PYRAMID AND THE WEDGE: THE MONUMENT AND ITS WASTE

In 1918 the Russian architect Nikolai Kolli made a proposal for Lenin's *Monumental Propaganda*, a proposal that was eventually erected in plaster form for the May Day celebrations of that year. In some respects *The Red Wedge Cleaving the White Masses* is a three-dimensional articulation of the familiar revolutionary emblem that was used to depict the Bolshevik's fight against the invading "White Armies." It is also, however, a remarkable critique of the project of monumentality. In Kolli's work the red wedge literally splits open the plinth that supports it, thus presenting the internal and irreconcilable contradiction lying at the heart of a project intending to commemorate, with monuments, the achievements of the revolution. On the occasion of the May Day celebrations to honour the demise of the Ancien Régime and the continuing victory of the revolution, Kolli's monument exacts a critique of monumentality but only at the price of its own failure to escape the very conditions of monumentality.

Revolutions, by definition, cannot be static and eternal: in order to continue their claims to be revolutionary, they must be (permanently) against permanence. Revolutions, however, must also address the question of their own practical hold on power: if a revolution is "victorious" it will by necessity seek to represent its "victory," so that it may be historicized, legitimated and guaranteed. Kolli's wedge can be read, then, as an emblem of this very contradiction: it keeps alive the dialectic of permanence/impermanence, not just as a problem of monumentality but as a problem for the representation of the revolution itself. A similar acknowledgement of this dialectic is to be found in the "Theory of Ruins" formulated by Albert Speer with the expressed support of Hitler himself. In this case it was a question of

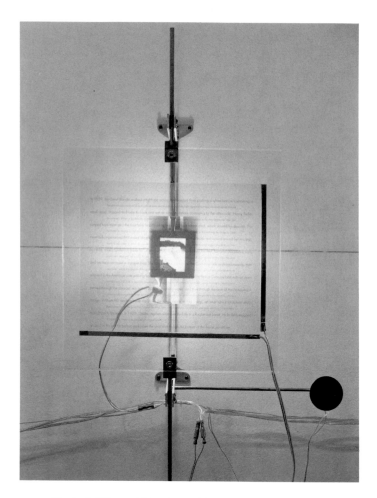

Elizabeth Diller and Ricardo Scofidio *Foto Opportunity* (1992)
installation detail

presenting the Nazi Reich as a ruin, precisely to achieve the effect of historical permanence; to acknowledge the demise of the régime in a way that suggested that it would be remembered as the antiquity of the future.

If Kolli's monument marks the death of the monument it does so by insisting that the problem of monumentality continues, not necessarily in its proper place – as the physical manifestations of a régime's occupation of the public realm – but elsewhere in the internal contradiction that will dominate the revolution which, when resolved, will inevitably bring about its very demise. As the revolution approaches the condition of monumentality, its "guardians" will quickly become the new Ancien Régime. In this respect, as much as Kolli's monument is a tomb for monumentality, it is also a tomb for the revolution. As Derrida has shown, the tomb commemorates the disappearance of something (life) by attesting to its perseverance:

> *This double function belongs to the funerary monument. The body of the sign thus becomes the monument in which the soul will be enclosed, preserved, maintained, kept in maintenance, present, signified. At the heart of this monument the soul keeps itself alive, but it needs the monument only to the extent that it is exposed – to death – in its living relation to its own body. It was indeed necessary for death to be at work – the Phenomenology of the Spirit describes the work of death – for a monument to come to retain and protect the life of the soul by signifying it.*
>
> Jacques Derrida, *Margins of Philosophy*

Another project, although at first sight might not seem to qualify as public art at all, nevertheless continues, albeit unwittingly, Kolli's grave reflections: on April 13, 1989, the *New York Times* announced that Staten Island planned to construct out of New York's garbage a unique monument that would dominate the familiar New York skyline. Somewhat improbably, the Staten Island authorities were preparing to build a giant, thirty-million-ton pyramid that when completed (anticipated in 2005) would have been as high as the Statue of Liberty. The *New York Times* article kindly included alongside the illustration of the planned pyramid of garbage, an image of the Great Pyramid of Giza, showing how the Staten Island authorities would manage to double in size and volume the historical antecedent. The scheme was utilitarian (the city has to dispose of its garbage somehow) but it was also designed with a monument in mind: to remind New Yorkers of how important garbage is.

Waste in this example is produced as a monument to the city's trace of its own occupations, of the occupations of those who inhabit its publicly defined, civicly

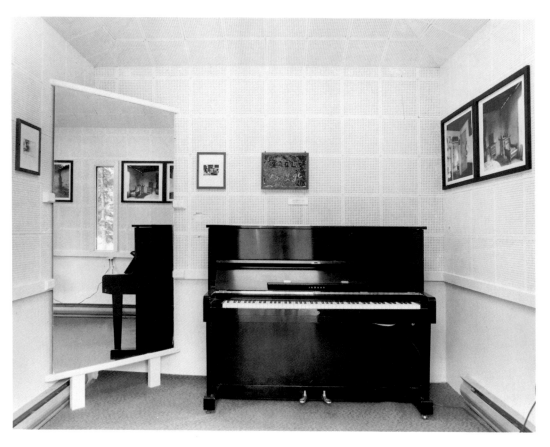

Marik Boudreau with Martha Fleming & Lyne Lapointe, *Attention* (1992)
one of three installation sites outside the gallery

defended and legally inscribed borders. Rapidly disposed of (more rapidly in some areas than in others) garbage must nevertheless reappear somewhere else as the reminder of its temporary disappearance from the place where it was first deposited and accumulated. It does not matter how far you remove it from its source, it will always return in one form or another. Perhaps the most common form of that return is in the environmental damage that it has come to represent. Or in the case of developing countries, its return is in the images of the poor whose scavenging through the mountains of waste testify to the continuing and residual exchange value of garbage (here the "garbage scavengers" literally take the waste back into circulation, back into the city to be sold). What in any case has become increasingly clear is that while garbage can indeed be disposed of and removed to another place, from this other place it will immediately and ceaselessly plot its return (in the form of acid rain, ozone, contamination) and demand to be treated and removed again and again.

The Egyptians built *the* pyramids and New York would like to build *pyramids of garbage*. Perhaps there is some continuity between the experience of the city of old and our own putative public occupations. But this would only be a highly qualified commensuration of experience. What is strikingly commensurate, however, is the formal and ideological connection that the pyramid of garbage shares with Kolli's wedge. The dialectical relationship between the city and its garbage or more properly, the dialectical tension that would divide the city against its own public definition (the waste is the evidence of a certain public occupation) resonates with Kolli's attempt to bring base and monument together even as he splits the one with the other. The garbage pyramid reintroduces as monument what is unallowable in the city. The compulsion of the public sphere to foolishly attempt to (temporarily) evacuate itself of the very signs of its corporeal inhabitations (an irony that is the unmistakable target of the pyramid of shit), this "futile" and impossible gesture is also one that Kolli's monument presciently identified as existing between the revolution and its desire for monumental commemoration. Both monuments, Kolli's and the one that would properly belong to the waste of New York, are tombs (in the Derridian sense of reversal) and both therefore testify to the continued perseverance, even in decomposition, of problems of permanence and monumentality, of impermanence and commemoration, and of waste in the place of its expunction. If these problems are not exactly on site any more, if they remain veiled and scarcely recognizable, they are nevertheless always contiguous and dialectically implicated in every public project that might wittingly or unwittingly have an aesthetic engagement with the public realm.

The pyramid of garbage is, of course, Kolli's wedge in reverse. Instead of splitting its base open, the excrescence of the earth or, rather the excrescence that is the industrial and domestic metamorphosis of the earth's contents, spits upwards, destroying the useful landscaping of the cityscape. Shit and garbage protrude from the base that can contain them no longer and in so doing this pyramid of garbage revisits the history of modern sculpture. Rodin, then Brancusi and finally Robert Morris spelt the end of the régime of the sculptural object separated from the world by the effect of its base. Their work may have marked the end of a régime that would have the object, separate, venerated and stable but as *any end* will eagerly announce, the base will return, periodically and in varying degrees of veiledness. It will return as the excrescence of the sculptural object, of the statue in particular, but of everything that will attempt in the public sphere to mark, structure and commemorate certain types of occupation, bodies or imaginary events. Between Rodin and Morris, then, Kolli's wedge reprises the privilege of the base, resurrects it without nostalgia, simply as the reminder of the ghost that, even as Morris installs his mirrored cubes in Castelli's own white cube, will continue to haunt any sculptural project.

The pyramid of garbage recycles Kolli while at the same time as it tips its hat to Piero Manzoni. It begs the question whether we can ever resolve the contradiction between a public space that requires rigorous order and cleansing with the inhabitations that quite naturally spoil all such attempts at expurgation. In juxtaposition with Kolli's impossible monument to the revolution, the pyramid might also suggest that, with the aesthetic forms that from time to time will be introduced into the public realm as something extra we might, when imagining a public art, be usefully drawn in the old direction of monumentality – not because monuments gracefully perform aesthetic acts of public beauty, but rather because, as the discussion above on *interest* suggested, it is in the monument that we can find a history of public art and also *the* history of all those who would have us remember their particular form of political organization, their form of the organization of the public sphere, even if it was only in theory. If Alois Reigel was clear that such a commemorative project, such a remembering, is impossible, then this does not at all contradict the fact that the public, whoever he or she is, still longs for such a job of monumentality. We could say, following Bataille, that the monument (with its base) is the job of all public art, the ineluctable pull of its heretofore unexorcizable able demons. Abstraction, then, as the sign of the removal of the monument and its plinth from the public sphere, is perhaps like the pyramid of garbage – a reminder that the base of everything has just slid a little deeper. However, in its rank decrepitude, it persists.

# THIS IS YOUR MESSIAH SPEAKING
# ALLO, VOTRE MESSIE VOUS PARLE

### VERA FRENKEL

AND, THAT AFTERNOON AT THE SHOPPING CENTRE,
HE SAID, (DEVIL THAT HE WAS),
HE SAID, THAT VERY AFTERNOON
AT THE SHOPPING CENTRE,
"THIS IS YOUR SAVIOUR SPEAKING.
THE BEST IN THE BUSINESS.
WELCOME!" HE SAID,
"SHOP AROUND. LOOK SHARP. BE SMART.
AND I'LL TELL YOU A STORY,
A TRUE STORY" (HE SAID)
"ABOUT A PEOPLE" (HE SAID)
"WHO DIDN'T SHOP AROUND.
LISTEN CAREFULLY."

CET APRÈS-MIDI-LÀ AU CENTRE D'ACHATS,
IL PARLA (AVEC UNE HABILITÉ DIABOLIQUE).
IL PARLA AU CENTRE D'ACHATS
CET APRÈS-MIDI-LÀ,
ET DIT «C'EST VOTRE MESSIE, QUI PARLE
CHAMPION TOUTES CATÉGORIES.
BONJOUR,» DIT-IL
«REGARDEZ BIEN, SOYEZ MALINS, COMPAREZ LES PRIX.
JE VAIS VOUS RACONTER UNE HISTOIRE,
UNE HISTOIRE VRAIE,» (DIT-IL)
«SUR DES GENS» (DIT-IL)
«QUI NE SAVAIENT PAS FAIRE LEUR CHOIX.
ÉCOUTEZ BIEN.»

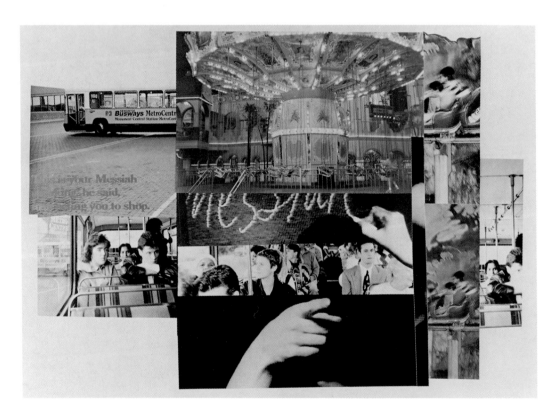

THIS IS YOUR MESSIAH SPEAKING, INSTRUCTING YOU TO SHOP.
ALLO, VOTRE MESSIE VOUS PARLE, ET QUI VOUS DIT: ENTREZ.

AND HE, THEIR LEADER, HE SAID, (HE SAID),    ET LEUR CHEF, AVEC UNE HABILITÉ DIABOLIQUE,
DEVIL THAT HE WAS,    LEUR DIT (DIT-IL),
"TAKE OFF YOUR CLOTHES."    «OTEZ TOUS VOS VÊTEMENTS,»
THEY LISTENED CAREFULLY.    ET L'AYANT ÉCOUTÉ,
AND THEY TOOK OFF ALL THEIR CLOTHES (HE SAID).    ILS OTÈRENT LEURS VÊTEMENTS (DIT-IL).
THEN, NAKED IN THE TIRELESS PALM OF FATE,    ET, NUS DANS LA PAUME INÉBRANLABLE DU DESTIN
(STILL LISTENING; STILL LISTENING CAREFULLY)    (ÉCOUTANT TOUJOURS, ÉCOUTANT ATTENTIVEMENT)
THEY BURNED ALL THEIR BELONGINGS AND    ILS BRULÈRENT TOUTES LEURS POSSESIONS
WAITED    ET ATTENDIRENT
BY THE SHORE    SUR LE RIVAGE
FOR REDEMPTION,    LA RÉDEMPTION,
FOR A THOUSAND YEARS OF PEACE;    MILLE ANS DE PAIX;
FOR THE MILLENNIUM.    LE MILLÉNIUM.

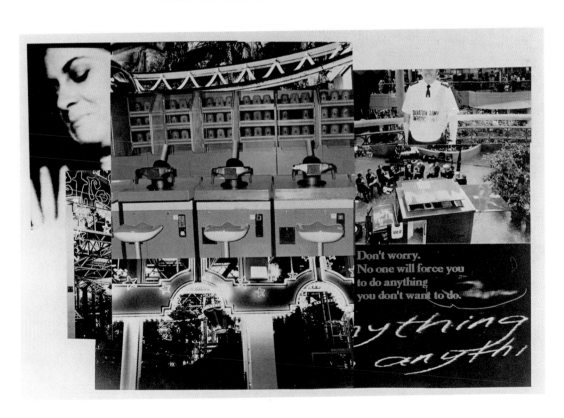

N'AYEZ CRAINTE. PERSONNE NE VOUS FORCERA À FAIRE QUELQUE CHOSE QUE VUS N'AURIEZ PAS ENVIE DE FAIRE.
DON'T WORRY, NO ONE WILL FORCE YOU TO DO ANYTHING YOU DON'T WANT TO DO.

THEY WAITED, AND AS THEY WAITED,    ILS ATTENDAIENT, ET COMME ILS ATTENDAIENT
IT GREW COLD. IT GREW DARK.    LE FROID VINT AVEC LA NUIT
IN THE COLD, DARK WILDERNESS    ET DANS LA NUIT FROIDE ET DÉSOLÉE
THEY WAITED FOR PEACE AND PLENTY.    ILS ATTENDAIENT LA PAIX ET L'ABONDANCE
AND, AS THEY WAITED, MADE SHRINES    ET EN ATTENDANT, FAISAIENT
OUT OF WEAPONS OF WAR.    E LEURS ARMES DE GUERRE DES AUTELS.

\*

"YOU CAN SEE FROM THIS, OF COURSE,"    «CELA VOUS MONTRE, BIEN SUR,»
(HE CONTINUED),    (CONTINUA-T-IL)
"HOW CRUCIAL IT IS    «À QUEL POINT IL EST IMPORTANT

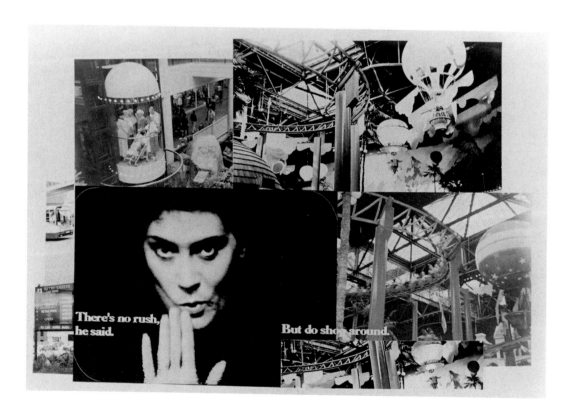

THERE'S NO RUSH, HE SAID, BUT DO SHOP AROUND.
ON EST PAS PRESSÉS, DIT-IL, MAIS ENTREZ, ENTREZ VOIR.

To choose the Messiah
with the right credentials."

We listened carefully.
"Remember," (he went on)
"I'm your Healer,
And your Joy.
I know you,
And what you need."

De se choisir un Messie
qui ait de sérieuses références.»

Nous avons écouté attentivement.
«Souvenez-vous,» (poursuivit-il)
«Que je vous apporte la Guérison
Et la joie.
Je vous connais,
Je sais ce qu'il vous faut.»

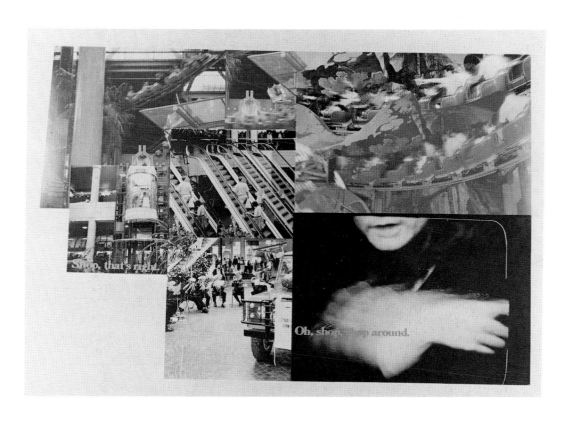

Entrez, Oui, Entrez. Faites Votre Choix.
Shop, That's Right. Oh Shop, Shop Around.

"I KNOW (FOR EXAMPLE) THAT PEOPLE MUST SHOP
FOR THE RIGHT MESSIAH AT THE RIGHT PRICE.
WHERE REDEEMERS ARE CONCERNED,
COMPARE GUARANTEES.
ASK YOURSELF; IS THIS REALLY THE MESSIAH SPEAKING?
THE REAL MESSIAH SPEAKING?
ASK YOURSELF" (HE SAID),
"IS THIS REALLY THE BEST VALUE FOR MY MONEY?"
"SHOP AROUND," HE SAID,
"SEE FOR YOURSELF," HE SAID.
"I'LL BE WAITING."

«JE SAIS (PAR EXEMPLE) QUE LES GENS
CHERCHENT LE MESSIE QU'IL LEUR FAUT AU MEILLEUR PRIX.
ET POUR CE QUI EST DES RÉDEMPTEURS,
COMPAREZ LES GARANTIES. DEMANDEZ-VOUS;
EST-CE VRAIMENT LE MESSIE QUI PARLE?
LE VRAI MESSIE QUI PARLE?
DEMANDEZ-VOUS» (DIT-IL),
«EN AURAI-JE VRAIMENT POUR MON ARGENT?»
«ENTREZ ET COMPAREZ,» DIT-IL,
«FAITES-VOUS UNE IDÉE,» DIT-IL.
«J'ATTENDS.»

\*

AND, SHORTLY AFTERWARD, IN THE HEART OF THE
SOUL OF THE CORE OF THE SHOPPING CENTRE, SLOW
AND CLEAR, THESE ARE THE WORDS THAT WERE HEARD:
– IN THE ELEVATORS, THE SNACK BARS, THE
WASHROOMS, THE BANK AND THE BOUTIQUES –
THESE ARE THE WORDS THAT WERE HEARD:

ET PEU DE TEMPS APRÈS, ON ENTENDIT
AU COEUR DU COEUR DU CENTRE D'ACHATS
PRONONCÉS CLAIREMENT ET DISTINCTEMENT CES MOTS
– ON LES ENTENDIT DANS LES ASCENSEURS, DANS LES SNACK-
BARS, DANS LES TOILETTES, À LA BANQUE
ET DANS LES BOUTIQUES – ON ENTENDIT CES MOTS:

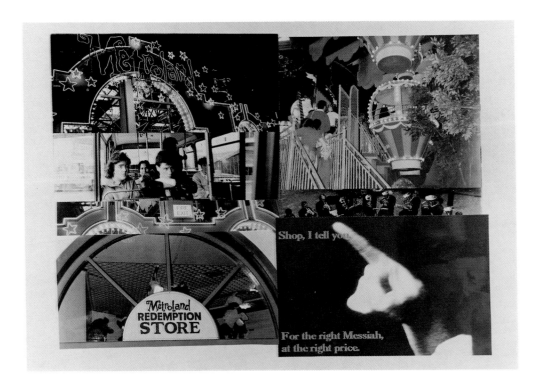

SHOP, I TELL YOU, FOR THE RIGHT MESSIAH AT THE RIGHT PRICE.
FAITES VOTRE CHOIX, CHERCHEZ LE MESSIE QU'IL LEUR FAUT AU MEILLEUR PRIX.

| | |
|---|---|
| THIS IS YOUR MESSIAH SPEAKING. | C'EST VOTRE MESSIE QUI VOUS PARLE. |
| THIS IS YOUR MESSIAH SPEAKING, INSTRUCTING YOU TO SHOP. | C'EST VOTRE MESSIE QUI VOUS PARLE, ET QUI VOUS DIT: ENTREZ. |
| DON'T WORRY. NO ONE WILL FORCE YOU TO DO ANYTHING YOU DON'T WANT TO DO. NO ONE WILL EVER FORCE YOU TO DO ANYTHING YOU DON'T WANT TO DO. | N'AYEZ CRAINTE. PERSONNE NE VOUS FORCERA À FAIRE QUELQUE CHOSE QUE VOUS N'AURIEZ PAS ENVIE DE FAIRE. PERSONNE NE VOUS FORCERA JAMAIS À FAIRE QUELQUE CHOSE QUE VOUS N'AURIEZ PAS ENVIE DE FAIRE. |
| THERE'S NO RUSH (HE SAID), BUT DO SHOP AROUND (HE SAID). SHOP, THAT'S RIGHT. OH, SHOP, SHOP AROUND. | ON N'EST PAS PRESSÉS (DIT-IL), MAIS ENTREZ, ENTREZ VOIR (DIT-IL). ENTREZ, OUI, ENTREZ. FAITES VOTRE CHOIX. |
| SHOP, I TELL YOU. SHOP, HE SAID, | JE VOUS DIT, FAITES VOTRE CHOIX FAITES VOTRE CHOIX, DIT-IL, |
| OR SOMEONE WILL SHOP FOR YOU! | OU QUELQ'UN LE FERA POUR VOUS! |

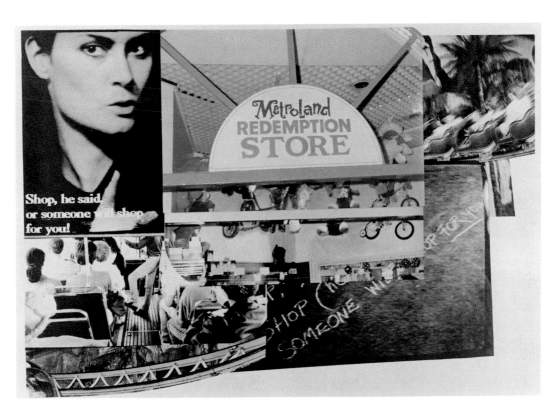

FAITES VOTRE CHOIX, DIT-IL, OU QUELQU'UN LE FERA POUR VOUS!
SHOP, HE SAID, OR SOMEONE WILL SHOP FOR YOU!

# THE OTHER PUBLIC

*The arrival of ghosts on the scene coincides with the coming of a disembodied society, a
society without substance.*
Claude Lefort

1

Some attention to the modern differentiation of civil and political societies invariably
proves exigent in discussions of the public sphere in its present or possible forms.
Depending on one's ideological proclivities, that distinction will either offer itself as
the bar to, or the guarantee of, a free public realm. (Indeed, as is more frequently the
case for thinkers looking to ironize their relationship to modernity, it may offer itself
as both.) In recent history, one of the most compelling discussions of the modern
relationship of civil to political society has come from the French political philosopher
Claude Lefort. His treatment of the issue both draws on and marks a significant
revision of Marx's analysis in "On the Jewish Question."

In Marx's view, the merely formal equality protected by the juridical and political
institutions of the state not only ignores but actively legitimates substantial inequalities
within civil society, even as it supervises the replacement of customary ties which had
characterized that society in its feudal organization with the laws of capitalist
exchange. It is this double role that gives the civil/political distinction, in Marx's
account of capital, a crucial function in the imaginary inversion of the real conditions
of our existence. While Lefort follows much of this reading, endorsing Marx's
critique of the inequalities that persist in the face of a merely "political"
enfranchisement, he nevertheless sees in the logic which informs this enfranchisement
a gesture worthy of less dismissive analysis. Lefort's stated project is then, one of
reclaiming the political from the necessitarian determination it receives at the hands of
Marx's critique of "political economy." This reclamation will likewise involve a
vindication of the modern "democratic revolution," a revolution he will want
nonetheless to loosen, if not entirely unhinge, from its liberal moorings.

From Lefort's standpoint, Marx's misunderstanding of formal democracy's relationship to the break with feudalism causes him to misconstrue democracy's originality, an originality that can only adequately be understood from the standpoint of its relationship to the monarchical state-form. In Lefort's genealogy of political modernity, this monarchy state had already put the state/society division (and its attendant division between power and right) into place. In order to consolidate these divisions according to that form we call modern, it remained only for "democracy" to transform the bodies of power and of right into purely abstract entities.[1] In this view, the emergence of the monarchical form both is and is not the birth of the modern state; by its implementation of the distinctions between power and right, church and state, it has already put in place the social recognition of a difference that cannot be politically instituted, a recognition Lefort sees as requisite for the achievement of democracy. The temptations of Eusibean "political theology" notwithstanding, Christianity's insistence on maintaining the difference between heavenly and earthly cities insured that the human *communitas* rigorously refrain from fully identifying itself with its divine counterpart (and therefore with those ends that organize it). Hence, if the king is the figure allowing the earthly city to open onto a certain eschatological horizon, he is also, within this eschatological scheme, the bar insuring the merely partial character of that opening. Because it takes its figural significance from a communality of Christian souls to come, the royal body is predicated on the imminence of its disappearance. Viewed from this eschatological standpoint, the king is, in his essence and from the start, a left-over, an obtrusion of the past into the future, thanks to which an outline of the present can come into view. The originality of democracy would consist in the attempt to remove any such obtrusion, and thereby to make the future's imminence fully present.

But if, as suggested, the monarchical form is vitiated by its democratic future (albeit a future it describes in eschatalogical rather than political terms), it is likewise the case that that future is haunted by the persistence of its past. Precisely because it draws the disincorporation of power out of its eschatological dimension in order to institute it in a political present, democracy involves less a disappearance of power's phantom body than the multiplication of its forms. Because its sovereign unity (the origin and end of political practice) can no longer be determined in a proleptic figure of "self-externalization," the democratic state demands this externalization immediately; in other words, it demands a ramification of its unity through the particular existents on whose basis that unity enjoys its present possibility. At its furthest limit then, democracy (as the realization of the concrete universal) would

involve nothing other than the extension to every citizen of both the privilege and pathos of the sovereign position. That this extension can only occur antinomically, by cancelling itself in the very moment of its institution – this is the problem or aporia to which the modern theorization of the political seems incessantly to return.

This aporia has been described by Lefort in terms of an impossible coincidence of utterance and enunciation produced in that self-claiming performative peculiar to modern man.[2] Its consequences for the symbolic institution of the social can be mapped as follows. Under the monarchical paradigm, the king had incorporated his people as a political unity, transforming them, by his symbolic founding act, into a collectivity of rights-bearing subjects. Producing in this act the intersection of myth and reason, custom and statute, by means of which the state is linked to the pre-political origins of its sociality, the royal personage thereby sutured over the antinomical character of the rights claim by identifying it with a form of immemorial donation. When modernity produced the exorbitant demand that the claimant appropriate that donation in the form of a self-legislating present (thereby revealing "the essence of the political"), then it is upon nothing other than their capacity to do justice to the aporetic character of that present that political institutions had to base their legitimacy. This meant positioning the founding act within the social body itself. But how is this to be done while still managing to retain the corporate integrity of that body? In other words, how is modernity to immunize its body politic against the effects of social disintegration arising from the becoming immanent of the agent of externalization?

For Lefort, the solution to the problem is to be found in its very source: the element of temporality. For him, democracy, to the extent that it describes a particular form of political institution, represents less the substantial achievement of a project of universal suffrage than the putting in place of formal conditions under which that achievement can become the goal of an ongoing process of political deliberation. (It is this formal "futurization" of the substance of the universal that arguably distinguishes him most decisively from Marx.) To the extent to which the classical problem of sovereignty has migrated into the legal technologies that sustain the right of state, that process may be described in the following way: the articulation of legal values bears an essential reference to the element of universality. It is in such a reference that the law finds its claim to right. However, if rights are understood to exist universally in persons (and thereby to pre-exist their particular protection by particular states), it remains the case that they can only be given recognition in the actualization of those particular laws whose justification they are understood to be.

Hence the justification can only occur retroactively: the universality of the law has no constitution, no existence, prior to the precipitous appearance of positive statutes (and the nation states that legitimate them.) This means that the law's universality is only ever virtual, never given in tradition but always having to be discovered. Hence we could say that the form of reflection that emerges for modern law is one wherein the law must rediscover its own constitutive universality in a chain of signifying values.

All of this is to say that, for Lefort, modern political practice brings into play something like a problem of the sublime, that is, a constitutive inadequacy of our present judgments (and the positive statutes to which they give rise) to the ideas (universal freedom and justice) to which they lay claim. In fact, although Lefort does not make this connection, the process of serial enfranchisement he describes as democracy's reinvention of politics as a process of "institutionalized contestation" (a process which eschews the possibility of any definitive declaration of universal rights but continues, nevertheless, to advance toward universality as its formal horizon), would correspond to what Kant describes in his Third Critique in terms of a mathematical aspecticization of the sublime. This account of the sublime would also be more or less in keeping with the Kantian version of human history as a process of political enlightenment, the law's illegibility there being read as the merely yet to be read each time out. But as recent commentators have been quick to note, there is also a sense in which for Kant that illegibility can be understood not merely as the *yet to be read* but as the unreadable. This account of the non-adequation of positive law to categorical imperative relates it not to a distance between legality and morality progressively sublated through an infinity of relative apprehensions, but to a distance at once absolute and immediately comprehended (albeit as the incomprehensible itself). As Kant suggests:

> . . . *to be able to even think the infinite as a whole indicates a mental faculty that surpasses any standard of sense. For thinking the infinite as a whole with a standard of sense would require a comprehension yielding as a unity a standard that would have a determinate relation to the infinite, one that could be stated in numbers; and this is impossible. If the human mind is nonetheless to be able to even think the given infinite without contradiction, it must have within itself a faculty that is supersensible.*[3]

In the case of this latter sense of distance, the sentiment of infinitude or incompletion does not arise as a result of the potentially endless series of positive claims that can legitimately demand recognition under a principle of universality.

Rather it arises from a lack of finite determination essential to the quality of universality as such. Simply put, the set that includes "everyone" can only do so antinomically; there is a task of extra-mathematical synthesis which arises as a result of the irreducibility of the idea of the "one" to the enumerative limit named in the "every." Rather than a problem of *compositio* (that is, of some quantitative superadequation of the set of empirical objects to the understanding that would designate them), it is here an issue of the reflexive folding of the concept back on itself. If this reflexion is the source of the concept's capacity to stand as designator of a given class of objects, it is also what immediately divides that conceptual designation from itself, that is, from itself as an idea of reason.

From a political standpoint, this is the problem of the position from which the "everyone" would be not enumerated but named, or alternatively, it is the problem of the ex-position of this position of the name. Indeed, our sense of politics as being, in the last instance, either a programmatic practice of judgment according to concepts of understanding, or a reflexive practice of judgment according to principles of reason, would seem to depend crucially on whether we side with the exigency of position or its ex-position. Here an illuminating point of comparison would be Carl Schmitt.

In Schmitt's legalistic interpretation of the symbolic founding act and the form of right to which it gives rise, politics would demand the legal institution of an extra-normative instance in the political body, the position from which a single agent would name (and therefore render a first judgment on) the limits of inclusion in that body. For Schmitt then, the first problem of politics is the problem of securing such a position, limit or front (by means of a localization of the exception).[4] Lefort, on the other hand, wants precisely to preserve the imminence of the exception – through the institution of political technologies which subject the punctuality of the decision it demands to a process of serial displacement. The motive behind this preservation would be Lefort's conviction that the securing or putting in place of a position immediately exposes it to its outside (the border that allows for a positive delimitation of a given collectivity already contains that collectivity's other within itself).[5] This implies a form of political constitution in which the question of who will count as enemy and who will count as friend remains potentially open.[6] In fact, this remaining open is precisely the "institutionalized contestation" Lefort describes as democratic process. However, as the above phrase indicates, for Lefort, democratic polity as *politics* already implies the symbolic institution of this openness, that is, the irrational precipitousness with which modern nation states brought themselves into existence as

political-theological principalities provides the historical and institutional basis for that determinate opening of the process of cosmopolitan ex-position (the holding up of public figures to rational scrutiny) we call the public sphere. This emphasis on the nation state as providing the historical-institutional foundation for democratic practice can hardly be said to be a theme in Lefort's work. (His emphasis on the social as locus of democratic values strongly mitigates any such thematization.) Nevertheless, it remains an implicit assumption of his theorization of the democratic impulse. Hence, in the final analysis, Lefort too will acknowledge the originariness of the position. But for him this irreducibility tends to be viewed from an historical (that is, temporal) rather than a legal (that is, systematic) standpoint. From out of the irrational substrate of such history arrive those Shakespearean ghosts Lefort hears haunting the democratic revolution. That the voice of the people is haunted by this irrational past, and that their self-legislating act is already, therefore, an act of ventrilocution, would be, in Lefort's account, the problem democracy raises both to and as itself.

It will not be my intention in what follows to question the legitimacy of this thesis as an historical account. It undoubtedly offers a profound contribution to the understanding of the democratic impulse as a central feature of our modernity. Rather, in what follows, I wish to question – following a line of inquiry opened, on occasion, by Lefort himself – whether this problem of the historical foundations of democracy can be said to exhaust the aporias that find shelter in its name. In other words, is the uncanny character of the democratic moment reducible to this persistence of an irrational past? Or is it not rather a matter of the early arrival of its future?

Let us recall that Hegel had a name for the future's early arrival. He called it the terror. The terror, in Hegel's account, was nothing other than the immediate coming out of imminence of being's excess over appearance. Or rather, it was a form of politics conducted in the name of making that excess appear. Hence it marks the point at which a socius turns on those particular appearances from which it had originally drawn sustenance (but whose resistances are now perceived as mere "leftovers" of an irrational past) so as to eliminate them in the name of the sublimity of the idea of the people as one. As Lefort's student, Marc Richir, suggests:

> *At this founding moment of origin there is encountered a curious conjunction between, or rather a frightening coalescence of, the somewhat Rousseauesque idea of an original liberty, fraternity, and amity, and the terrorist reality of a universal treachery of each towards everyone, making each individual a potential traitor in the eyes of the community . . .*

*appearances betray as soon as they bear the mark of individuality or individuation (as soon as man distinguishes himself from the community by means of them), but they also betray by betraying the forces on which one relies in order to achieve a goal or establish a State.*[7]

Returning to the political problematic we have been describing as Lefort's, returning, that is, to the sublime character of modern democracy, we can pose the same problem in the following way: there is no democratic protection of the indeterminacy of the social which would not either succumb to the fanaticism of the revolutionary terrorist, or avoid that danger by means of a merely mathematical administration (legal, political, economic) of the indeterminate. For it is only by virtue of the implementation of these technologies for administering sociality that the modern state has shown itself adequate to the task of circumventing the absolute clash of values (the imminent death of each and everyone, at the hands of each and everyone) induced by the becoming empty of the place of power. Now clearly Lefort would want to separate the name of democracy from this merely technical innovation. The aporia upon which his work turns can then be restated in the following way: either terror (as the interminable imminence of the interminable) would be the unspoken essence of democracy or, conversely, the trivialization of democracy in the creation of technically administered forms of publicity would be the democratic cost of terror's avoidance.

Bearing this in mind, it will be my concern in what follows to mitigate somewhat Lefort's claims regarding the historical originality of the democratic intervention. As we have just seen, that originality cannot be described as a shift from power's mythic determination in the person of the king to its indetermination in the temporal elaboration of the will of the people. In fact the place of democratic power is never actually empty; the abyss opened by the withdrawal of dogmatically asserted substance is continually being filled with positive contents, however arbitrary, delegative or provisional. On the other side of the equation, the two strains that together form a theory of the monarch distinct from its oriental variants – on the one hand, of the emperor as representative of a *consensus juris* and, on the other, of the king as God's representative – did not fail to acknowledge the merely provisional, contingent character of power's localization (thereby barring the way to any thoroughgoing immanence). In the first case, Lefort notwithstanding, the ruler's sumptuary figure involves less a sacramental body than a legal, formal fiction according to which the ruler enjoys power as a designated representative of his people. Nor would the influence of Christian doctrine on the early modern theorization of the monarch

efface the merely formal character of this sovereign power. On the contrary, it would clarify the legal doctrine by making explicit its recourse to an exceptional agent or will. Our mitigation of the Lefortian thesis could therefore be stated as follows: in ruthlessly ridding the socius of any figure of self-externalization, democracy, far from inventing the distinction between symbolic and real, positively evacuates it, depriving itself of the very figure with which that distinction could find a representation. As Richir suggests: "But what characterizes the Terror is that the Kantian 'moment of the sublime' is never completed . . . the initial gap between symbolic founding act and phenomenality is hollowed out from the depths of the abyss from which the latter returns as imminent death."[8] In order to elude the terror resulting from this revolutionary collapsing of the distinction between symbolic and real, it was necessary that a certain statistical body take over the labour of the sumptuary fiction or *figura*. If this "body" serves as guarantee that democracy's utopian future remains distinct from its administrative present, if it allows, in other words, for a certain computational lag to temper the immediate imminence that characterized the terror, it does so only, as I shall attempt to indicate at the conclusion of this paper, by eliding the problem of sublime comprehension (a comprehension I associate with a problem of the name) which must subtend this serial apprehension of social *quanta*.

2

In a work entitled "Permanence of the Theological-Political?" Lefort establishes with admirable clarity both the sense of continuity and the sense of novelty established by post-Enlightenment political philosophy in its break with political theology:

> *Once we recognize that humanity opens on to itself by being held in an opening it does not create, we have to accept that the change in religion is not to be read simply as a sign that the divine is a human invention, but as a sign of the deciphering of the divine or, beneath the appearance of the divine, of the excess of being over appearance. In that sense, modern religion or Christianity proves to be teaching the philosopher what he has to think. He rejects religion insofar as it is the enunciator of Revelation but, insofar as it is the mode of the enunciation of the divine, he at the same time accords it a power of revelation which philosophy cannot do without if, that is, it ceases to divorce the question of human nature from the question of human history.[9]*

It is not difficult to discern in these words the account of political sublimity

adumbrated above: whether it is a question of political theology or of political philosophy, what will be at stake is the coming to pass of an event which is itself indeterminate, irreducible to the order of appearances, but which nevertheless represents an essential feature of any account of the political (for the very good reason that it is constitutive of the possibility of the appearing of appearances in general and as such). Hence, as Nancy has hinted, the difference between pre-modern and democratic politics cannot simply be that of a practice adequate to the demands of alterity and one inadequate, but of two different modes of alterity's management. In the first, pre-modern instance, alterity is interiorized according to a logic which is spatial: the aporia of transcendence and immanence is resolved by way of the articulation of a figure which localizes that aporia (the body of the *Christomimetes* stretched out on the cross joining heaven and earth). Alterity is thereby recognized, but in that very recognition put out of play. Conversely, in the democratic instance, the aporia is serialized: the political community *imagines* itself (or more precisely conceptualizes itself) as nothing other than a concatenation of names that approximate (metonymically) a referent which never properly precedes it, but only appears retroactively as a virtual effect of the concatenation. History, in sum, becomes the substance of political community. But just as the mystic body of the king had proceeded in two directions, breaking apart in its double nature the very communion to which it pointed, so too the name of history indicates two incommensurable but inseparable articulations: on the one hand, it marks the space of possibility for a science of causal relations and the promise of progressive enlightenment which would be that science's political correlative; on the other, it marks the intervention of an event or advent which pulverizes the continuity of that space upon which causality (and its political analogues) depend. If these two articulations are inseparable, it is because the very condition of possibility of the causal chain, of the movement from instant to instant (whose logic is, on the historian's account, purely immanent), is that each instant is already worked by a force that exceeds it. There is, in other words, immanent in immanence itself, a something that transcends it. This something involves us with a difference which is not the difference mediating particular identities or instances, but one that is at once internal to and constitutive of these instances. This is, as we have seen, the problem posed not by the number or sum, but by the name, by the name as that which traces the withdrawal of the eidos from every eidetic determination.[10]

Having said this, let us return to Lefort's "Permanence of the Theological-Political." Lefort's argument regarding the democratic invention can be summarized

as follows: power is nothing other than the means by which society organizes and legitimates those differences internal to it by reference to a place from which those differences can be, in Lefort's phrase, "seen, read and named." The privilege accorded to this place (the articulation and virtual occupation of which *is* power) lies in its capacity to manifest society's self-externality, that self-transcendence which serves as condition of any immanence and from which its "quasi-representation of itself" derives. The above holds for society in general and as such. But again, what for Lefort is peculiar to democracy (or more precisely, to its modern variant) is the care with which it avoids projecting this position onto the real, its insistence on the virtual or symbolic dimension of power. According to Lefort, "of all the regimes that we know, it [modern democracy] is the only one to have represented power in such a way as to show that power is an *empty place* and to have thereby maintained a gap between the symbolic and the real."[11] Let us leave aside the question of whether this characterization is adequate to the predemocratic formation. Lefort then goes on to add that the democratic exercise of power requires "a repeated and periodic contest." It is in fact Lefort's acknowledgment of this second exigency, his recognition that democratic power requires these provisional occupations precisely in order to avoid the illusion that its emptiness can be made to *appear*, that distinguishes him from the Jacobin terrorist. That said, what is lacking here, in my estimation, is an adequate analysis of the relationship of the second condition to the first. What Lefort pays insufficient attention to is the fact that the much vaunted gap between symbolic and real is subjected to a process of temporal economization (the periodic repetition of "election time" as a kind of managed repetition of "the state of emergency") which, in *symbolizing* it (for the electoral representative is nothing other than a figure of the fact that the place of power is never "really" occupied) elides its *real* appearance. This is not a suggestion to which Lefort would be liable to accede. He argues that "it must . . . be made clear that the gap (between symbolic and real) is merely indicated (in the democratic formation), that it is operative, but that it is not visible, that it does not have the status of an object of knowledge." Here everything would rest on the question of whether a rigorous distinction between "indication" and "visibilization" could be maintained (to allow the former to expunge from its symbolic efficacy any imaginary residue.)[12]

In defense of that distinction, Lefort suggests that electoral politics replaces the monarchical image of the people's unity with a thoroughgoing atomization of the social body:

*This phenomenon is, as we have noted, combined with the singular procedure of universal suffrage, which is based upon the principle of popular sovereignty but which, at the very moment when the people are supposed to express their will, transforms them into a pure diversity of individuals, each of whom is abstracted from the network of social ties within which his existence is determined, into a plurality of atoms, or, to be more precise, into statistics. In short, the ultimate reference to the identity of the People, to the instituting subject, proves to mask the enigmatic arbitration of Number.[13]*

Now certainly Lefort would not deny that the process of social abstraction necessary to the assertion of universal suffrage implies a certain democratic *imaginaire*, one whose rhetorical arsenal would include "the people, the nation, humanity, and even the individual." Nor does he deny the role played by electoral process in securing such an *imaginaire*. Indeed, he tells us that the electoral process brings into focus the democratic delineation of a specifically political activity which has the effect of "erecting a *stage* on which conflict is acted out for all to see." His point, however, is that this staging of the social, rather than providing us with an image of unity, allows us to glimpse power itself as the product of a process of contestation. This is no doubt true but it is equally true that this situation arises as a result of the relationship between social contestation and social integration having been dialecticized in such a way as to reveal each to be the very image of the other (hence the miraculous efflorescence of the people's sovereign will from out of the statistical atomization of the social body). These observations follow, more or less, the tenor of those questions raised to Lefort by Jacques Derrida and Jean-Luc Nancy at the conference, *Le Retrait du politique* in 1981. (Nancy asks if the imaginary presentation or incorporation of the symbolic does not evince a tendency to resurrect the effects of totalitarianism in the anonymity of democratic "general power"; Derrida inquires as to how this totalitarian risk internal to democratic process might be arrested.[14]) Lefort's response to these questions is instructive. He does not deny their general pertinence; indeed, he readily admits that putatively democratic political institutions can easily ossify, producing thereby the sort of homogenization and bureaucratization of everyday life to which Nancy's and Derrida's questions allude. However, he then goes on to locate the safeguards protecting the democratic institution against such ossification in the consensus arising unofficially, non-institutionally, in a free public sphere. For Lefort, if democracy is to maintain itself as an ongoing process of self-invention, this process finds its guarantee less in the institution of any particular political technology for staging conflict in order to manage consensus (for example, democratic elections),

than in the preservation of a space of publicity from which the terms of that conflict might arise more or less organically. Hence, despite his dialecticization of two distinct, if not precisely competing, versions of democracy (as, on the one hand, a social process of exposing the arbitrary character of power's position, and, on the other, the political putting in place or position of technologies designed to guarantee the disinterested continuance of such a process of exposure), Lefort nevertheless decides on the social as the privileged arena of democratic practice. Therefore, the problem of the position, of the symbolic founding act, will characteristically be treated as a difficulty extrinsic to democracy's essence. Bearing this in mind, I want to pose the following question in the concluding portion of this paper: what happens to the problem of the symbolic founding act (that inaugural moment in which the *res publica* is gathered to itself) when the position from which such an act might derive has been ramified throughout the field of the social (as locus of spirit's cunning). What Lefort does not stress, and what will be of particular concern in this paper, is the fact that the delimitation of a social space (wherein significant public discussion can obtain) defines an imaginary process (that is, a process irreducible to the political as symbolic institution of the social) by means of which individualities are both constituted and co-articulated. To borrow a formulation of Hannah Arendt's that Lefort himself recalls, it assumes the mutual giving and receiving of appearances thanks to which citizens constitute their particularity in relation to one another. This implies, of course, an *aisthesis* peculiar to the democratic organization. Indeed, it is in such an *aisthesis* that those individualities which represent the atomic units of democratic organization are constituted. To this I would add a further observation. When the sacred origins of the social bond (what Lefort calls the excess of being over appearance) have been liberated from any theological substance, when the hyphen articulating political-theology has been transformed (through a process of secularization) into the bar separating two incommensurable disciplines, then it is to such individualities in their aesthetic capacity (a capacity which, as we shall see, both is and is not that process of giving and receiving appearances described by Arendt) that the social must look for the visible signs of its invisible origins. That said, the absence of any elaboration of an aesthetics of the democratic moment represents, especially in a thinker of such cultured erudition as Lefort, a surprising lacuna.

To attempt in the limited space of this paper to fill this gap in any definitive way would be to beg *hubris*. In this concluding portion, I will therefore adjure myself to a more modest task – that of indicating the general lineaments of the labour this interrogation of the democratic aesthetic would involve. I begin with the following

observation: the autonomous aesthetic sphere to which the Enlightenment gave birth represents the site on which the recognition of the figural inadequacy of the statistical body is at once interrogated and supplemented. (Such would be, respectively, its critical and its ideological functions). However, in the extent to which this supplement possesses an interrogatory dimension, it already implies its own supplement, a certain supersensible additive. This would be the explanation for Kant's addition of an analytic of the sublime to the analysis of the pure judgment of taste. But this addition cannot fail to move the question from beyond the parameters of the giving and receiving of appearances Arendt names as the public sphere (a naming which Lefort cites with approval). I would like, by way of conclusion, to approach this sublime undoing of the public space constituted on the basis of an aesthetics of specular reciprocity by way of the following anecdotal indirection.

In his General Theory of Employment, the British economist, John Maynard Keynes, expresses a predicament that startlingly resembles the problem posed for a socius that would establish itself on an aesthetics based on a rigorously formal calibration of value. The problem Keynes explores is that of "conventional judgment," by which he would understand "the psychology of a society of individuals, each of whom is endeavoring to copy the others." Within such a situation, there arises the paradox that each individual is attempting to bring his or her judgment into conformity with an average consensus which can itself only be obtained when all the individual preferences have been calibrated. Hence we get what systems theorist Jean-Pierre Dupuy describes as a "tangled hierarchy": the first term must itself be rendered as a product of the second. The result is, of course, a radical indetermination of value or, rather, a "phantasmatic" determination of that indetermination.

Something remarkably close to this problem emerges with the Kantian demand that both our aesthetic and our ethical judgments be universalized (a problem inherited, as we shall see, by both the Lefortian and the Arendtian elaborations of a democratic aesthetic). As in the Keynesian hypothesis, the judging agent is put in the position of sacrificing its immediate interests in the name of the other. In the Keynesian scenario, the problem of settling this difference between the affective interest of the individual and that of the universal is shown to elude mathematical adjudication (according to the principle of the statistical norm or average). The average implies that the measure of value arises by calibrating a plurality of affective responses which have first appeared in their pathological immediacy. The scenarios drawn by Keynes' "conventional judgment" on the one hand, and Kant's "aesthetic

judgment" on the other, is that this immediacy is immediately mediated by my desire
to please the other by desiring his or her pleasure as my own. The object of my
pleasure is therefore immediately a phantom object, the object of the other's pleasure.
The aesthetic object whose finality Kant describes as lacking in end (that is, in
exterior interest) is thus shown to be lacking in finality as well. Its determination is
always already *unheimlich*, derealized. It is to this infinitely distant object of the other's
pleasure, and not to anything that would appear on the basis of a *sensus communis*, that
we must turn if we are to face the challenge of making a space for democracy's future.

Despite his insistence that the establishment of a public sphere (understood in
more or less Kantian terms) provides the basis for the democratic efficacy of electoral
process, we find in Lefort occasional glimpses of this uncanny dimension of the social
(and the threat it poses to any traditional acceptation of the phrase "public life"). But
in Lefort, its demand characteristically returns as a return of the religious, that is, of
the superstitions of a predemocratic past. No doubt, the interminable character of this
return is painstakingly acknowledged by Lefort. Nevertheless, his democratic practice
represents nothing other than an attempt to mitigate the effects proliferated by such a
return. But what if we were to discover in this other space not the persistence of
modernity's religious past but the promise opened by its future? Is it certain that this
future can still bear the name of democracy or even, indeed, of politics in general?
That is, is it truly possible to identify the revelation of being's excess over appearance
(as the future's definitive donation of its imminence to the present) with a moment of
historical advent (say that of the democratic revolution)? The eschatalogical horizon
opened by these questions arguably qualifies them as theological, albeit as negatively
so. To them, we might therefore imagine Lefort responding with the words of the
eighteenth century Danish humanist, Ludvig Holberg: "If a man learns theology
before he learns to be a human being, he will never become a human being." In
other words, if we are to become human beings, then we must first dispose of the
present task at hand – a task which Lefort, of course, understands as political. For it is
only, or so the modern story goes, on the basis of attending to that task that we are
authorized to pursue our future, to advance, that is, to a consideration of last things.
To this it may be replied that the historical essence of our humanity lies precisely in
the interminable overtaking of the present by the future. The figure of our human
present depends constitutively – such would be the force exerted by the invisible – on
this failure of the future to wait its proper trope or turn.

NOTES

1    Claude Lefort, "Politics and Human Rights," in *The Political Forms of Modern Society: Bureaucracy, Democracy, Totalitarianism*, ed. John B. Thompson, trans. Alan Sheridan (Cambridge: MIT Press, 1986), 254–55.

2    See Lefort, "Politics and Human Rights," 256–57.

3    Immanuel Kant, *Critique of Judgment*, trans. Werner S. Pluhar (Indianapolis: Hackett, 1987), 113.

4    For the most definitive statement of Schmitt's position available in English, see his *Political Theology*, trans. George Schwab (Cambridge: MIT Press, 1985), 36. See also his *The Concept of the Political*, trans. George Schwab (New Brunswick: Rutgers University Press, 1976) and *The Crisis of Parliamentary Democracy*, trans. E. Kennedy (Cambridge: MIT Press, 1988).

5    My discussion of this immediate exposure of the position (an exposure without which there could be no positing) is indebted to the work of Jean-Luc Nancy, in particular to his essay "Of Being-in-Common," in *Community at Loose Ends*, ed. Miami Theory Collective (Minneapolis: University of Minnesota Press, 1991), 1–12. However, Nancy's discussion of this expositional inflection to which the propriety of the position is submitted in its very essence does not concern a political problematic in the sense in which Lefort would use that term. It does not, in other words, concern the symbolic institution of the social. That exposure of the "in common" Nancy describes involves rather an ontological problematic which is prior to the difficulties and aporias which can be seen to emerge with the empirical constitution of any given community. Nevertheless, the paradigm Nancy elaborates can be usefully applied to the political problematic which concerns Lefort, that is, the fact that the articulation of a position, in the extent to which it must demarcate a limit or border from which it is never rigorously separable, opens that which it putatively protects to the violence of the outside. That said, it is useful to clarify the incommensurability between Nancy's approach to the "in common" and Lefort's. This incommensurability would derive from differing evaluations as to the extent to which "democracy" would be adequate to the task of naming this process of exposition. Says Nancy: "Whatever is not democracy either exposes nothing (tyranny, dictatorship) or presents an essence of being and of common meaning (totalitarian immanence). But democracy, for its part, exposes only that such an essence is inexposable. There can be no doubt that it is the lesser evil. However, the *in*-common, the *with*, withdraws its pretensions: from inappropriable exposition . . . we pass to the spectacle of general appropriation, through the logic of the spectacle and against it at the same time . . . appropriation of capital, of the individual, of production and reproduction (of the "technic") inasmuch as it is "in-common," taking the place of the taking place of the in-common." It shall be clear in what follows the extent to which the questions and criticisms of Lefort's position these lines imply have guided my own reading of his work.

6    We could say that Lefort and Schmitt share an antipathy to political rationalism, each insisting in their different ways that political antagonism is not susceptible to conceptual jurisdiction. However, the way they process this insistence is strikingly different. Schmitt would institute a locus of legal decision (whose legality in no way bears upon a claim to cognitive legitimacy) thanks to which antagonism could be expelled from the body politic (according to the friend-enemy paradigm); Lefort, on the other hand, is

concerned to try and find a way of institutionalizing that antagonism, of placing it inside the body politic, a placement which can only entail the redefinition of that body as the very process of its own auto(dis)figuration.

7   Marc Richir, "The Betrayal of Appearances: The Terror and the Sublime," *Art and Text* 33 (Winter 1989), 44.

8   Ibid., 50.

9   "Permanence of the Theologico-Political?" 223.

10  I adapt this characterization of the name from Giorgio Agamben's discussion of the name in *The Coming Community*, trans. Michael Hardt (Minneapolis: University of Minnesota Press, 1993). Agamben reminds us that the distinction between *methexis* and *mathesis*, substantial participation and formal resemblance, is itself mediated by the sense of homonymy which arises as a result of the relationship of exemplarity which obtains between an idea and the sensible objects that are brought under its jurisdiction. There is something of the idea which is beyond formal jurisdiction, something which is not form, not *eidos* as such – for there is, such would be Aristotle's point, no form as such – but form insofar as it is already negatively manifested by the name. (To that extent the name will mark the point of failure or inadequation of every aesthetic of the beautiful.) The name traces an outline around the immediate disappearance of the eidos from every eidetic determination. It would no doubt be possible to relate Agamben's thinking of the name to the thematics of "being-in-common," of "exposition" and of "the limit" as they are explored in Jean-Luc Nancy's recent work on community. Also pertinent would be Jean-François Lyotard's discussion of the name's quasi-diectic function in "The Different, the Referent, and the Proper Name," trans. Georges Van den Abbeele, *diacritics* 14:, 4–14.

11  Ibid., 225.

12  Let us also point out that within the monarchical paradigm the royal body did not have the status of "an object of knowledge," but rather a form of imagination. Such a body does not give knowledge of that indetermination of the social, rather, it gives us a figural approximation of its infinite mystery.

13  Claude Lefort, "Permanence of the Theologico-Political," in *Democracy and Political Theory* (Minneapolis: University of Minnesota Press, 1988), 227.

14  "La question de la democracie," in Jacob Rogozinski, et.al., *Le Retrait du politique: Travaux du Centre de recherches philosophiques sur le politique* (Paris: Éditions Galilée, 1983), 86–7.

In Corumbà, in the Pantanal, where they did the project on the abandoned ranch, water rises every November in those spring months to utterly cover the fences that otherwise bow to ownership's obligations. The river Paraguay abandons itself and gives up the wild birds and the crocodiles from the otherwise confined territories of brief forest within a few metres of its banks. Briefly, they inhabit the submerged fields, and fish in the places once staked out for cattle. The flow of water will admit no measurement under or through it.

And in wandering through the forest here in the Eastern Townships of Québec, through areas haunted by the Underground Railway so very close they are to the frontier, following a stream up-river could mean even more than stumbling on an old snake fence capped with razor wire. It could mean happening onto the other side of the border in the dead centre of the woods and becoming stateless.

Privacy and property have come to mean the same thing, and there is no intimacy without ownership. A few centuries later, the market site on the water will be considered a "marginal site" by city planners, as the complexities of the word "market" transmute to absorb developing international commerce, and the evidence of exchange within the fabric of the city is subsumed and hidden in what becomes the "financial district." In some cities, like London or New York, the financial district cannot bring itself to move too far from the site of its maritime origins, looming over the phantom docks like an adult child visiting an elderly parent in a home. These newly marginal sites are reinvented as tourist sites, the mainstreetism of a Disney mentality calling people again to the square, paying now a homage of manufactured pleasure to the site which has produced not only their labour but also their leisure, and which knows that this too must be strictly regimented. When we are not constructed for unbearable work, we women are constructed as leisure. I lay my body out in the water and want so much to be carried downstream in the dappled, odourous climate of my most private thoughts. Above all, I would share this with my friends. Fearless.

The cane is coming. It's been cut. Down. Coming down the river, into the canal, where the water turns a mill wheel. Bitter cane. Refining as if through a filter of latitudes towards a whiter north, the deep ships bring it up from the Caribbean misery to which it is shackled. Its bark cracks. Dogs bark and bay, the barque heaves out of the bay. Whip crack. Enslaved people still cut down cane in this world, and until recently some of it came to us, came into the Lachine Canal. So many muddied waters eddy round and between us all.

This cane, the dog, the shackle, the ship. The mill. The broken open ovens of the silken sweet sweet liquid. All are called Redpath. And a museum of weevily talismans collected against death. Fossil teeth in amber, another sweet sweet liquid now rigid with age. What flows now? Not water in the canal, not really. Not blood in the veins of cane-cutting Haitians in the Dominican Republic, not really. Redpath Crescent in the Golden Square Mile. Teak and wrought iron elevators creak up the three short flights in the bank manager's residence on this street.

On the other side of the tracks, the photographer flows through the abandoned shell of the sugar refinery, whose heat will no longer melt. Ice. She slips. Sweet sweet liquid of the memory of her life in the staircase dangles nonchalantly above a steep drop.

# REQUIEM FOR A TOPPLED STATUE: HISTORY AS KITSCH AND REMAKE

RéGiNE ROBIN

History, as everyone knows, is written by the victors or their scribes over the tenuous traces of what remains, traces sometimes shaped by chance, that are managed, interpreted and find their way into chronicles that subsequently become outmoded and disintegrate, leaving shreds of memory that can, at any time, be recycled and revamped. History is written against a backdrop of silence, of memory lapses, taboos, repression and screen memories, over traces that have been effaced, wiped out. Nothing is more fragile than the trace, and nothing could be easier than to alter it by rewriting and falsifying it using means such as revisionist ploys, simulacra and the inversion of signs. When traces cannot be found, one invents or, rather, reinvents them – reinvents the past, origins, time immemorial; one confuses place and time, creates pastiche and imitation, makes the past like new again, makes it over into a fake.

One is reminded of the great archaeological metaphor that runs through the work of Sigmund Freud.

> Now let us, by a flight of imagination, suppose that Rome is not a human habitation but a psychical entity with a similarly long and copious past – an entity, that is to say, in which nothing that has once come into existence will have passed away and all the earlier phases of development continue to exist alongside the latest one. This would mean that in Rome the palaces of the Caesars and the Septizonium of Septimus Severus would still be rising to their old height on the Palatine and that the castle of S. Angelo would still be carrying on its battlements the beautiful statues which graced it until the siege by the Goths, and so on. But more than this. In the place occupied by the Palazzo Caffarelli would once more stand – without the Palazzo having to be removed – the Temple of Jupiter Capitolinus; and this not only in its latest shape, as the Romans of the Empire saw it, but also in its earliest one, when it still showed Etruscan forms and was ornamented with terracotta antefixes. Where the Coliseum now stands we could at the same time admire Nero's vanished Golden

*House. On the Piazza of the Pantheon we should find not only the Pantheon of today, as it was bequeathed to us by Hadrian, but, on the same site, the original edifice erected by Agrippa; indeed, the same piece of ground would be supporting the church of Santa Maria sopra Minerva and the ancient temple over which it was built. And the observer would perhaps only have to change the direction of his glance or his position in order to call up the view of one or the other.*

*There is clearly no point in spinning our phantasy any further, for it leads to things that are unimaginable and even absurd.*[1]

For Freud, these are "phantasies," phantasms or metaphors used to illustrate the functioning of the unconscious, of what is most archaic in human beings. Ruins, now, suffer a curious fate, for as soon as they are excavated they are threatened. Once uncovered, they risk being transformed into "remains," "rubble," "debris." Still, a covered ruins makes no sense whatsoever; it must be exposed, remain out in the open, in order to acquire its status as ruins. Today's new archaism makes use of ruins, but ruins that exemplify the peculiar characteristic of having been fabricated, woven into a narrative the gist of which is that they were always slated to become ruins. Ample proof of this exists in the statues, pedestals, signs and symbols, the gigantic red stars, the buildings and mausoleums that crowd the public squares and stadia of eastern Europe. They have been reduced overnight from "glorious monuments" to ignominious residues. What is one to do with them – put them in museums or destroy them? Is there any way of escaping the return of phantoms or, better still (given the mania for embalming), the remake, the return of "The Mummy." As luck would have it, the Museum of the Hungarian Workers' Movement in Budapest – where, not so long ago, one could go to gawk at dinosaurs[2] – was recently leased to an organization that sets up temporary exhibitions. A recent article in *Le Monde* had the following:

*It was not without a certain sense of humour that Hungary conferred symbolic immortality on forty years of its history. On Sunday, 27 June [1993], during festivities to mark the second anniversary of the withdrawal of Soviet troops, the city of Budapest, led by longtime dissident Gabor Demszky, inaugurated the first open-air museum of socialist statues to be set up in a former state of the Soviet bloc.*

*In the shadow of the Martyrs' Monument, under the benevolent gaze of two colosses of the Red Army, an honour guard parodying the kind of official ceremony often held during the 1950s (i.e., processions of pioneers and proletarian heroes, speeches peppered with communist jargon) joyously celebrated the birth of this peculiar kind of amusement park,*

*which is to be opened to the public on August 1.*

*Covering four hectares on the outskirts of the city, the museum includes some forty statues and a dozen or so commemorative plaques dating from the previous régime. This is one of the few places in Hungary where one can still display the red flag without having to be concerned about breaking a recent ban that prohibits the use of communist insignia except for "cultural" or "educational" purposes.*

*As a concession to history, the statues of founding fathers Marx, Engels, and Lenin nestle in two ends of the neoclassical pantheon erected at the entrance to the museum. The other relics have been arranged in three categories: historical events, political figures, and monuments to the liberators of 1945, who resurfaced in 1956 to put down the Hungarian insurrection. Amid flowers arranged in a red star (which formerly decorated the entrance to the Bridge of Chains), a wall rounds off the story.*

*The opening of the park was preceded by a spirited debate between those who favoured destroying the statues and those who wanted them preserved — not to mention, of course, those who advocated selling them (but to whom?) and donating the proceeds to the "victims of Communism." On this issue the deputy mayor of Budapest, Miklos Marschall, was emphatic: "We wanted to steer between the two extremes of creating a socialist Disneyland that would make a mockery of history, or belabouring the point with an overly serious place." The result is typically Hungarian — a compromise tinged with ironic savvy.*[3]

People are making a concerted effort to undo, erase and transform into ruins everything that, until quite recently, made up the social fabric of this world. They are refashioning a past for themselves and, by design or happy coincidence, are rediscovering old symbols, emblems and hymns. But this past is a petrified past, preserved, as it were, like the great mammoths. Shortly before his death in 1991, the Georgian philosopher Merab Mamardachvili remarked: "When the youth of today awaken, when they come into consciousness and thought, they find themselves in a forest bristling with cadavers."[4] Every step backward is considered an improvement. Georges Nivat speaks of a "generalized bluff." "And on top of this," he says, "one has the incredible revival of the costumes and ceremonies of the old social classes that existed prior to the Revolution. Assemblies of the nobility are again springing up just about everywhere, as if today were yesterday; compendia of armorial bearings are much in vogue. Similarly, cossack regiments have resurfaced complete with their hetman (elected by God knows whom) and *nagaika* (the whip that leaves bad memories), their uniforms and cartridge belts. Thus attired, they parade from one end of the country to the other."[5]

It is anyone's guess whether this is a revived, a fantasized version of the past, or whether it is indeed the present. An American version of the same scenario (which had its own brief stint in the limelight) runs as follows: in Malibu, California, the villa des Papirii of Pompei was reconstructed down to the finest details. And with the help of several mild earth tremors, cracks appeared, recreating a certain patina in this new, old villa. One begins to imagine that the Malibu villa may, in most respects, suffer the same fate as the original. Now what film genre is this, horror or the fantastic?

Meanwhile, mourning has become an impossible task in the east, where an immense return of the repressed holds sway while waiting for the tidal wave of resentment!

In this labour of turning things into ruins or debris, first on the agenda is the exchange of corpses or mummies, the flurry of send-offs and returns. Here are a few examples.

On 16 June 1989, Imre Nagy, the Hungarian prime minister celebrated for his role during the 1956 uprising, was reburied after an imposing public funeral. At the same time, people were called upon to submit ideas for a memorial to the victims of the repression of 1956. Finally, as a way of "museifying" a recent past that could not pass away, an illusory attempt to strip it of its aura, a major exhibition on Stalinism opened its doors in Budapest. The exhibition was titled, *Sta-lin Rá-ko-si*, in an allusion to the slogans that had brought crowds into the streets.

> *The visit begins at the heart of the exhibition with a huge pile of gifts sent to Rákosi for his sixtieth birthday in 1952. From there, visitors make their way into rooms that show the effects of Stalinism on daily life: a meeting hall teeming with workers eager to join the Party; posters exemplifying the kind of boundless conformity common in both East and West during the 1950s, singing the praises of the great Socialist Revolution on its thirty-second anniversary, glorifying the beloved comrade-cadre Rákosi and pointing to the months of the collecting of scrap iron. On the other side a series of rooms show the more sombre aspects of Stalinism: an office with police files; instruments of torture employed at the former headquarters on Andrassy Street; a mock trial; work clothes worn by an inmate of the Recht labour camp. Finally, a fist of Stalin about the size of a three-year-old child, along with photographs showing the destruction of the statue (dating from 1956) signal the end of this period.*[6]

September 1993 saw the return to Hungary of the ashes of Admiral Miklos Horthy who, following the suppression of the Hungarian Revolution of Béla Kun,

ruled from 1920 to 1944 as the quasi-fascist dictator of the country. The mint printed a coin bearing a likeness of the Regent, and the radical right called upon the people to make this ceremony into a "great display of national continuity." From this angle, the communist régime would have been no more than an interlude and by erasing it the country would be able to link up with its "glorious past." So much for arrivals; what about departures? The incredible episode of the Dimitrov Mausoleum in Sophia is deserving of attention. During the events of 1990, the mausoleum was surrounded by protesters who demanded the immediate removal of Dimitrov's embalmed corpse (he had received the same treatment as Lenin and Stalin) and the conversion of the mausoleum to other purposes. A special committee was set up and entrusted with the task of ruling on Dimitrov's mortal remains. Although many people spoke out, saying that both the mausoleum and the body should be left untouched, it was to no avail, for the mausoleum was situated right in the middle of the city and its symbolic import could not be ignored. On 18 July 1990 the family of the deceased succeeded in having the body removed clandestinely; it was cremated, and the ashes were transferred to Sophia's main cemetery.

> [T]he day after the body's removal, the inhabitants of the City of Truth organized a "trash fest." The people of Sophia brought along books, portraits, uniforms, and medals – in short, all sorts of relics proclaiming the intimate bond that supposedly existed between each person's private history and the Great History of Socialism. Carting the souvenirs of a past that already seemed remote, they hurled them against the walls of the mausoleum. But the tomb was empty and the mausoleum, now disburdened of its sarcophagus, seemed impervious to their actions; their gestures could not conceal it. The mausoleum proved to be more cunning and cruel than the somewhat short memories of its supporters and adversaries. It had acquired an existence apart from the presence or absence of its miserable human remains. It submitted without flinching to defilement and burial under debris, presaging that, sooner or later, the day would come when it would be cleaned off and restored.[7]

Let us start by asking how this country, this empire, could crumble like a house of cards, and let us enquire as to the meaning of the surge of nationalism now sweeping through most of central and eastern Europe. Are we witnessing a nineteenth-century style of regression, a consolidation of the nation state in countries that were deprived of this stage and that now, after the collapse of communism, are implementing a sort of catch-up programme, even if the latter assumes forms that, to us, may seem archaic? Or are we – despite the tragic face of appearances – seeing

something else entirely, namely, a plunge into the frenetic desire for consumer goods and the adoption of the American model, an entry into postmodernity but through the wrong door?

For a long time the inhabitants of the countries of the east – that is, the future countries of the west, since, as everyone knows, Japan is a western country and Prague, until quite recently, still belonged in the east – have been sandwiched between the true and the false, been fictional characters in a holographic universe, in the kingdom of Père Ubu. They have long had to do without either reference points or meaning – not to mention the meaning of meaning.

Prominent historical figures vanished from official photographs, textbooks, pedestals and paintings in museums – after, that is, having vanished *tout court*. Touch-ups of the factual were so constant, so much a part of the daily round, that history became dreamlike and fantastical, a made-to-measure account that was neither true nor false but merely adjustable. Every ideological deviation became an occasion for minor or major adjustments.

The régime was born amid a general climate of iconoclasm. All of the symbols of czarism were replaced: the imperial eagles gave way to the red flag and star, plus the hammer and sickle; the International and the *Warszawianka*[8] replaced the old hymn to imperial Russia, and Petrograd (later Leningrad) took the place of Saint Petersburg. All sorts of new rituals and forms of greeting were instituted. When the régime fell, it did so under a reverse version of this same iconoclasm, one that brought back the old hymns and flags and renamed cities and towns. (While the new Saint Petersburg is the most famous example of renamed cities, many people have not abandoned the idea of giving back Volgograd, formerly Stalingrad, its old name of Tzaritsyn.) There was also the destruction of insignia and statues – those of Sverdlov, Dzerzhinsky and Kalinin were among the most recent – and finally of Lenin himself. The latest reports have him packing his bags and preparing to leave the Tomb, which has become uninhabitable.

Little by little a double memory came into being. On one side was the officially sanctioned memory; ceaselessly reworking and manipulating the past, it was an abridged version fuelled by mythological and utopian ideas that had long been emptied of their substance. On the other side, there was the counter-memory of those who had been, along with their families, in various ways victims of the system, those to whom Solzhenitsyn dedicated *The Gulag Archipelago*, those who in the Gorbachev years would found the *memorial* movement. For the most part, however, one had the a-memory of those who wished to remain in the dark, who desperately

sought to dissociate themselves from events, to slip through the net. This group opted for amnesia, for living from day to day, stockpiling provisions, concocting petty schemes, bartering, and hoarding hard currency (particularly dollars) for the day when – rather, the day which (as everyone knows) finally came. In the end, then, one had a triple memory that made no sense because, in the system taken as a whole, the sociohistorical reality had to accommodate itself to discourse, not the opposite. The famous "wooden tongue" that prevailed before Gorbachev's accession to power in 1985 was the chief symptom of this constant rehashing, this marking of time that verged on the absurd.

For a long time, from the turn of the century at least, the inhabitants of the countries we have been speaking about have lived in an environment transformed entirely into kitsch. Keep in mind that central Europe is the locale of the frothy châteaux of Ludwig II of Bavaria; in this respect, the communist régimes merely took over from him – with cheaper versions of course! Let us follow Claudio Magris in his peregrinations along the Danube. Budapest will be our first stop.

> The buildings of Budapest are eclectic, given to historical posturing, weighty in themselves and often adorned with heavy decorations; their non-style occasionally appears as some bizarre face of the future, the sort of backward-looking yet futuristic townscape of the cities posited in science-fiction films such as Blade Runner: a future that is post-historical and without style, peopled by chaotic, composite masses, in national and ethnic qualities indistinguishable, Malay-Redskin Levantines who live in shacks and skyscrapers, twelfth-generation computers and rusty bicycles fished up from the past, rubble from the Fourth World War and superhuman robots . . . The eclecticism of Budapest, its mixture of styles, evokes, like every Babel of today, a possible future swarming with the survivors of some catastrophe. Every heir of the Hapsburg era is a true man of the future, because he learnt, earlier than most others, to live without a future, in the absence of any historical continuity; and that is, not to live but to survive.[9]

Consider this passage and ask: What if, today, the real postmodernism was not where we expected to find it? What if it, too, came from the east?

Let us continue on down the Danube, to Subotica in Yugoslavia (which, as we all know, no longer exists).

> An abandoned synagogue appears to have popped out of Disneyland, with its swollen domes, glaring colours, fake bridges hanging between broken windows, steps overgrown with

*grass . . . It is . . . as if each and every one of the aldermen, returning from Vienna, or Venice, or Paris, had sketched out a piece of what he had . . . Fakery seems to be the poetry of Subotica. In the imagination of Danilos Kĭs, . . . fakery becomes not only the appalling falsification of life brought about by Stalinism but also the clandestine split personalities of the revolutionaries who, to escape from the powers that be, change, multiply, disguise and lose their identities.*[10]

Consider the Disneyfication of the cities of the east, the juxtaposition of incompatible elements that now seem emblematic of these cities' past and, perhaps, of their future as well. And last but not least, consider Ceausescu's Bucharest:

*"Hiroshima" is the name bestowed by the people of Bucharest on the quarter of the city which Ceausescu is gutting, levelling, devastating and shifting . . . Ceausescu's megalomania, at least as far as this pharaonic building project is concerned, appears to take a peculiar form of demolition, which is to say transference from one place to another. He does not demolish buildings, in fact he frequently preserves them, but he shatters the landscape by moving edifices to some other site . . . Ceausescu, for his part, takes delight in these removals, and is the proprietor of the Pantechnion firm which crates up the scenario of the centuries.*[11]

Consider this packing up of history, the prepackaged, neatly wrapped past so dear to Ceausescu.[12]

In a recent article dealing with attempts to expel the inhabitants of a certain village and with the subsequently abandoned plans to relocate them, Chantal Delterre-de Bruycker writes:

*This is the model that architects had in mind when they designed the new collective rural dwellings (those of Snagov are intended for four families apiece) in a style that was reminiscent of low suburban housing and came equipped with certain tokens of a purely conventional "rusticity" – for example, the "soba," or traditional stove, whose ceramic elements were made available to all tenants even though they had willingly rid themselves of their own traditional household furnishings. Ostentatiously named "villas," these dwellings constituted a new form of fakery, evoking bourgeois comfort by means of a cubbyhole ostensibly reserved for bathroom fittings – even though there was no running water.*[13]

With a rigged history and a thwarted language, in a Disneyfied *trompe-l'oeil* setting, the people of the east also looked on as nature and the environment disappeared, vanished before their eyes, became a hologram or a virtual image. Whatever happened to the Aral Sea? It was still there yesterday, or the day before. Just the same, it *is* strange. What if the Atlantic were to suddenly up and withdraw, without any warning? These people have been confronted with a history that runs the gamut from Orwell to *Blade Runner*, a hollowed-out history that is neither true nor false. Unaware that the walls of the Kremlin were made of cardboard, they took them to be impregnable like the Berlin Wall. Then to everyone's amazement, the whole thing collapsed like a house of cards. It was Alice in Nightmareland. How does one respond to such trauma – for trauma there was, even if the developments were considered salutary? How does one recover and find one's bearings? A single, solitary answer seems to be sweeping the whole planet – the *identity gambit*, the return to the past, reruns and remakes.

In a recent book, Jean Baudrillard used the metaphor of "thawing out" to discuss the recent developments in eastern Europe. What if freedom, like certain kinds of food, did not react well to freezing and thawing? What if it sought "nothing so much as to barter itself away in a fervent embrace of automobiles and kitchen appliances?"[14]

Baudrillard also touches on what I will call the "delete" phenomenon, according to which history is leaking away like an old pen. Instead of "saving" on the computer, one deletes everything in order to backtrack or start all over again.

> *We are in the process of wiping out the whole of the twentieth century. We are wiping out all signs of the Cold War one by one, perhaps even all the signs of World War II and those of all the century's political and ideological revolutions. The reunification of Germany and many other things are inevitable, not in the sense of a leap forward of History but in the sense of a reverse rewriting of the whole of the twentieth century – a rewriting that will surely take up a very great deal of the century's last decade. At our present rate, we should soon be back to the Holy Roman-Germanic Empire. Here, perhaps, is the illumination we may expect for the present* fin de siècle, *and the true* meaning of the much-debated phrase *"the end of History."*[15]

The tape of history is permanently on *rewind*. The past is henceforth the sole source of nourishment for identity, the only truly reassuring sanctuary. Subsequently, all reasoning and argument originate in fantasy, wild flights of fancy that authorize all

passions and aberrations in a sort of Croatia of the mind.

It is imperative that the mechanisms of meaning be started up again, even at the price of meaning itself. Indeed, to provide a meaning one is called upon to remember things that never even happened. One is obliged – in an operation symmetrically opposite to the workings of the great Stalinist machine of yesteryear – to constantly manufacture a past; this, in turn, requires mimicking the resurrection of the past, imitating and parodying it, starting over again with slight alterations. Thus the Croats transform themselves into Ustasha and adopt the flag of their Nazi-inspired Republic of 1940. The main square of Zagreb is stripped of its former appellation, *Square of the Revolution*, to be renamed *Square of the Heroes of Croatia*. The Serbs, who today are the real aggressors, are busy replaying the scenario of their valiant resistance against the Ustasha régime and see themselves as heroes even when they massacre their neighbours. It is the same old story all over again. Aleksandr Solzhenitsyn regrets that, in his earlier writings, he was of two minds with respect to Vlasov; now he understands him better. On the anniversary of the Wars of the Vendée, he told the French that all revolutions, starting with their own Revolution of 1789, are bad. Thus everything comes to be contemplated, analyzed and experienced against a background of disaffection. In the midst of such a dash backward, nobody wants to be outdone by anybody else. When can we expect the return of kings and emperors (there must be at least one Hapsburg currently looking for work) along with priests, popes, astrologers and an endless train of other avatars? Alain Brossat writes of an "hystericization" of memory: in Kosovo, fighting broke out over the memory of a five hundred-year-old battle; in Transylvania, arguments having to do with memory and the respective prerogatives of Hungarians and Romanians led to a pogrom; the corrosive autumn months of 1989 were given over to the ritual murder of the master who had for so long bent a terrified population to his will; statues of Lenin and other emblems of communist power were defiled.[16]

In Prague, people even went so far as to settle accounts with the past, inventing a law to deal with "the illegality of the communist régime and with resistance to it." This law stipulated that "the régime based upon communist ideology, which had, from 25 February 1948 to 17 November 1989, determined the direction of State policy in Czechoslovakia as well as the fate of its citizens, was criminal, illegitimate and reprehensible." The law went on to say that "the Communist Party of Czechoslovakia was a criminal and reprehensible organization, as were all other organizations based upon its ideology . . . and the leaders and members of the CPC were responsible for the way the country had been governed." Moreover, "citizens'

resistance to this régime was legitimate – even when carried out in concert with a foreign democratic power – and consequently deserving of respect."[17] As Jiri Pelikan wrote, after an extensive analysis, "One cannot rewrite history by passing a law."

Poor Gorbachev! He was not a kitsch figure, even if his origins were kitsch. For he was a modern, he believed in the system and wanted to reform it from within. But the system was rotten to the core and he knew it. This was why he and a few others including Shevardnadze and Iakovlev decided to leap into the fray. An enormous task awaited them. From as early as 1985, Gorbachev had envisioned the struggle as taking place on two fronts. The first was symbolic; it was the *glasnost* approach, openness and plain speech. In this regard, much remained to be accomplished. One had to shuck off the conventional *nomenklatura*, recover an authentic memory, reexamine the history of the Soviet Union and its immense murky tracts, rethink and reevaluate collectivization and the pace of industrialization after the first Five Year Plan, review the "preeminent" role of the Party, (that is Stalinism), rethink the organization of the judiciary (one of the cogs in the totalitarian machine), rethink the social contract, make the Soviet Union into a just society, liberate people's minds, make room for initiative, give back to Soviet citizen a sense of dignity and even imagine that the reality of socialism might one day come to resemble the concept. On the second front was *perestroika*, or the restructuring of the economy. This was the more delicate matter due to its greater immediacy and visibility. The country had to be pulled out of its decline, its stupor and stagnation, one had to put an end to the chaos, the monopolies and corruption, the mafias and gangs, to find ways of increasing productivity, stimulating innovation, of completely restructuring the positively catastrophic system of distribution. But to what end? At this point the picture gets a little foggy. Gorbachev hesitated, lost time, alienated liberals and conservatives alike by his belief that the system could be made competitive through sweeping reforms without, however, a return to capitalism or a fully integrated capitalist system, without giving up what had been the basis not only of the October Revolution but of all socialist movements prior to 1917, namely, the socialization of the means of production. Gorbachev believed that all this was both possible and feasible, that it would take much time and effort, necessitate the end of the Cold War and general disarmament but that, in the long run, his country would be revitalized and would come out all right. He thought that, above and beyond the corruption, a glue or a linchpin could be found that would enable the Soviet Union to hold together, that it was Sovietism, the multi-ethnic State. However, what he took to be the strongest point in this system turned out to be precisely its "weak link" (to use an outmoded

expression employed by Lenin). Gorbachev is undoubtedly the last tragic, Shakespearean incarnation of a system that could not be reformed. One can only begin to imagine what would have been the result of Gorbachev's approach in Khrushchev's day, at the time of the Twentieth Congress of the Communist Party of the Soviet Union, that is, in 1956, three years after the death of Stalin.

There are those who will say that it was catastrophic that Gorbachev's opening of Pandora's box after years of a repressive utopia should lead to a violent return of the repressed, that we were not spared this stage of historic development. Indeed!

Let me be quite clear on this point. Emphasizing what issued from Pandora's box does not mean being nostalgic for the former system. Who could be? Still, one must get beyond a certain naïve attitude which consists in thinking that everything that followed the demise of communism, all returns of the repressed, are by definition positive – in other words, that the enemies of my enemies are my friends. Also, one must dismiss another attitude that, while seeing clearly the immense shadows accompanying democracy's first faltering steps (a fetishized market, generalized ethnicity and, for the time being at least, a hopeless economic situation), still believes that one can make the best of it by saying that this is the price one has to pay, the inescapable way out and that, in any case, "it cannot be worse than before." Unfortunately, it can. "It can always be worse" because history is blind tragedy. This attitude makes use of argumentation that is, like the road to Hell, paved with good intentions. The worst is not always inevitable but it is often likely.

I am not denying the need to create an ancestry, to replay the story of origins, to compose founding myths or a gratifying past, to invent traditions and a collective memory. I just do not see why this should lead to rancour and hatred, nor why nationalisms that have seen the wicked fairy Carabossa leaning over their cradle should constitute the royal way to collective self-actualization. Why should the general balkanization not continue indefinitely?

Finally, who would (going against today's often repeated "doxa") deny that these eastern countries were necessarily slated for destruction, that they did not constitute a civilization, a cultural whole in which there prevailed, along with certain constraints of course, a degree of consensus or (until quite recently) a certain measure of hope – despite all the various ways in which socialism had been defaced?

*The timely volatilization of "real socialism" in the other Europe has become fodder for a massive retrospective flood of speculation on the inevitability of its downfall. Doomed from time immemorial – because of its intrinsically despotic nature, the aporias of Marxism, the*

*absurdity of the precepts of economic interventionism – to meet such a calamitous and chaotic end, the sphinx so newly dispatched to the next world has withdrawn deeper into its riddle. Gone and forgotten are the impressive stability, the capacity for survival exhibited by this world for decades on end, and this in spite of severe ordeals and periodic maladies. What was it that enabled the USSR to survive the terrible defeat of 1941, to turn it around at the cost of unheard-of sacrifices? What made it possible for Hungarians to come to an agreement and to make the kind of compromises exemplified by Kadar after the horrible repression of the Hungarian Revolution of 1956? What allowed the Yugoslavian identity established under the leadership of Tito to hold despite four years of continuous warfare that pitted Serbs against Croats, Chetniks against communists, the Ustasha against one side or the other?*[18]

All this militates against a rereading of history which, from 1917, or even from as early as 1905, sees nothing but a "pile of ruins in the making." A certain degree of courage or, perhaps, of Nietzsche's untimeliness is called for if one is to get beyond the intoxication and euphoria and consider what the collapse of communism and the end of the Soviet Union might mean for the history of our civilization. Do we really think we can erase it all just by striking the "delete" key?

What we are getting is a past cobbled together from kitsch and phantasms, shunted around like Ceausescu's ruins, an uprooted past continuously revised and edited – remains, ruins, rubble, rubbish, remnants, relics and so on. The new nationalisms are postmodern even if they are the heirs of nineteenth- and twentieth-century movements that run the gamut from the Romantic *Volksgeist* to every kind of fascism, taking in, in the process, the ambiguities and ambivalences of colonial and neocolonial liberation movements, not to mention certain even more ambiguous movements that see themselves as acting out anticolonial scenarios whereas, in reality, they have taken refuge in the most hypersensitive of the "small is beautiful" style of credos. As Claudio Magris so aptly states:

*[A] small people which has to shake off the disdain or indifference of the great – of those whose greatness may perhaps have only a little while to run – must also shake off its complex about being small, the feeling of having constantly to rectify or cancel this impression, or else totally reverse it, glorifying in it as a sign of election. Those who have long been forced to put all their efforts into the determination and defence of their own identity tend to prolong this attitude even when it is no longer necessary. Turned inward on themselves, absorbed in the assertion of their own identity and intent on making sure that*

*others give it due recognition, they run the risk of devoting all their energies to this defence, thereby shrinking the horizons of their experience, of lacking magnanimity in their dealings with the world.*[19]

These nationalisms are remakes, Hollywood costume dramas, B-movies shot on shoestring budgets with a few Reagans of the wild east thrown in. "Go east young man!"

The current commemorative reshaping of the past can take two forms: either one memorializes history, leaving it to petrify in museums (and bringing about the return of the repressed), or one attempts to historicize memory, keeping it at bay and going into mourning over the past. The work of mourning is exemplified by Hans Jürgen Syberberg who sought, with *Our Hitler: A Film from Germany*, to face the Nazi past, to deconstruct its mythology and demystify its shoddy basic symbols. Alexander Kluge's *Die Patriotin* is another example; relying upon an aesthetics of collage, fragments, debris and scraps, it searches for another Germany and is able thereby to confront the true past without turning it into myth. The work of mourning can also be a labour of exorcism, as we can see from Anselm Kiefer's paintings with their devastated plains, ravaged landscapes and monumental Nazi architecture.

The same operation is also signalled in the opening lines of Christa Wolf's autobiographical novel, *A Model Childhood*. "What is past," she says, "is not dead; it is not even past. We cut ourselves off from it; we pretend to be strangers." As a young adolescent in Nazi Germany, Wolf joined the Hitler Youth. She lived in a small town in eastern Germany, a town that is now part of Poland. In her novel she relates how, as a citizen of the German Democratic Republic, she set out one day to visit her birthplace. On the way there, all sorts of memories and questions begin flooding into her mind. How, she asks herself, were we able to function so easily, how did we make it past 1945, and how did we get from fascism to communism in East Germany? Was it with the same apathy with which we watched fascism taking hold throughout the country, particularly in our town? This truly is an archaeology of memory. To write history by writing stories about things that happened to her personally without, however, making up stories – this is the task Wolf sets for herself. How long will it be before the great Russian or Ukrainian novel of the thirties, or indeed, of the Gorbachev years, asks the same questions? Whether the water that carries it to us flows under the Bug, the Dnepr, the Dnestr or some other Volga, we know for certain that it shall be written, for we are well aware that all these cultures are great cultures. No one who has ever seen a play by Kantor could ever forget it,

nor could anyone who has ever been taken by the beauty of Prague ever get over it. Lovers of the works of Pasternak, Mandelstam and Platonov know just how inspired Russian literature can be. And these examples are just a few among thousands.

The work of mourning, again, is present in this excerpt from Heiner Müller's *Explosion of a Memory.*

> FORGOTTEN AND FORGOTTEN AND FORGOTTEN
> *The Thaelmann Song The Partisans of the*
> *Amur and Onward to the Final Fight*
> *The neckcloth wet from Stalin's memorial service*
> *And the torn blue shirt for the friend who fell*
> *At the Berlin wall Stalin's monument*
> *For Rosa Luxemburg The ghost cities*
> FORGOTTEN *Kronstadt Budapest and Prague*
> *Haunted at night by Communism's spectre*
> *Knocking its signals through the cities' plumbing*
> FORGOTTEN AND FORGOTTEN AND FORGOTTEN
> *It's always buried by the shit again*
> *And rises once again out of the shit*
> FORGOTTEN AND FORGOTTEN AND FORGOTTEN
> . . .
> *I didn't cry I hadn't any tears left*
> *I didn't enter where the woman died*
> *I stood in my wet mud-tracks on the carpet*
> *What do I care for your Socialism*
> *It soon will all be drowned in Coca Cola*[20]

The work of mourning continued throughout the Gorbachev years with Abuladze's film, *Repentance,* and with the plays of Chatrov and many others. It could also be discerned in the paintings of Alexander Melamid and Vitaly Komar, proponents of a Soviet style of pop art or postmodernism that came to be called *Sots art.* In their paintings, the entire arsenal of Stalinist signifiers – the Young Communists in their red scarves, the hammer and sickle, the revolutionary ballads that became part of a new folklore, the ritualized affability, the watchwords and slogans, the aesthetic of social realism with its schmaltzy, sugary humbug – is cut into pieces and moved around, allegorized and spoofed from within.

Meanwhile, the strains of mourning resonate in the names the people of East Berlin gave to the statues of Marx and Engels at the Marx-Engels Forum. "Sakko and Jacketti," they called them, alluding to their bourgeois style of dress. In German, "sakko" means "jacket" and the expression obviously echoes the names of Sacco and Vanzetti.

For the return of the repressed, on the other hand, we have *Pamiat'* with its anti-semitism, its offenses à la Jean-Marie Le Pen. As well, it is manifested in the recent absurd and bloody failure of the uprising of Yeltsin's opponents in the Russian parliament, in the persecution of caucasians carried out under the pretext of cracking down on mafiosi and criminals of every stripe. It is a hysterical emphasis on ethnicity, the skinheads in Germany making the Nazi salute and firebombing the homes of immigrants under the gaze (a mixture of complicity and uneasiness) of the authorities and the general populace. It is Edgar Reitz (albeit with a different ideological bent) making *Heimat*, a film that harks back to the soil, a subdued variant of *Blut und Boden*. A film steeped in nostalgia, *Heimat* takes us through the daily lives of four generations of a German family. It virtually skips over the thirties, espousing a Germany where it is good, from time to time, to slaughter the family pig, to love, to rejoice in the cycle of the seasons, a Germany that knows nothing of genocide or Auschwitz. (Memory, here, is quite simply debarred.) In the same vein is the desire to wipe out the very memory of the existence of the German Democratic Republic, to eliminate the slightest traces of it. Faced with such taboos, it may be worthwhile asking what then becomes of the writers of the former GDR?

This is an all-purpose past under general surveillance, a petrifying memory, a past packaged à la Christo, way beyond true or false, canned like the installations of Arman or Christian Boltanski, newly erased, repressed, a supposedly ancestral past exhumed, reinvented, brandished as if it were the only bastion of identity, a pasteboard stage set, a remake.

Soon it will be time to compile the list of the ruins – the mausoleums, monuments, statues, flags, hymns, medals, insignia, emblems, mottoes, slogans and symbols. But can a deposed history be exhibited or simply made into an art installation? Could it be set up in a showcase or transformed into a hologram? Could we not, then, imagine an alternate reading of the famous opening sentence of Marx's Communist Manifesto: "A spectre is haunting Europe – the spectre of Communism?" Should we bury the tokens of the past? Recycle or reuse them? Buy medals at the Brandenburg Gate and cart back the spoils – a piece of the Berlin Wall, for example, to be set up somewhere in our garden? It is a safe bet that these things will, in a

manner totally unknown to us, come back to haunt us. For no matter how hard we try to convert this past into ruins, rubbish, vestiges and relics – try as we may to up-end its signs and its emblems, to set it aside, to concoct facsimiles and fakes to stand in for it, regardless of how much we strive to museify it, to parody, deride and satirize it, despite all our efforts to criminalize it, to find scapegoats, to make others accountable for it, no matter how many statues we smash, how many fragments we keep in museums, how fiercely we fasten on symbols, how often we exhume and rebury them – the fabrication of ruins can in no way counter the need to mourn and to subject the past to a critical, non-hysterical reading. We should read Elsa Triolet's novel, *Le Monument*, published in 1965. In it she relates the story of a sculptor who was commissioned to do a statue of Stalin in Prague in 1956. So hideous did the fruit of his labours seem to him that it drove the artist to suicide. His will bequeathed the payment for the statue to the blind, who would never have to see their city so dishonoured. Today, again, there is no lack of unseeing people who are oblivious to the ugliness of both the toppled statues and those that have come to replace them. "The end of Communism: the winter of the soul, December 25, 1991" – this from Danièle Sallenave, who certainly cannot be taxed with being nostalgic for the old order.[21] For there is, in the red banner hoisted at Christmas, something tragic that compels us to reflect on (and not merely kitschify) the way we dispose of the past and its symbolism.

Translated from French by Don McGrath

### NOTES

1   Sigmund Freud, *Civilization and its Discontents*, trans. James Strachey (New York: W.W. Norton and Company, 1961), 17.

2   See Berthold Unfried, "La Muséification du socialisme réel," *Communications* 55 (1992), 37. The theme of this issue was *L'Est: les mythes et les restes* (The East: Myths and Remains).

3   Yves-Michel Riols, "Hongrie, les statues socialistes au musée," *Le Monde* (30 June 1993).

4   Quoted by Georges Nivat in "Russie libérée, Russie brouillée," *La Lettre internationale* 34 (Fall 1992), 67.

5   Nivat, 70.

6   Susan Greenberg, "Les Funérailles nationales d'Imry Nagy," in *À l'Est la mémoire retrouvée*, ed. Alain Brossat, Sonia Combe, Jean-Yves Potel, Jean-Charles Szurek (Paris: La Découverte, 1990), 146.

7   Vladimir Gradev, "Le Mausolée de Dimitrov," *Communications* 55 (1992), 79–80.

8   A song composed around the time of the 1815 Polish uprising against Czar Alexander (translation).

9   Claudio Magris, *Danube*, trans. Patrick Creagh (New York: Farrar, Straus and Giroux, 1989), 265.

10    Ibid., 323.

11    Ibid., 377.

12    This whole passage from Magris must, of course, be put in the past tense. The original publication of his book dates from 1986, that is, three years before the events of December 1989.

13    Chantal Delterre-de Bruycker, "Les Démolis de Snagov," *Communications* 55 (1992), 91–92. Italics mine.

14    Jean Baudrillard, *The Transparency of Evil: Essays on Extreme Phenomena*, trans. James Benedict (London: Verso, 1993), 94.

15    Ibid., 97–98.

16    Alain Brossat, *Le Stalinisme entre histoire et mémoire* (Paris: Éditions de l'aube, 1991), 22.

17    See *Le Monde* (20 August 1993).

18    Alain Brossat, "La Fin d'un empire," *Communications* 55 (1992), 202–203.

19    Magris, 225.

20    Heiner Müller, *Explosion of a Memory*, ed. and trans. Carl Weber (New York: PAJ Publications, 1989), 147. See "Postscript: Requiem for the Gorbachev Years," in Régine Robin, *Socialist Realism: An Impossible Aesthetic* (Stanford: Stanford University Press, 1992), xxxi to xxxvii.

21    Danièle Sallenave, *Passages de l'Est: Carnets de voyage* (Paris: Gallimard, 1992).

# FOTO OPPORTUNITY:
# EIGHT STRATEGIES OF NIAGARA FALLS

eLizaBetH DiLLer anD ricarDo Scofidio

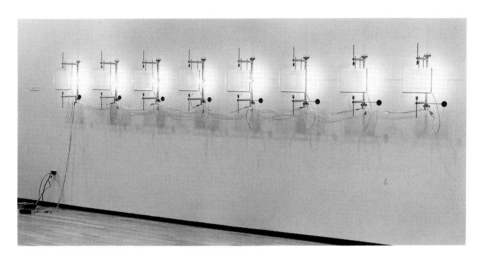

. . . a convenient stop for, 'Ride Niagara,' a simulation barrel ride over the Falls. Turn me off while you enjoy the

*In tourism's reconfiguration of space, tourist sights are mechanisms of scopic control, apparatuses on a*

park and take some snapshots, but make sure you turn me on again once you're ready to see more. –tone–

*grand scale which bring into focus the sights, while displacing the 'unsightly' into a visual blind zone, for*

As you round the curve down-river, you will be approaching the International Water Control Structure, built to

*example, national roads are optically engineered to obscure industrial blight and ghetto from view,*

regulate the water quantities. Built in 1957, it effectively cut the water by 50% thereby slowing down the

*while keeping the scenic continuous.*

erosion from 3 feet to just 1 foot per year. Peak power demand, and therefore water-generating capacity

*Photo opportunities are usually the moments in which the actual sight corresponds with its expected image.*

in Niagara is during the early morning and evening hours, even further increased during the months of shorter

*Frequently, sights must struggle to match their representations. Engineers are still combatting the natural effects of erosion on*

daylight hours. Fortunately, this period coincides with the slower tourist season so that more water can be

*Niagara Falls so as to preserve the promise of the official postcard image.*

diverted from the river during high demand months without risking complaints from valued tourists . . . –tone–

*The sign inevitably attracts attention to itself as it attracts attention to the sight. But it is also what comes to fill a deficiency*

Continue forward until the turn-off into the Maid of the Mist parking lot, where you can leave your car and

*intrinsic to the sight for without the marker, the sight cannot attract attention to itself, cannot be seen and therefore, cannot be*

board a boat that will take you within 300 feet of the Falls. Your admission includes heavy weather gear.

*a sight. — Van den Abbeele*

Do button up or you'll be drenched.

—excerpt Auto Tour

McClane, the tenacious travel agent of Rekal, Incorporated (*Total Recall*) offers his clients an alternative to the hellishness of contemporary tourism – jet lag, crowds, crooked taxi drivers, lost luggage, pickpockets, currency exchange and air traffic delays. His sales pitch to prospective client Doug Quail (Arnold Schwarzenegger): "With Recall Incorporated, you can buy the memory of your ideal trip, cheaper, safer and better than the real thing. What's more, the package offers options to travel in alternate identities." In this remake of Philip Dick's post-touristic vision, the Rekal client will emerge from sedation, implanted with extra-factual memories of a travel adventure, free from vagueness, omissions, ellipses and distortions and with tangible evidence such as souvenirs, ticket stubs, a stamped passport and proof of immunization.

Considering a more immediate scenario, will the unlimited freedom of movement promised by tele-technologies render travel obsolete? Perhaps United Airline's recent offer to redeem frequent flyer miles for flight simulator time confirms technology's threat to conventional travel. With remote control in hand, one can already tour the world without the expenditure of movement. The fixed no-option itineraries of commercial travel videos and Travel Television Network guarantee the exotic every time and at no risk.

Despite the fluid mobility afforded by teletechnologies and the futility of mobility in a progressively homogenized world, tourism continues to be one of the fastest growth industries. It has been argued that the reason conventional travel remains so highly valued is precisely to counteract the effects of the technological world. Jonathan Culler maintains that one of the characteristics of modernity is the belief that

### Terror
*Geologists estimate that the Falls are 10,000 to 30,000 years old. About 12,000 years ago, the Falls were 7 miles down river, eroding*

### Obscurity
*as much as 6 feet per year. The average flow over the American and Bridal Veil Falls varies from 8,000 to 10,000 cubic feet (735 to*

### Power
*918 cubic meters) per second or 60,000 to 75,000 gallons (227,124 to 283,905 liters) per second. The flow over Horseshoe Fall varies*

### Privation
*from 42,000 to 90,000 cubic feet (3,857 to 8,264 cubic meters) per second or 315,000 to 675,000 gallons (1,194,401 to 2,333,145*

### Vastness
*liters) per second. The water falls at an accelerating rate of 9.76 meters per second. At the Horseshoe Fall, 2,620,800 to 5,616,000 pounds*

### Infinity
*(1,188,795 to 2,547,418 kilograms) or 1,310 to 2,808 short tons (1,189 to 2,547 metric tons) strike the water below each second.*

### Succession and Uniformity
*The American Fall has a crest length of about 800 feet (244 meters). The Bridal Veil Fall has a crest length of about 40 feet (12.2 meters).*

### Difficulty
*The Horseshoe Fall has a crest length of about 2,500 feet (762.5 meters) and flank-to-flank width of about 1,000 feet (305 meters). During*

### Magnificence
*daylight hours from the 4th to the 10th month of the year, about 102,000 cubic feet (2,856 cubic meters) per second is diverted*

### Light and Color
*for hydroelectric power. During the other months, 152,000 cubic feet (4,276 cubic meters) per second is diverted. The two Canadian power*

### Sound
*plants together are capable of producing 2,000,000 kilowatts; the American power plant has a capability of 2,400,000 kilowatts.*

### Bitters and Stenches
*The Falls are illuminated using 18 xenon gas spotlights, each producing 250,000,000 candlepower.*

—Edmund Burke, Philosophical Enquiry Into the Origin of Our Ideas of the Sublime and Beautiful, 1757

authenticity has somehow been lost, and that it can be recuperated in other cultures, in the past and in nature.

The tourist certainly yearns for the authentic; tourism fuels that desire. In sights of the national past, for example, travel promotions lure tourists with the temptation to: "stand on the *very* spot the general fell," "witness the *actual* sights, sounds and smells of the clashing troops," "see the *original* manuscript later drafted into law," "observe the *genuine* skills the early settlers used in making soap," etcetera. In the rhetoric of authenticity, italicized adjectives certify the real.

North American tourism produces the authentic past with a fictive latitude in which mythology and popular fantasy are blended together into the interpretation process called *heritage*. The tourist agrees to the terms with no sense of loss. In considering the touristic gaze, John Frow discussing Culler argues, "things are never expected to be real, rather, things are read as signs of themselves, idealized and often frustrated . . . hence, the structural role of disappointment within the touristic experience." No anxiety is posed for the tourist so long as the expected narrative is sustained.

The tourist's reluctance to take seriously the pretenses of traditional ethical historiography permits tourism broad latitudes in the production of authenticity. By passing the limitations of chronological time and contiguous space, touristic time is reversible and touristic space is elastic. Correspondences between time and space – between histories and geographies – are negotiable.

Unrestricted viewing of Niagara Falls did not begin until 1885. 'Free Niagara!' was the rallying cry in

*Criminals Hall of Fame  •  French Perfume Factory  •  Guinness Museum*

the 1870s as a group of dedicated citizens led by landscape architect Frederick Law Olmsted and artist

*of World Records  •  House of Frankenstein Wax Museum  •  Louis Tussaud's Wax*

Frederick Church and joined by Carlyle, Ruskin, Emerson and Longfellow, set out to extricate the Falls

*Works  •  Lundy's Lane Historical Museum  •  Aquarium Reptile Museum  •*

from the clutches of profit-hungry land owners. Defending public entertainments and social events, J.B.

*Movieland Wax Museum  •  Ripley's Believe It or Not! Museum  •  That's Incredible*

Harrison said, 'Young people cannot sit in silence gazing at the Falls, through all of a long summer day,

*Museum  •  Circus World  •  Fun House  •  Haunted House  •  IMAX*

thinking of aesthetic sublimities, or communing with the Absolute and Infinite.' The lands around the

*Theater  •  Niagara Go-Karts  •  Tivoli Minature World  •  Whitewater*

falls had become a vulgar tourist trap, with visitors having to pay to see the cataracts through peepholes

*Waterpark  •  Fantasy Island  •  The Space Spiral  •  Houdini Magical Hall*

in the fence. The campaign resulted in the establishment on July 5, 1885, of a nation's first state park,

*of Fame  •  Our Lady of Fatima Shrine  •  Marineland and Game Farm  •*

embracing 435 acres of land along the American Falls. The Canadians followed with similar action

*Oak Hall Par 3 Golf  •  Spanish Aerocar  •  Waterslide  •  Doll's House*

around their portion of the cataract, and the protection of the Falls was assured. The park's creation

*Museum  •  Niagara Splash Water Park  •  Herschell Carousel Factory Museum*

affirmed the premise that the nation's natural treasures belong to everyone.

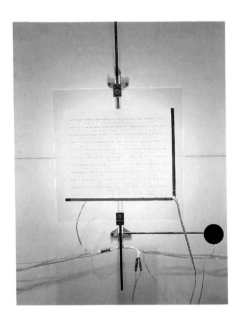

Each text is printed on fluctuating liquid crystal panels timed at six-second intervals. Continuous audio offers a self-guided automobile tour of Niagara Falls.

In 1801, Theodosia Burr, daughter of the future U.S. Vice President and her new husband, embarked on

*Caller: Is this the Quality Inn? This is Elise speaking. How may I help you? C: I was wondering, do you have rooms with jacuzzis? FD: Yes we do. Do you*

their 'bridal tour' equipped with nine pack horses and a train of servants. In 1804, Jerome Bonaparte

*have a particular date in mind? C: Late July. What are your rates? FD: A room for 2 with a jacuzzi and a queen size bed would be $139 for a weekend. We have*

(Napoleon's younger brother) and his Baltimore bride followed the example of their high society

*lots of options for newlyweds, like roses and champagne, but there would be an additional charge. C: My lover Michael has an allergy to flow- . . . DIAL TONE. FD:*

predecessors. A new social custom of honeymooning at Niagara Falls was born, however, only a small

*Niagara Hilton reservations, may I help you? C: Yes, I was wondering whether you had any heart-shaped beds? FD: I'm afraid not. C: That's too bad. Anyway, my*

number were able to undertake the expense of travel for pleasure to Niagara, still considered frontier

*gay lover and I are interested in booking a room. I wanted to make sure that we wouldn't be harassed. FD: No. C: It's a bit more complicated . . . there might be a*

country. It was not until the opening of the Erie canal in 1825 and the construction of railroads in the 1830s

*third person. FD: What do you mean, you want an extra bed in the room? C: No, that's not necessary. FD: Oh . . . can you hold please? C: Yes. FD: Perhaps,*

and 40s that made Niagara Falls accessible to middle–class lovers. The craze of the romantic

*you may want to try the Bel-Aire. C: Thank you. DIAL TONE C: Hello, is this the Bel-Aire Motel? FD: Yes. C: I was wondering whether you cater primarily to families*

honeymoon can be traced to the 1841 song of the year, 'Niagara Falls,' which became so popular that

*or couples? FD: Most of our visitors are married couples, and some newlyweds. We have several bridal suites. C: Well, you see, my lover and I are gay, and*

it helped to institutionalize the custom. Speculating on the explanation of Niagara's honeymoon appeal,

*we hope that doesn't present a problem. FD: (titters) No, that's your business. C: Do we have to worry about making too much noise and disturbing your guests?*

one historian associates an inevitable link between the tumultuous falls of water and the Judeo-Christian

*Are your walls insulated? FD: Well, if you keep it under control. C: Oh, one more thing . . . there might be a third person. FD: These rooms are for two, only.*

myth of the Fall, original sin. Another attributes it to the aphrodisiac effect produced by negative ions

*C: But we'll pay double. FD: I'm sorry, I'll have to check with the manager. C: And also, do you have any equipment, you know . . . like, rope? FD: Maybe you*

generated by falling water.

*should try the Bit-o'- Paris Motel.*

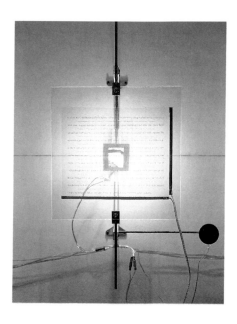

This situation is not surpassed, and probably not equalled, in the United States, as a site for the establishment

*Fourteen weeks after the Love Canal neighborhood was declared a disaster area, it has finally begun to look like one. The state has*

of manufactures. The country in the vicinity of the Falls is rich in soil, romantically beautiful in formation, and

*bought 237 homes contaminated by toxic industrial chemicals leaching out of an old landfill, emptied them, boarded them up and sur-*

proverbial for salubrity. The pure and limpid waters of the Niagara – always flowing with a uniform current,

*rounded them with a half mile of chain link fence. Now construction workers, wearing gas masks on windless days, have flattened the*

and full banks – are as propitious to the health, as they are conducive to the comfort and luxury of its inhabi-

*garages in the area with bulldozers, poured a mountain of clay on the landfill and have begun to dig drainage ditches through the*

tants. From the head of the rapids to the Great Falls, a distance of three-fourths of a mile, there is a regular suc-

*backyards. A fleet of buses waits to evacuate all the homes outside the fenced area if an explosion of a cloud of poisonous dust blows*

cession of chutes, which give, in the aggregate, sixty feet of perpendicular descent . . . for hydraulic operations.

*out of the construction site – a pretty slim possibility, according to the foreman. The sad but necessary evacuation of the neighborhood*

Practically speaking, the extent to which the water power may be applied here is without limit. The upper half

*started in early August, when the State Health Department decided that the 82 different chemicals discovered leaking into basements*

of Iris Island might be covered with machinery, propelled by water power; the lower half, situated in the midst

*and air of the homes fronting the landfill were dangerous to families at the southern end of the canal bed; the families had extremely*

of falls and rapids, where nature courts the imagination in her most sublime, beautiful and fascinating forms,

*high miscarriage and birth defect rates. Later studies have suggested that residents also have abnormally high rates of liver cancer*

might be converted into delightful seats for the residence of private gentlemen, or appropriated to Hotels and

*and unusual amounts of hyperactivity, and that their children have a high incidence of seizure-inducing nervous disease. Claims total-*

pleasure grounds for the accommodation of the numerous strangers who annually visit this spot.

*ing $2.65 billion have been filed against the city of Niagara Falls.*

—excerpt from advertisement, Invitation to Eastern Capitalists and Manufacturers, 1825

Presuming that all histories are constructs anyway, what is at stake in rethinking authenticity is the question, who's authenticity? It is not the *authentic* but rather, *authentication*, that needs to be interrogated, that is according to Frow, "the practices by which limits and discriminations are set, and about the relativized systems of value which enable them."

For the tourist, the camera is the ultimate authenticating agent, producing evidence of the sight having been seen. Tourism is dominated by sight. Sightseers pay to see sights; sight makers produce sights and sustain their value. Attractions can be understood as optical devices which frame the *sight* within a safe, purified visual domain while displacing the *unsightly* into a visual blind zone.

Scopic control operates at a grand scale in sites of nature, *nature* being a favourite tourist destination and one of tourism's most auratic attractions. The production of nature is perhaps tourism's subtlest undertaking. Roads through national parks, for example, are optically engineered to obscure industrial blight and ghetto from view so that the scenic can be kept scenic. This continuity is only punctuated by photo *opportunities*, the *official* set of views. A *photo opportunity* can be thought of as a prescribed location in which the sight corresponds with its expected image and is thus offered to the affirmative camera of the tourist.

In 1959, the Great Blondin walked a tightrope across the Niagara River pushing a wheel barrow containing a
*The sensationalism fostered by promoters of stunts and hucksters around the Falls appealed to a new consumer attitude toward*
small stove, stopped mid-rope to cook and eat an omelet, before continuing to the other side. Henry Bellini
*the cataract. When a guidebook reported that the rapid current and numerous eddies in the river below the Falls 'are*
jumped from mid-rope (the couchone leap) holding onto a 12 foot rubber cord, which slowed his descent. This
*calculated to impress a stranger with an idea that a passage in the ferry is hazardous,' or that crossing the bridge to Goat*
never-before-performed thrill ended abruptly in 1873, when the rubber line broke and wound around Bellini's legs.
*Island 'is calculated to alarm the traveller for his safety,' it conveys a subtle sense of deliberately staged spectacle, as if the*
In 1876, Maria Spetlerina made the crossing with bushel peach baskets on her feet, her arms shackled in irons
*place were designed and run for the viewer, specifically in order to create feelings of alarm or excitement. Even the word*
and her head enclosed in a paper bag. She crossed from the U.S. to the Canadian side walking forwards, then
*'spectacle,' which is a favorite of the guidebooks and travel memoirs, implies a show expressly for human entertainment; its*
returned to the American side walking backwards. In 1911, Lincoln Beachy flew a Curtis biplane with an open
*first definition in O.E.D., is 'specially prepared or arranged display of a more or less public nature, forming an impressive or*
cockpit through the cataract mist within 20 feet of rushing water, and then through the arch of the Honeymoon
*interesting show or entertainment for those viewing it.' When guidebooks proclaim that 'no spectacle can be more sublime,*
Bridge. William Hill made a barrel trip down the lower rapids in 'The Thing,' an inner tube contraption which
*than is presented by the great Falls,' or that 'the mind, filled with amazement, recoils at the spectacle, and loses for a moment,*
brought him to his death. In 1920, Charles Stephens went over the Falls in a Russian oak barrel. He foolishly strapped
*its equilibrium,' there is an overtone of commercialism. —E. McKinsey*
an anvil to his feet for ballast, and when the anvil shot through the bottom of the barrel, so did he.

Often, a sight must struggle to resemble its expected image. In Niagara Falls, for example, engineers are fiercely negotiating hydroelectric demands as they are combatting the natural effects of erosion to the receding waterfall in order to preserve the grandeur permanently preserved in its postcard image. Here, the postcard has become the fixed referent after which the mutable sight models itself. "Fortunately, peak power demands coincide with the slower tourist season so that more water can be diverted from the river to the hydroelectric plant without risking complaints from valued tourists," explains the annual economic report from the Chamber of Commerce.

Niagara Falls is an early example of tourism's commodification of vision. Prior to 1885, independent entrepreneurs built tall barriers to obscure the Falls from view and charged the public a fee to see the cataracts through peepholes. In a step toward the democratization of nature, the federal government secured unrestricted viewing of the Falls by establishing the first state park. With this gesture, the waterfall was returned to the free gaze of the public. Concomitantly, the commodification of the sight dilated to encompass associated amusements and support functions which have come to define the economy of a region.

For a local economy whose survival is largely based on the preservation of an image, the plight of Niagara Falls demonstrates the inextricability of a tourist sight from the network of representations which it

The civil jurisdiction over the Falls of Niagara, as well as the shores and waters of Niagara river, is divided between the State of New York and the Province of Ontario. But the sublime exhibition of natural powers there witnessed is the property of the whole world. It is visited by tourists from all quarters of the globe, and it would seem to be incumbent upon both governments to protect such travelers from annoyance on either side. It is well known, and a matter of universal complaint, that the most favorable points of observation around the Falls are appropriated for the purposes of private profit, while the shores swarm with sharpers, hucksters and peddlers who perpetually harass all visitors. The Governor-General of Canada proposed that an International Park be established, enclosing a suitable space on each side of the river, from which all annoyances and vexations should be excluded. He thought that each government might obtain control of a sufficient area to keep sacred for the free use of those who, coming there from all parts of the world, desire to view the grand scenery without molestation.

—excerpt from Commission of the State Reservation

| | U.S. | Canada |
| --- | --- | --- |
| Visitors | 3,004,000 | 3,420,500 |
| Income generated | $182,000,000 | $221,000,000 |
| $ per day, per capita | 59.70 | 63.50 |
| Percentage of visitors who stay overnight | 40% | 38% |
| Purpose of visit: Sightseeing | 66% | 59% |
| Other events | 10% | 18% |
| Visiting friends, relatives | 10% | 4% |
| Shopping | 6% | 3% |
| Honeymooning | 1% | 2% |
| Conventions, other | 7% | 14% |

–recent Tourism Economic Impact Study

produces and which produce it. Affirming the play of supplements in tourist sights, Georges Van den Abbeele argues, "the sign inevitably attracts attention to itself as it attracts attention to the sight. But it is also what comes to fill a deficiency intrinsic to the sight (for without the marker, the sight cannot attract attention to itself, cannot be *seen* and therefore, cannot be a *sight*). A chain of supplementarity is established in the inevitable proliferation of markers as each marker stands for the other, indecidably replacing it and adding to it."

The touristic construction puts into motion an exchange of references between a sight and its indispensable components – the postcard, the plaque, the brochure, the guided tour, the souvenir, the snapshot and, further, the replica, the reenactment, etcetera. Given the extensive production of contemporary tourism, a tourist sight can be considered to be only *one* among its many representations, thus eliminating the "*dialectics of authenticity*" altogether.

$$T_{ij} = \frac{GP_iA_j}{D_{ij}}$$

*The distinction between tourist and*

$T_{ij}$ = some measure of tourist travel between origin i and destination j,

*theorist is all the more difficult to sustain*

$G$ = the proportionality constant,

*if one remembers that the first definition*

$P_i$ = the measure of population size, wealth or propensity to travel at origin i,

*of the word 'theory' cited by the Oxford*

$A_j$ = the attractiveness or capacity of destination j,

*English Dictionary is 'a sight, a spectacle'*

$D_{ij}$ = the distance between i and j.

*from the Greek 'theoria.'*

—formula used to forecast attraction between sites and tourists,

—Georges Van den Abbeele

based on Newton's Law of Gravitation

# DESTRUCTION AND VANDALISM DURING THE FRENCH REVOLUTION

daniel hermant

## A POLITICAL HISTORIOGRAPHY

The history of the French Revolution is, from the outset, a polemical history. In this polemic, both supporters and adversaries of the Revolution found vandalism to be a particularly serviceable subject for debate. As Louis Réau writes in the preface to his Histoire du vandalisme,[1] "Most of the writers who tackled or merely touched upon the history of vandalism behaved like 'partisans,' indicting their adversaries in order to exonerate their clients. History thus understood degenerates into accusations and counter-accusations." Indeed relations between both camps were marked by acrimony. At the end of the nineteenth century, for example, in a radical France solemnly celebrating the first centenary of the Revolution, official Republican historiography argued against publications inspired by political and religious convictions rigorously opposed to its own. Alphonse Aulard denounced "counter-revolutionary claptrap" and bristled at those who dared to "heap opprobrium on the Revolution, presenting our grandparents as vandals and brutes."[2] In more restrained language, F. Benoît thought that "the appreciation of the artistic role of revolutionary governments has felt the effects of the grudges harboured by partisans of the Ancien Régime who, ever since their defeat, have multiplied their exaggerated recriminations and their slanderous charges."[3] In the other camp, Gustave Gautherot, a professor at the Institut catholique de Paris, castigated the Republican historians; P. Robinet became "a fierce Jacobin," while E. Despois was cast as the "chaste son of the Revolution" who endeavoured to cover "his mother's disgrace with a thick mantle of equivocation."[4] Both camps conceded the existence of devastation caused by vandalism – indeed, it was impossible to deny it. The very term, "vandalism," was an invention of the Revolution. Disagreement bore on the extent of the damage and particularly on who was responsible for it.

Historical change, war and turmoil due to the counter-revolution – such were

the main explanations advanced by Republican historiography to account for the destruction. Aulard developed the hypothesis of Republican self-defence, placing war at the origin of the destructive process. This idea was taken up by Robinet, for whom the devastation was only "just retaliation for the impious war waged against France by the leaders of the Roman Catholic Church."[5] In their desire to secure a more precise attribution of responsibilities, Republican historians also sought to evaluate the magnitude of the destruction. This involved, on the one hand, tallying up the losses and, on the other, comparing them with those of other epochs. Vallet de Virville and H. Bordier denounced the prejudice that made the French Revolution responsible for the massive disappearance of historical documents.[6] According to Despois,[7] the extent of the losses had been clearly exaggerated and the value of the destroyed monuments overestimated. Besides, if the people had manhandled, burned, pummelled, pulled down and smashed without a second thought for the work of art, this was because they were incapable of distinguishing aesthetic merit from the meaning of the subject matter. But if this was ignorance, whose fault was it? Could the citizens of the Revolution be reproached for tolerating attacks on those same Gothic monuments that royalty had taught them to despise? Most importantly, vandalism was not restricted to the Revolution; in this matter, the Ancien Régime hardly set the example for the New! The lure of gain, an attitude that could scarcely be deemed revolutionary, had, along with politico-religious strife, played a key role in the destruction. In his attempt to gauge the real significance of these two factors during the Revolution, Benoît concluded that the avariciousness of the bandes noires had been more damaging than political passions.

In showing the limited and accidental character of vandalism between 1789 and 1799, and in finding royal or religious antecedents for it, Republican historiography was destined to encounter resistance from those for whom the Revolution was a systematic campaign of destruction. These historians, who were often Catholic, held the revolutionary leaders, particularly the Jacobins, responsible for an official, administrative form of vandalism. In his Crise de l'histoire révolutionnaire,[8] A. Cochin criticized the hypothesis of Republican self-defence advanced by Aulard. In the writings of Gautherot vandalism became a "plot," a "conspiracy" aimed at satisfying a "fierce hatred of Catholicism." For this systematic vandalism (vandalisme "d'appareil"), L. Courajod substituted popular vandalism. He considered it imperative that the revolutionary government not be confused with "this dark, occasionally reckless force that was the very soul of the Revolution and that impelled it to proscribe every vestige of the past."[9] The Revolution, experienced as a triumph of

the uncultivated masses, was condemned, while the Republic, as an administration, was absolved despite the failure of its protective measures. This distinction between the leaders and the led has vanished in the writings of Louis Réau, who simply contents himself with recalling the "revolutionary climate," in other words, "the atmosphere of envy and hatred" that explained so much ruin.

These two militant historiographies were less interested in analyzing the notion of vandalism than they were in condemning or exonerating the Revolution. Thus, while pursuing contrary objectives, they were in agreement with respect to the means used. The Revolution was on trial and each side gathered evidence to support its case. These conflicts masked ideological choices. E. Boutaric lamented: "We have broken with that ancient France which was the queen of the world, with the France of Saint Louis, Joan of Arc, and Louis XIV. Between it and ourselves we have dug a vast ditch which we have filled with blood and ruins."[10] "A church," said Victor Hugo ironically, "why it's fanaticism itself! One denounces a monument, massacres a pile of stones, slaughters ruins."[11] Yvan Christ spoke about that "convulsive hatred of the spiritual which often led the demolishers to tear down churches."[12] While the anathemas found so frequently in the historiography of vandalism obviously served political ends, their import was derived primarily by way of values that are, by definition, permanent, and that fundamentally unite or divide individuals. This explains why most studies of vandalism during the French Revolution are tempted to expand beyond their narrow time frame – 1789 to 1799 – to cover a longer period. For example, an introductory chapter of Gautherot's book explores the antecedents of Jacobin vandalism. In this chapter, Gautherot justifies Christian vandalism dating from the end of the Roman Empire while condemning the vandalism of the sixteenth century. (Luther is seen to be a precursor of Hébert.) Gautherot's closing chapter is devoted to contemporary vandalism – that is, the vandalism of the 1900s – and to Maurice Barrès' campaign to save crumbling churches.[13] Regardless of the general values underlying such struggles, the approach is always the same: history is unified by appealing to the transcendental – it matters little whether this be cultural, political or metaphysical as long as it provides history with an all encompassing subject of inquiry. Within this framework, one has only to retrace the efforts undertaken by vandals of every description – be they heretics or reactionaries – to prevent the triumph of history's "ultimate aims." This makes it easier to understand the Manichaean flavour of most literature on vandalism.

Still another direction may be discerned in the historiography of vandalism. During the romantic period in the nineteenth century, the renewed favour bestowed

upon Gothic art helped to popularize the idea that monuments deserved to be
protected and maintained in their original state. Between 1834 (when Guizot, the
Minister of Public Instruction, spearheaded the establishment of a historical
committee on arts and monuments) and 1887 (on May 30 of that year a law was
passed creating a commission on historical monuments that was to complete its work
in 1889), such notions of protection and respect gradually acquired institutional status.
Can this development be explained as a "monarchist" response (after 1815) to the
excesses of revolutionary vandalism? The answer is hardly so simple for, in the
attention devoted to monuments, ideological aims counted for less than the
monuments' sheer diversity. Far from judging artworks on the basis of their role in
society, one took a more modest interest in their individual fates. The study of means
replaced that of ends, and bibliography became (an archeological or museographic)
technique. Characteristic of this new view is the replacement of the term "vandalism"
(already a judgement and hence too pointed) by the more neutral and descriptive
word, "destruction." Unfortunately, this terminological sanitization was due not so
much to a new outlook as to an idealistic approach to art history that severed it from
its social context. Thus the coupling of vandalism and destruction, as it was handed
down from historiographic polemics, continued to be uncritically accepted. Analysis
was condemned to being simple morphological description.

Inadequate as a problematic, passionate in form and ideological in principle – by
all accounts the historiography of vandalism starts from the irreducible observation
that the destruction is scandalous and keeps coming back, as if fascinated, to this same
point. Its content is more commemorative than explanatory: through its narrative of
destruction it relives a drama and tries to have the reader do likewise. Putting itself in
the shoes of those who actually lived through the Revolution, such historiography
could only reproduce, in its specific manner and language, the Revolution's own
polemical discourse on vandalism. At this point, we will determine the shape the
latter took.

THE VANDAL CONSPIRACY

Under the Ancien Régime, art, as a "display of sovereignty" or "means of
enjoyment," was the very image of political power, the symbol of riches. Conversely,
it was also a sign of the people's exclusion from the same wealth and power. The
Revolution soon made this an untenable situation for all concerned, especially for the
common people. It became necessary to strip the aristocrats of "the last playthings of

their foolish pride." Compromised by their past – whether this was royal, aristocratic or religious – artworks were targeted for destruction and, when the time came, were indeed destroyed. France's revolutionary housecleaning dates from 1790. It began slowly but picked up its pace after the flight and subsequent downfall of the king. The patriotic ire of the summer of 1792 was frightening to behold. On August 14, a decree of the National Assembly stated that the sacred principles of liberty and equality would no longer suffer the people to be exposed to the sight of monuments raised to "pride," "prejudice," "tyranny" and "feudalism," and that, as a result, such monuments would be either "turned into gun barrels" or destroyed.

This policy was not without contradictions. In fact, as far as the Revolution was concerned, the establishment of a state founded upon equality was merely a precondition for a vast reorganization of the country's cultural heritage. Such reorganization relied on both protective measures and the promotion of existing cultural achievements. A national bibliographic index had to be set up, along with a National Museum to house the "innumerable treasures" locked away in monasteries and private residences. As well, public education was in need of development. In short, the monopoly of the privileged few over knowledge was to be broken, just as their hold on social and political power had been. Unfortunately, the destruction of artworks directly contradicted such projects. Far from fitting together, the social revolution and the revolution of the *lumières* got in each other's way. Politicians hesitated between two choices: either destroy all vestiges of Ancien Régime politics without worrying about artistic merit or preserve the nation's entire cultural legacy depite the latter's far-reaching and dishonourable involvement with the Ancien Régime. Opting for just one of these policies would have meant either the *lumières'* victory over liberty or the reverse; as it turned out, however, the Revolution proved either unwilling or unable to choose, and ended up trying to reconcile the irreconcilable. This gave rise to a steady stream of contradictory measures whereby protective clauses were appended to destructive decrees. The populace was urged to show the same degree of zeal in destroying proscribed signs as in preserving objects of interest to history, education and the arts. The Revolution set its own limits to the destruction it engendered. This policy, which illustrates the internal divisions in the Revolution, was also a way of covering up such conflicts. The destruction of artworks was presented not as the consequence of these conflicts but as simple deviations from revolutionary practice, due exclusively to "excesses" or "abuses" committed during the implementation of revolutionary measures – the National Convention's decrees had been distorted. Thus the destructive impulse was marginalized; its origin was to

be found not at the centre of the Revolution, that is, among the assembled body of national representatives, but somewhere on the periphery. The destruction in the provinces was said to be more rampant than in Paris, that is, at the base – among the executors – of the revolutionary system, instead of at the summit. What was required for the preservation of the country's cultural treasures was not a reexamination of the aims of revolutionary politics but simple technical measures.

The spread of the destruction threw this makeshift scheme into disarray. Those defenders of the arts who had been merely worried at the outbreak of the Revolution were seized by panic over the extent of the pillaging: "Must we break every frame containing a *fleur-de-lis*? Or draw grey or black swaths of paint over the works of Raphael, Poussin and Lebrun just because their immortal brushes have passed on images of kings or princes? Where will it all stop, considering that despots made their presence felt everywhere, and that the sole purpose of the arts was to provide them with new means of enjoyment?"[14] This disastrous situation resulted from a corrupt development of the Revolution which steered France, not toward the future, but toward the past and barbarism. This is the concern expressed by Grégoire when, addressing the Convention, he described a painting that showed Ignorance breaking statues and a barbarian armed with a flaming torch.

Barely tolerable, especially during a period of revolutionary crisis, the contradiction between *lumières* and equality was rationalized at the expense of great theoretical effort. Unspeakable because it was Republican, the destruction was characterized by those it aggravated first as barbarian and then as vandalistic, after the most barbaric of the barbarians. It could then be discussed, described and denounced without incurring any political risks. Vandalism served to qualify the many forms such destruction took: it wrought havoc by knocking down precious monuments, burning works of art, stealing and breaking medals, tearing down and ripping up engravings, threatening libraries and private galleries, and torching books. The multifaceted nature of the destruction made vandalism a dynamic phenomenon that spread and multiplied like the vocabulary used to designate it – one had vandalistic turmoil, vandalistic orgies of destruction, and so on.

The discourse on vandalism that arose between 1792 and 1794 was more than linguistic convenience or a practical smokescreen for discussion of the current destruction.[15] Above all, it represented an attempt to clear the Revolution of the terrible indictment of being responsible for this destruction. In such circumstances it was only natural that this discourse should try to sever the obvious link uniting destruction and revolution. Grégoire is quite clear on this point: "In the name of the

fatherland, let us preserve the masterpieces of art. The glory of the Convention, as well as the people, demand that our monuments and the horror they have engendered be passed on to posterity on behalf of the same people who would annihilate them."[16] In order for these statements to be credible, a new origin had to be found for the destruction. For if the Revolution preserved, who or what destroyed? Here again, let us hear what Grégoire has to say. His third report on vandalism outlines the causes of the destruction: first came ignorance, that universal scourge that was, of course, widespread not only in the provinces but also in Paris; next in order was the unconcern of the administrations or municipalities – not only did they not respect the regulations developed to protect artworks, but they sniggered when one spoke to them about preserving monuments; finally, Grégoire denounced the roguery of a host of individuals who were always ready to sell or misrepresent art objects as long as there was a few francs to be made! As for the "political" destruction carried out in the name of the struggle against "fanaticism," this was indicative of another form of fanaticism that was as much to be feared as its predecessor. Lurking behind such provisional reasons, vandalism lent them unity and made the destruction doubly frightening. For Grégoire, the destruction presupposed vandalism just as vandalism referred one inevitably to the destruction. This game of mirrors was not neutral, since vandalism constituted political action and purpose; it made no mystery of its goals, which were to "proclaim ignorance, proscribe the learned, banish genius, and paralyze thought,"[17] in other words, to destroy the *lumières* – note the broad application of the concept. But to destroy the *lumières* was to attack liberty, for it was the *lumières* who had made the Revolution! In fact, to attack the *lumières* was to favour the triumph of tyranny. Vandalism, as a project, constituted the exact reverse of the revolutionary project: the pair, *lumières*/liberty, was set term for term against that of ignorance/tyranny. The origin of this double opposition is quite remote, since vandalism becomes confused with the return of an odious past. Faced with a progressive Revolution, vandalism reversed the narrative of history. Its triumph would take France back to "the barbarism of the earth's infancy." Resonances between the past and present gradually brought the image of vandalism into sharper focus, so that it continued to gain in credibility. The Revolution's agents of destruction were the direct heirs of the historic barbarians – the Vandals, to be sure, but also the Goths, Visigoths, Ostrogoths, Saracens and Moslems. The exploits of the one were comparable with those of the other. As Grégoire put it to the Convention: "At Strasbourg in the eighteenth century they outdid the Alains and the Saracens."

Now that we have made our diagnosis, it remains for us to specify the pathology

of this veritable social malady constituted by vandalism. Counter-revolutionary by definition, situated on the margins of the Revolution, its workings could only be obscure and clandestine. It is true that vandalism often operated openly, as at Verdun where the municipal officials made a bonfire of paintings, books and tapestries,[18] and at Vitry-sur-Marne, where two administrators defaced, destroyed and smashed statues and paintings, in addition to damaging all the church ornaments.[19] At such moments, it seemed that vandalism could not be stopped. Yet actions such as the above were never actually carried out in its name. Instead, they masqueraded as excesses of patriotic zeal or exploited the ignorance of the masses. At Langeais, Citizen Deschamp, who was a member of the district Directory, defaced "a splendid, exquisitely crafted Christ."[20] Called before the Temporary Commission on the Arts, he explained that since "a number of citizens had complained about the continued existence of signs of superstition in a century of reason, I took it upon myself, on behalf of the administration, to get rid of such signs; for this purpose, I asked for a team of workers who betook themselves to the church where, after having cut through the stone around the iron supporting rod, they brought the Christ to the ground." Deschamp's sincerity is evident and not unlike that of the unfortunate Blaney-Laisné, the self-styled bibliographer of Gaillac who, after having converted an ancient Gothic antiphonary into index cards, met the reproaches of the Committee for Public Instruction with the following ingenuous declaration: "If this means that I acted in the spirit of vandalism, I must confess that I did so without being aware of it."[21] Vandalism "set traps for the loyalty of citizens" and "under the banner of patriotism, destroyed in order to put the Revolution on trial." (These expressions come from Grégoire.) Vandalism transposed the meaning of events and made the Revolution responsible for the destruction it engendered. These types of procedures, as well as their underlying aim, ensured vandalism a secure place in the conspiracy that a beleaguered France saw everywhere, especially in the betrayal of the king, the break with the Church, and in emigration. The Revolution owed it to itself to thwart this plot.

After the pathology, the treatment. Grégoire's analysis of vandalism leads quite naturally to remedies. The report he presented to the Convention on 14 Fructidor, Year II bore the suggestive title, "Rapport sur les destructions opérées par le vandalisme et sur les moyens de le réprimer." In his memoirs Grégoire boasts of having "created the word [vandalism] in order to kill the thing." The task that lay before him was considerable: "to separate the truly guilty from those who only appear to be so, having been led astray," or "to distinguish error from crime." It consisted in

drawing the boundaries of vandalism and, by doing so, delineating the symmetrically opposite borders of revolutionary France and clearing it of the charges of barbarism that had been brought against it. The indirect forms of action employed by the vandal conspiracy made this indispensable task very difficult. In order to create confusion, vandalism modeled its behaviour on that of the Revolution. It was more an instigation to destroy than a direct agent of destruction. This shift from the effect to the cause made the link between vandalism and destruction imperceptible on the material plane. Accused on the basis of its presumed intentions, vandalism had no discernible existence apart from the vandals themselves! Thwarting the vandalism plot meant revealing it to the public by means of spectacular denunciations.

There was thus no lack of conspirators. The "ferocious and shrewd Pitt," and even "the vile Catherine," worked the strings from abroad, but the enemy was first and foremost within. In 1794, Grégoire's various presentations to the Convention brought to light those responsible for the vandal conspiracy. In his report on the bibliography, submitted on 22 Germinal, Grégoire denounced the Royalists and counter-revolutionaries, alluding to the recently defeated followers of Hébert and Danton – yet he produced no names. On 14 Fructidor, after the fall of Robespierre, he resumed with more sweeping allegations and, this time around, furnished names. Manuel was planning to demolish the Porte Saint-Denis, while Hanriot, portrayed as a latterday "Omar," wanted to burn the Bibliothèque Nationale. Chaumette was out to destroy the rare animal specimens in the museum, Hébert was demeaning the language of liberty, and Lacroix would have all ranks open to illiterate soldiers. Dumas was going around saying that all men of wit should be guillotined and Robespierre, on the pretext of making the French into Spartans, was setting up a military dictatorship. Grégoire's allegations are striking in their sheer diversity, even in their futility, for the unity of vandalism was to be found more in the doer than the deed – for the public, it was the arrests of individuals that put a face on the vandal conspiracy. From being still somewhat vague in the spring of 1794, when successive denunciations targeted the Royalists and the followers of Hébert and Danton, the public face of vandalism was brought into sharper focus later in the summer. In his third report delivered in Frimaire, Year III, that is, at a time when the political situation had become clearer, Grégoire painted his definitive portrait of vandalism – culminating in Year II, that year of "terror and crime," it was one of the essential features of Robespierrism. This fortunate coincidence, aided by the expedient of anti-terrorist repression, would make it possible to reveal the extent of the vandal conspiracy. Did not Garrau, a member of the Convention, declare before his

colleagues: "I have seen charges of terrorism and vandalism drawn up against certain men"?[22]

The repression, insofar as it was concerned with the destruction of art objects, was orchestrated by Grégoire. It can be traced, at the local level, in the correspondence carried out for the duration of Year III between the Temporary Commission on the Arts and the various départements. Their exchange is dominated by one obsession: weed out the guilty parties. At Senlis, the worrisome silence maintained by the district and the national official seemed to portend appalling damages;[23] at Carpentras, an overly timorous artist-commissioner was curtly admonished and told that when administrators, "who should be born protectors of national property . . . look dry-eyed upon the disintegration and defacement of objects of science and art, a commissioner-artist is entitled to raise his voice, to unmask such barbarism."[24] At Sens, when informed of the extent of the destruction by Diélaine, the municipal librarian, the commission recalled that all friends of the arts, and especially all administrators, were bound by law to bring the vandals to justice.

Given the determination of the authorities and the extent of the destruction they recorded, the meagre results obtained – that is, the limited size of the vandal conspiracy – comes as a suprise. Even the most well-founded charges of vandalism failed. Take the case of the goldsmith Rondot, the above-mentioned national official of the Troyes Commune and a presiding member of the revolutionary committee.[25] Accused first by the local architect, Milouy, and subsequently by Grégoire, of having, with a number of accomplices, broken and melted down the treasures of the church of Saint Étienne, he was brought before the criminal court of his département and, despite a spirited self-defence, was incarcerated in the Aube house of detention. There he drafted a memoir with the intention of exculpating himself, and brought his case to the attention of the authorities in Paris. In Frimaire, Year III, he submitted a petition to the National Convention. Released from prison on the orders of the Committee for General Security, he made use of the opportunity to demand that all criminal proceedings against him be stayed. Rondot was not the only inhabitant of Troyes to be threatened; the entire former town council – like him, supporters of Robespierre – was compromised. The mandate of the Committee for General Security did not prevent the abandonment of legal action – if the committee released a few individuals, it had no intention of preventing justice from pursuing its necessary course against all those who had offended against it.[26] The efficacy of such networks of interest was not so much the mechanical translation of a balance of power between

two camps – those of the Republicans and vandals, the latter on the wane though still benefitting from numerous machinations – as a sign of the complexity of the ties binding destruction and the Revolution. In such circumstances, the mildness of the repression was not due to any failings of the Temporary Commission on the Arts – quite the opposite; it stemmed from a deliberate policy which made the pursuit of criminals of secondary importance and which was (need we say it) in total contradiction to the content of the discourse on vandalism.

Metz[27] provides us with another example. Jacquin, an itinerant member of the commission, was initially "saddened" to learn of the extent of the destruction. He subsequently issued a proclamation "inviting all good citizens to denounce the destroyers and wastrels." His goal, he said, was "not so much to discover the identities of the barbarians – I do not see the point of reviving hatreds that would be unprofitable for the public – as to urge the good citizens to provide information relating to the existence of monuments." The national official in the district spoke in a similar vein, saying that "one had to cast a veil over past destruction." This attitude is easily understandable; the denunciations did not draw a line between a France that destroys and a France that protects, but merely served to justify the triumph of one party over the other. In Metz, once again, the district tossed off decree after decree against the "instigators of the destruction," in this case the former departmental administration, now taxed with being "Robespierrist and an enemy of education." Indeed its behaviour prior to 9 Thermidor was, as Jacquin was obliged to remind it, far from irreproachable. "I denounce," he said, "those civil servants who are responsible for the waste, for discount and unlisted sales; I denounce the incompetence of [the] staff . . ."[28] At bottom the accusers were as culpable as the accused and, whether it was Metz or some other place, the entire Republican administration, no less than the supporters of Robespierre, was compromised by the destruction. The list of those implicated would include: municipalities that transformed churches into clubs or salpêtre workshops, leaving them "completely stripped and reduced to the bare walls"; the army which demanded money for the manufacture of cartridges or had the lead roofing of cathedrals removed so that it could be made into shot; and the National Convention whose contradictory legislation indirectly authorized a significant portion of the destruction. In such conditions, why rekindle passions, especially local passions? Thermidor could not and did not make the slightest change in this situation. Those it singled out as guilty fit the profile, not so much of a sociology of destruction as of a factional struggle; their camp was not that of the destroyers but of the vanquished! No sooner had the reins of

(national or local) power slipped from their hands than the supporters of Hébert, Danton and Robespierre, along with the Jacobins and even the Royalists, were classified as vandals – whether rightly or wrongly, it makes little difference. Riding the political tide, vandalism sailed from counter-revolution to the Revolution, and from Royalism to Robespierrism! Manipulated by power, or rather by the various powers that successively gained ascendancy, the hypothesis of a vandal conspiracy flubbed its entry into the sphere of the real and remained imperceptible outside of the declarations and arrest warrants issuing from those in power.

THE ISSUES: A CULTURAL DEBATE

Arbitrary as an explanation of events, the discourse on vandalism nevertheless took root in daily life by denouncing the all too real destruction taking place. According to the finders, either an erudite elite (made up of scholars, bibliographers, numismatists, archivists and antiquarians) or simply cultured individuals (art lovers, aesthetes and artists), things could not be clearer. On the one hand, there was the degradation of the nation's artistic heritage and the proliferation of destructive acts, while on the other there were attempts at protection or conservation. Thus the stakes were considerable – the artistic legacy of the Ancien Régime and two camps, those of the destroyers and defenders of art. Still, the analysis of the situation that we have seen taking shape is extremely inadequate as an account of what actually took place. If there was, at least on the material plane, indisputable opposition between the two camps (one protected while the other destroyed), in the realm of intentions things were far from clear. The indignation provoked by the destruction was felt only by the defenders of art since, across the road, their opponents had a clear conscience – after all, the destruction was not the result of a plot against the *lumières* but the indirect result of Republican efforts. A statement issued by the police department of the municipality of Paris reads as follows: "We are flooded with complaints which state that patriots are offended by the sight of monuments erected by despotism in the years of slavery, moments that obviously should not be left standing under the rule of liberty and equality."[29] The destruction was, therefore, more an expression of civic awareness and patriotism than the work of vandalism. When the National Assembly ordered the destruction of public monuments that brought despotism to mind, it did so under pressure from public opinion. And the Temporary Commission on the Arts was acting on a proposal from two sans-culottes when it decreed that all paintings and portraits representing descendants of Hugh Capet be catalogued, brought together in

one place and destroyed.[30] Although reworked, extended and systematized by the revolutionary assemblies, the destruction was, initially, largely spontaneous for, in the political climate of the day, it became a convenient means of affirming or reaffirming one's patriotism. Sergent takes note of this on a visit to the former royal residences at Saint-Cloud. "Every Sunday," he writes, "the beauty of the place draws a throng of citizens; it is essential that their gaze be no longer sullied by such images [the royal portraits]. Otherwise one runs the risk that some citizens, offended at the sight of anti-Republican images and thereby driven to tear them down and trample on them, might, in the process, damage other objects worthwhile keeping; indeed, we would find it highly regrettable should some superb Mignard suffer the effects of this patriotic wrath."[31] The destruction extended well beyond the domain of art; better still, it infiltrated the latter only by accident. The Republican project required the demolition of both the real facets and the symbols of power (whether royal, seigniorial or ecclesiastical) but did not concern itself with their artistic value. In the name of the antifeudal reaction it burned châteaux and estates and, on behalf of the struggle against fanaticism, destroyed churches, statues and tombstones. It pursued tyranny all the way down to its most modest emblems, its seals, flags and uniforms. In short, it misconstrued the specificity and the confines of the realm of culture, reducing the latter to signs of fealty or fanaticism and purging it in the same manner as the Ancien Régime. When all is said and done, it was more a form of iconoclasm than of vandalism.

As the revenge of a people on the values of a culture and power that had always excluded and, worse still, victimized it, iconoclasm ridiculed, disputed and destroyed, and occasionally even preserved, all in order to loathe more fiercely. Chaumette wanted to commemorate the Saint Bartholomew's Day Massacre by reinstalling the fleur-de-lis hand that his predecessor had pulled down from the clock on the Palais de Justice. (It had stopped, "as if miraculously, at the onset of the massacre."[32]) Whatever form it took, iconoclasm denoted the rejection of a certain hierarchy or subordinate relationship and stressed social differences all the better to repudiate them. This feature was brought out quite clearly by the political establishment in Paris. The Paris Commune, having decided to send the pope a copy of the minutes taken during the despoilment of the reliquary of Saint Geneviève, declared that the "rags" and "bones" found in this "box" would be burned on the Place de Grève in expiation for "the crime of having helped to propagate error and for maintaining so many loafers in a condition of luxury."[33] Shocked at seeing the revolutionary committees surrounded by the wainscoting of the despot at the Palais Royal, Chaumette wished to convert

the building into a hospital: "The contrast would have been exquisite and, for once at least, humanity would have triumphed over tyranny."[34] Political implications were never far in the background. The political establishment was well aware of the power that signs exerted over the people. So in 1793, a member of the Convention complained about the failure of certain individuals to carry out decrees concerning the destruction of the royal tombs at Saint-Denis. He said that it was monuments such as these that "shore up the superstitions people have about royalty."[35] Sébastien Mercier, who was more uncompromising, judged it imperative to strike at the popular mind by destroying Versailles. In the provinces, at the popular level, iconoclasm was expressed in a spontaneous and largely unwitting manner by symbolic gestures steeped in a long past made up of rancour and hatred. At Ligny, in Lorrain, the populace desecrated the sepulchre in the Maison de Luxembourg. "Five princes of the house were dragged from their lead coffins and had their bones scattered among those of all the other classes in the parish cemetery."[36] A striking way, this, of reestablishing social equality! Iconoclasm was often joyous and playful. The Pontoise Commune announced that it had "just paid its last respects to the remains of the emblems of aristocracy. Several cartloads of kings' insignia, queens' crowns, princely titles and other fodder for the bigotry of pride were delivered over to the flames amid gay songs and patriotic dances."[37] Certainly such ceremonies were sanctioned by the Republican administration – the texts that describe them emphasize their nationalist aims. The Pontoise Commune stipulated that gold and silver saints would be taken to the mint and "transmuted in the crucible of public usefulness." Still, nothing authorizes us to minimize the sensations of liberation and revelry made possible by the destruction. The true beginnings of an authentic revolutionary and popular language, iconoclasm flourished in the space opened up by the political and social struggle within the value system of elitist culture. Iconoclasm was, then, anything but a vandal conspiracy; in other words, it was not the simple negation of the above-mentioned values and did not, barring gross oversimplification, permit entrenchment behind the Manichean opposition of protectors versus destroyers. Then what explains the elaborate discourse on vandalism?

Shortsightedness? Hardly, for then how does one account for the immediate success of this discourse during the Revolution and its unrestrained reutilization by historiography? Furthermore, those who were given the daily task of flushing out the conspirators had serious doubts about the existence of a conspiracy. Was this, then, deliberate shortsightedness on their part? Faced with the reality of Republican destruction, the vandal conspiracy made it possible to maintain the fiction of an

ideology, that of the *lumières*; it was a bourgeois reading of revolutionary events (for the *lumières* were not neutral). Would one be better off looking for a deliberate strategy? Vandalism was not innocent; it superimposed the concept of destruction over the notion of vandalism – the latter defined in a purely negative fashion. To speak of vandalism was to deliberately overlook the fact that the destructive act is simply the negative aspect of a positive impetus: one destroys with reference to an (opposing) ideology, for monetary reasons or even out of indifference, which still represents a choice. It was to believe that a social revolution can only have a negative impact on cultural values, to implicitly adopt the viewpoint of the ruling classes preoccupied with measuring the extent of the pillaging! What does the denunciation of vandalistic destruction signify, if not the assumed existence of the precious and a determination to destroy it, if not the definition of a domain and the attempt to have it respected? At a time when art that had been compromised by its past had become an issue in the political struggle, the discourse on vandalism already signified resumption of control over the realm of the arts or, if you will, the end of popular initiatives in this sector. It also meant sealing off – by masking reality and reducing the destroyers to silence (at least at the conceptual level) – the space that had been opened up within the value system of elitist culture. On this level, the discourse directed against vandalism did not constitute a refuge outside reality for those left behind by political developments but a powerful means of action designed to alter the course of events. This presumably explains the overnight success of this "invention" during the Revolution, as well as its later uncritical adoption by historiography that, whether it was Republican or Royalist, was equally "elitist" in cultural matters. A deliberate strategy, therefore, at least for some, and most likely for the majority of the defenders of the arts, a confused awareness of the notion's strategic importance.

The details of this resumption of control are quite complex. Faced with popular initiatives that obscured the status of the art object, protecting the cultural heritage primarily meant attempting to disassociate it from other vestiges of the Ancien Régime, restoring it to its privileged status and expunging quotidian political qualities from it – in short, redefining it. This was no mean task, especially at a time when patriotic reaction did not trouble itself with fine points. Still, the defenders of the arts buckled down to it. First they specified the content of the art object, beginning with such "technical" criteria as the rarity of the work, the value of the precious metals used, and the quality of execution, and proceeding to the more delicate matter of "ideological" content – more delicate because it was mainly this that provoked attacks and because one could not, under pain of failure, directly oppose the iconoclastic

reflex of the people. A middle road was adopted: given that artworks have always been "draped in the livery of despotism," that is, devoted exclusively to serving the privileged, artists and their spokespersons strongly reaffirmed the specificity and inestimable value of the common cultural heritage, as well as its independence from the society in which and for which it was created. They claimed that art tempers moral severity, touches the heart, uplifts the soul and enlightens the mind. There could not be any true harmony between popular iconoclasm and this scholarly discourse which revived the ideology of the Enlightenment. This point is clearly illustrated by the history of the Popular Commune on the Arts, how it was torn between the temptations of the academy and those of the popular club. Members advocating the abolishment of signs of fealty were met with demands that such signs be preserved as "historical monuments," while the claim that patriotism should take precedence over the arts resulted in attempts to exclude non-artists from the membership.[38] On the one hand, the political content embedded in the precious made the latter totally unsalvageable; on the other, everything precious, regardless of its political perniciousness, was worthy of being saved – it was a question of one's viewpoint or, more particularly, of one's power base. It remained for this scholarly discourse to be inserted into the actual course of events.

This required principles of conservation and institutions capable of applying them, all of which had already been provided for by the National Assembly when, at the start of the Revolution, it moved to ensure the proper management of national treasures by framing regulations governing the cataloguing, sale and protection of such possessions, and by creating bodies capable of implementing these regulations. Made up of specialists such as scholars and bibliographers, commissions such as the Commission on Monuments and the Temporary Commission on the Arts[39] were able to designate the objects to be collected, as well as the proper means of preventing their deterioration. The passionate denunciation of vandalistic destruction made most of the populace aware of the existence of an artistic sector with its rules and partisans. It thwarted the iconoclast offensive by imposing limits on the destruction. Certainly, such limits represented not so much agreement on what should be preserved at all costs, as a shaky compromise that reflected the prevailing balance of power; but this compromise, in requiring the presence of protectors, worked in the latter's favour. The task of drawing a line, even a provisional line, between the precious and the political could only be accomplished by specialists familiar with both domains, and thus naturally excluded all popular initiative. Having arrested patriotic incursions into the arts, the discourse on vandalism prepared the way for the counter-offensive.

Political strife had forced the development of destructive legislation. Critics complained that its application was placed in the hands of "obtuse and avaricious" men who went around "hatchet in hand"[40] destroying and threatening the existence of "the finest monuments of French genius." In order to stop such pillaging, the number of destructive decrees was limited in the name of the fight against vandalism. The Convention decided that public monuments bearing proscribed signs that could not be removed without damage to the monuments would be transported inside museums.[41] A clever move, this, since the politically and socially neutral framework of the museum forced technical or artistic readings of the artwork upon visitors, thereby cancelling out whatever subversive value it may have derived from its feudal origin or end. In this way, the Convention got patriots to agree to close their eyes to the traces of feudalism tarnishing their cultural treasures, to think only in terms of the great educational opportunities such treasures would provide for artists and, inevitably, for the people. The Convention managed to create a place where – notwithstanding the popular success enjoyed by the Louvre from the first day it opened[42] – art objects were for artists' eyes only. All this, of course, presupposed the threat of destruction; there was, however, another option – disguise, or make-up. On the Porte Saint-Martin in Paris, "the figure represented by the emblem of Hercules crowned by Fame would no longer stand for the despot and would cease to be shocking once the great periwig identifying him was replaced by the kind of short, naturally curly hair seen on the Farnese Hercules."[43] This policy, spun on the wheels of the state, succeeded in eliminating popular initiatives in the arts. Specialists took the place of patriots in France's revolutionary purge; iconoclastic celebration gave way to museums, popular clubs to academies, and the destruction of artworks originating abroad or in the provinces was supplanted by their transfer to Paris. According to the Institute, a new period was beginning, for could "the term 'vandals' really be applied to those who make the transfer of antique statuary a point of principle, or . . . who receive, as allowances, masterpieces worth many millions and equivalent in value to entire provinces?"[44]

A shrewd ideological mold, vandalism helped to create a new distribution of power in the cultural domain. In such conditions, the concordance between political chronology and the chronology of the discourse on vandalism comes as no surprise. The major split remains that of 9 Thermidor – in other words, the date of the definitive rupture between the popular movement and the bourgeoisie. After 1795, the term "vandalism" lost some of its currency since, from then on, it had only a retrospective function, pointing to a historical period that had already elapsed. Of

course the Royalists would, under the Directory, make a concerted effort to restore the balance of power in their favour by criticizing the museum, that centrepiece in the appropriation of the cultural heritage for the new Republican bourgeoisie. For the Royalists, museums were "indecent," "absurd storehouses" that signified "the end of art" and "the work of vandalism, which will bring everlasting disgrace on the revolutionaries." This reutilization of the notion of vandalism, while it thoroughly appropriated the use made of the term by the cultural elite before 9 Thermidor, was merely a rearguard action with limited stakes – almost, indeed, a personal conflict between the sculptor, Deseine, and A. Lenoir, founder of the Musée des monuments français.[45]

The discrepancies between the chronology of vandalism and that of the destruction also fail to surprise us. Concerning the latter, 9 Thermidor was not a real rupture, and the destruction did not abate under the Directory – quite the contrary! But the danger had shifted; the destruction was no longer caused by intemperate iconoclasm but by "the rapaciousness of businessmen, by voracious speculators for whom the finest monuments are no more than pieces of iron, stone and lead to be torn down and sold, and for whom one thing is as good as the next as long as it can be disassembled and traded."[46] Little was said about such destruction, although it was actually quite extensive. It merely stemmed from decisions of an administrative or technical order – not from ideological or political struggles – because it did not call the hierarchy of social or cultural values into question.

The discourse on vandalism, as articulated by the French Revolution, was nothing but the ideological countenance of a process of political exclusion. The triumph of the vision borne by the socially and politically victorious bourgeoisie demanded a muddled version of events. It was necessary to confuse the ignorance of the popular classes with foreign plots, and terrorist destruction with Republican administrative negligence. All losers in the political struggle, whether or not they had ever worked in the arts, had to be relegated to the murky sphere of vandalism. The study of vandalism, carried out using the very categories it itself favoured (on the one hand, barbarism, ignorance, vandalism and, on the other, education, the *lumières*) reveals the forces that presided over the formation of a new cultural order. It is the same order that prevailed in France in the nineteenth century, and even into the twentieth. Such a study sheds light on one of the most intriguing aspects of the upheavals of the French Revolution.

Translated from French by Don McGrath

NOTES

1  Louis Réau, *Histoire du vandalisme: Les Monuments détruits de l'art français*, 2 vols. (Paris: Hachette, 1959).

2  Alphonse Aulard, "Boniments contre-révolutionnaires," *La Révolution française* (n.p., 1912).

3  F. Benoît, *L'Art français sous la Révolution et l'Empire: Les doctrines, les idées, les genres* (Paris: L.H., 1897).

4  Gustave Gautherot, *Le Vandalisme jacobin: Destructions administratives, d'archives, d'objets d'art, de monuments religieux à l'époque révolutionnaire d'après les documents originaux en grande partie inédits* (Paris, 1914).

5  P. Robinet, *Le Mouvement religieux à Paris pendant la Révolution*, 2 vols. (Paris, 1894–1898). Work published under the auspices of the Municipal Council of Paris.

6  Vallet de Virville, in the *Moniteur universel* (4 October 1854). H. Bordier, *Les Archives de France, ou l'histoire des archives de l'Empire, les archives des ministères, des départements, des communes, des greffes, des notaires, etc. contenant l'inventaire d'une partie de ces dépôts* (Paris: Dumoulin, 1855).

7  E. Despois, *Le Vandalisme révolutionnaire: Fondations littéraires, scientifiques et artistiques de la Convention* (Paris: G. Baillière, 1848).

8  A. Cochin, *La Crise de l'histoire révolutionnaire: Taine et M. Aulard* (Paris: H. Champion, 1909).

9  In *Alexandre Lenoir, son journal et le musée des monuments français*, vol. 1 (Paris, 1878–1887), xxii.

10  E. Boutaric, "Le Vandalisme révolutionnaire," *Revue des questions historiques*, vol. 12 (1872), 325–396.

11  Victor Hugo, "Guerre aux démolisseurs," *Revue des deux mondes* (March 1832). For a response to this article, see Montlambert, "Du vandalisme en France: Lettre à M. Victor Hugo," *Revue des deux mondes* (March 1833). On the important role that Hugo played in saving monuments, see J. Mallion, *Victor Hugo et l'art architectural* (Grenoble, 1962).

12  Yvan Christ, *Églises parisiennes actuelles et disparues* (Paris, 1947), 9.

13  As the word "vandalism" already constitutes an old historical reference in itself, it invites one to go beyond a brief chronology.

14  A.A. Renouard, Chardin and Charlemagne Junior, *Observations de quelques patriotes sur la nécessité de conserver les monuments de la littérature et des arts* (25 Vendémiaire, Year II), 10.

15  The discourse on vandalism is contained, of course, in Grégoire's various reports, particularly in the three he drafted for the Convention's Committee for Public Instruction: *Instruction publique: Rapport sur les destructions opérées par le vandalisme et sur les moyens de les réprimer*, (14 Fructidor, Year II, followed by the decree of the National Convention); *Instruction publique: Second rapport sur le vandalisme*, (8 Brumaire, Year III, followed by the decree of the National Convention); *Instruction publique: Troisième rapport sur le vandalisme*, (24 Frimaire, Year III). To these may be added two other reports presented by Grégoire at an earlier date. The first is the report on the bibliography, read before the National Convention on 22 Germinal, Year II. This served as a basis for the report of 14 Fructidor. The second report, tabled on 22 Nivôse, Year II, deals with inscriptions on public monuments. This contains the first instance of Grégoire's use of the word "vandalism." On the origins of Grégoire's reports, see J. Guillaume, "Grégoire et le vandalisme," *Études révolutionnaires*, 1st ser., 12–33; "Le vandalisme de Chaumette," *Études révolutionnaires*, 2nd ser., 348–424. Grégoire's reports are not the work of an isolated individual

or precursor. The initiative of taking protective measures cannot be attributed to him. The decree issued by the Convention following the presentation of his report of 14 Fructidor is in no way as detailed as the decree issued on 3 Brumaire, Year II, following the report of Romme. See the *Procès-verbaux du Comité d'instruction publique de la Convention nationale*, vol. 2, 659. This decree already contained all practical measures required to safeguard books, manuscripts, engravings, art objects, etcetera. Romme's highly interesting report vigorously condemns the destruction. On the term "vandalism" itself, see Max Frey, *Les Transformations du vocabulaire français à l'époque de la Révolution* (Paris: Presses Universitaires de France, 1925) and F. Brunot, *La Révolution et l'Empire*, vol. 9 of *Histoire de la langue française*.

16  Grégoire, *Troisième rapport sur le vandalisme*, 16.

17  Barère, *Rapport fait au comité de salut publique sur l'état de la fabrication révolutionnaire du salpêtre et de la poudre et sur la nécessité de supprimer l'agence nationale ci-devant régie des poudres et salpêtres* (26 Messidor, Year II), 5.

18  A.N. F17 (13 Frimaire, Year III, Verdun Meuse). Also see Grégoire, *Troisième rapport sur le vandalisme*, 9.

19  *Lettre du directoire de la Commission temporaire des arts à l'administration de Vitry-sur-Marne* (17 Pluviôse, Year III), A.N. F17, 1255a.

20  *Minutes de la correspondance de la Commission temporaire des arts, aux administrations des départements et des districts.* In his defence, Citizen Deschamps describes this Christ as a "poorly carved wooden figure without any artistic merit," A.N. F17a, 1255–1256.

21  Response of Blaney-Laisné, bibliographer of Gaillac (Tarn), to the charges of vandalism brought against him by the Committee for Public Instruction. Quoted in P. Riberette, *Les Bibliothèques françaises pendant la Révolution 1789–1795* (Paris, 1970), 83–84.

22  *Procès-verbaux du Comité d'instruction publique*, vol. 6 (Session of 14 Vendémiaire, Year IV), 749. This convergence between vandalism and Robespierrism can easily be followed in the dictionaries that, from the end of the Revolution, traced the transformations in vocabulary. Under the entry for "vandalism" found in *Le Néologiste français* (anonymous, 1796, B.N. X14335), we find: "[T]his was the term used to describe conditions in France under Robespierre."

23  *Lettre du directoire de la Commission temporaire des arts à l'administration de Senlis* (12 Nivôse, Year III), A.N. F17, 1255.

24  *Lettre du directoire de la Commission temporaire des arts au commissaire artiste du district de Carpentras (Var)* (27 Fructidor, Year III), A.N. F17, 1255.

25  On Troyes, see A. Babeau, *Histoire de Troyes pendant la Révolution*, 2 vol. (Paris: Dumoulin, 1873–1874), especially vol. 2, chap. 32; A. Prévost, *Histoire du diocèse de Troyes pendant la Révolution*, 3 vols. (Troyes, 1904); A.N. F17, 1037; and the *Procès-verbaux de la Commission temporaire des arts*.

26  Réponse du Comité de sureté générale à la lettre du représentant en mission Albert (23 May 1795).

27  *Rapport de Jacquin à la Commission temporaire des arts à propos de la situation à Metz* (Year III), A.N. F17, 1253.

28  Ibid. Jacquin drew up a list of fourteen charges against the district!

29  *Administration du département de police de la municipalité de Paris*, A.N. M, 666 (Dossier S).

30  See the deliberations of the Temporary Commission on the Arts for 25 Prairial, Year II (*Procès-verbaux: Commission temporaire des arts*, vol. 1, 225–226). A report from Versailles by members Picault and Varon dealt with a portrait of Hugh Capet Junior, from Saint-Cloud. "They proposed, and the Commission

decreed, that all paintings and portraits representing individuals of the Capet lineage would be catalogued and brought together in one place, and that, in accordance with this inventory, they would be completely and utterly destroyed, so that Royalist superstition should no longer find any adherents." This decree was passed on to the Committee for Public Instruction (*Procès-verbaux du Comité d'instruction publique*, C.N., vol. 4, 654) despite the observations of one of the Commission members who said that "a number of these paintings and portraits may contain traces of genius and originality that one would do well to preserve for education and the arts." The decree was easily passed at the Committee hearing, which Grégoire attended.

31  A letter postmarked Rambouillet, dated 3 August 1793, sent by Sergent to the National Convention, A.N. F17a, 1035, Sheaf B.

32  Reprint from the original *Moniteur*, vol. 18 (Vendémiaire, Year II), 170.

33  Ibid. (1 Frimaire, Year II).

34  *Les Révolutions de Paris* 211 (20 July – 3 August, 1793).

35  *Procès-verbaux: Convention nationale*, vol. 20, 134.

36  Philippe Baert, *Mémoire au sujet de la destruction des tombeaux de quelques rois et reines de France qui existaient dans l'abbaye de Saint-Germain-des-Prés à Paris en 1791* (7 May 1791), A.N. F17, 1036a.

37  Reprint from the original *Moniteur*, vol. 18, 209.

38  *Procès-verbaux de la commune générale des arts de peinture, sculpture, architecture et gravure – 18 juillet 1793, tridi de la 1re décade au deuxième mois de l'an II – et de la société populaire et républicaine des arts* (3 Nivôse, Year II, 28 Floréal, Year III) (Paris: H. Lapauze, 1903).

39  L. Tuetey, *Procès-verbaux de la Commission des monuments*, 2 vols. (Paris, 1901–1902); *Procès-verbaux de la Commission temporaire des arts*, 2 vols. (Paris, 1912); *Organisation et fonctionnement du conseil de conservation des objets de sciences et d'art* (Years VI–VIII), A.N. F17, 1034, File 11.

40  *Lettre du ministre de l'intérieur du 15 pluviôse an II à propos de l'éxecution de la loi du 4 juillet 1793*, A.N. F13, 212.

41  In section 2 of a decree of the National Convention, dated 3 Brumaire, Year II and issued in response to the Romme report, we read: "Les monuments publics transportables, intéressant les arts et l'histoire, qui portent quelques-uns des signes proscrits, que l'on ne pourrait faire disparaître sans causer un dommage réel, seront transporté dans le musée le plus voisin pour y être conservés pour l'instruction nationale."

42  The "Musée national" was opened on 10 August 1793 and enjoyed a measure of popular success. In the *Décade philosophique* 4:28 (10 Pluviôse, Year III), we read: "The museum is open to the public for only the last three days of the decade. On the other days admission is restricted to artists, who go there to paint or draw. We have been greatly taken by the sight of the people flocking to its doors; they observe everything with avid curiosity, ask for explanations, and alternately admire or condemn, in the process often showing sound judgement. The museum will soon be the most frequented of all promenades," 215.

43  *Lettre de l'architecte de la municipalité Poyet du 15 mai 1793*, A.N. M666, File 9.

44  *Andrieux report on the arrival of objects from Italy during Literature and Fine Arts Class at the Institut national des sciences et arts* (4 Brumaire, Year VI, Session 7), This marks a return to practices that were common under the Ancien Régime.

45  Deseine, *Opinion sur les musées où se trouvent retenus tous les objets d'art qui sont la propriété des temples consacrés de la religion catholique* (Paris: Beaudoin, Floréal Year XI). This is not the only report on the statuary formerly belonging to the Prince de Condé. (See also M. Tourneux, *Bibliographie de l'histoire de Paris pendant la Révolution française*, vol. 3: 16299–16301 (Paris, 1890–1913). These reports were drafted during the quarrel provoked by the petition that followed the publication of Quatremère de Quincy's *Lettres sur le préjudice qu'occasionnerait à la science le déplacement des monuments de l'art en Italie*. The initial response to this document came in the form of a letter that appeared in the *Moniteur* of 12 Vendémiaire, Year V. Under the Consulate, Deseine vigorously opposed A. Lenoir, founder of the Musée des monuments français.

46  Chagrin's report to the Conseil des bâtiments, which pertained to monuments decorating the premises of the Paris Commune, as well as to those intended to be used in religious services (16 Germinal, Year V) Ministère de l'Intérieur, A.N. F17, 1772. Here we have the whole problem of the "bande noire."

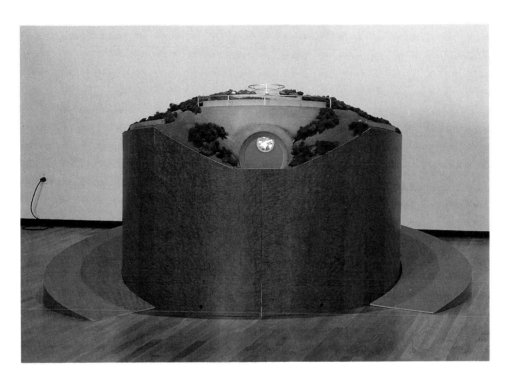

Jeff Wall and Dan Graham *The Model for the Children's Pavilion* (1989–1992)

# A GUIDE TO THE CHILDREN'S PAVILION
# A COLLABORATIVE PROJECT

jeff waLL aNd daN ɡRaHam

The *Children's Pavilion* is a public building located at the periphery of a playground. It is built into, and enclosed by, a landscaped hill. The structural shell of the hill-form is engineered in concrete. It includes a network of stairways, leading to a walkway around the summit. Large areas of the exterior surface are planed with lawn.

The structure is entered through a portal in the form of a three-quarter circle. The interior floor, made of concrete, is composed of three descending concentric rings with a system of steps leading from level to level. The central circle is a water basin.

The interior walls form a drum, which supports a low dome, at the apex of which is an oculus. In the oculus is installed a one-quarter sphere of two-way mirror glass, its convex surface facing the interior. Visitors inside the pavilion can look out through the oculus, and those on the walkway at the summit can look into the building. Both groups also see their own reflections on the partly-mirrored glass.

The diameter of the water basin is the same as that of the portraits. The diameter of the quarter-sphere in the oculus is twice that of the portraits.

## ARCHITECTURAL TYPOLOGY

Playgrounds are the special domain of children, but the children who inhabit them are usually attended and observed by adults – parents or guardians. Playgrounds are therefore also for adults, who are given the opportunity to witness their children's experience of childhood. In this setting, however, the children behave less as members of individuated nuclear families than as part of a horde of youngsters who mingle there in commotion.

The playground customarily features one or more symbolic mountain or hill forms. These are archetypes of complex experiences because they permit penetration underground through various openings, a primal exploration of the earth and, at the same time, an occasion for ascent and conquest, for the attainment of a privileged overview as "king of the mountain." In this process, one child becomes a big-shot by gaining the special place at the summit. At the same time, others are burrowing below, lurking in dark hiding places, and springing back into the light. These might then go up to the top, while the one on top tumbles or races back

down, girls and boys chasing each other, round and round.

The inside of the hill is of course like a cave or a grotto. Grottos are usually watery, and are associated with lunar goddesses, nymphs, prophecy, birth and a passage through subterranean realms to rebirth. It suggests also the invisible, but often audible, flowing of water inside the earth and the sudden, surprising appearances of springs.

Both grottos and the damp but less watery caves are sites of primeval image-making. Prehistoric adults took shelter in caves from animals and there created icons and pictures celebrating both their fear of these animals and their triumph over them in the organized hunt. The totemic image is a powerful element in tribal self-identification as well as a symbol of the maturation of the hunter. The skill in depicting the animal is a mark of maturity and mastery, and parallels the skill in hunting it: these skills are those of the provider, the magician, the leader.

Another aspect of this typology is provided by the observatory and the planetarium. Both derive from other things, structures like Stonehenge, for example, which was apparently used by the Druids for sighting positions of the planets. But they establish their generic identity in the modern, scientific epoch, the period of rationalism and world navigation. The planetarium belongs specifically to the era of democratically inspired dissemination and production of knowledge, in which the study of the heavens was made available to all citizens, not just an esoteric caste, like the Egyptian priests who controlled the ancient calendars.

The observatory is a structure devoted to optical study of the sky. It has no interest in studying the earth and never looks at it. It is most curious about the furthest reaches of the visible universe. It treats the earth only as an Archimedean point from which it can calculate how far it can see. It does this by means of curvatures of glass or other materials which focus energy, whether in the form of light, radio signals or other things. It is a photographic or cinematographic apparatus, a solar eye. It scans the universe for signs of other life forms and for data necessary for developing cosmological theories.

The planetarium is, on the other hand, a cinema. It reproduces, stages and projects cosmological narratives as entertainment and education. The darkened dome of the planetarium evokes the primitive world when early man first contemplated the stars and attributed totemic power to constellations, for example, "The Great Bear." The modern totemism of the planetarium is, however, attached to telescopic power and cinematographic projection itself.

The spherical form of the planetarium is reiterated elsewhere. In recent World's Fairs, for example, spherical structures present the cosmos and our earth as one world. These are emblems of a promised future, to be achieved through scientific progress, which would unite us into one global community, one "family of man." The mirror-clad *La Géode*, in Parc de la Villette in Paris, is the most recent and striking example.

The final element to be noted is something which is not, strictly speaking, architectural. This is the space capsule or flying saucer, which is round, cylindrical, disc-like, spherical or hemispherical. These are mostly seen in films, often films aimed at children, but are also featured as rides at amusement parks and science museums (which often resemble

each other). The spaceship promises an adventure, a journey to other worlds, a voyage into a hypothetical future. It is often a toy played with in the process of constructing adventure narratives of this kind, adventures in which past and future are intermingled, in which archaic forms appear futuristic and futuristic forms can be ruins.

PHOTOGRAPHS OF CHILDREN

The group of nine rondels or tondi includes portraits of children of different racial and ethnic backgrounds. The organization of the portrait group is related to the concept of the nation state and of its gathering of all its children into systems of universal public education, health, recreation, culture and citizenship. The concept of the nation includes in its substance the outcome of the great immigration patterns of modernity in which a variety of peoples with different customs have confronted each other within the terms of a common body of law. The group of children can signify the nation and, specifically, the nation's future, in a Pantheon-like assembly.

At the same time, the group's multiracial composition implies the plurality of nations and therefore forms an image of world culture. One classic manifestation of this idea is the photographic exhibition and book, *The Family of Man*, organized by Edward Steichen in 1955. In his 1981 essay, "The Traffic in Photographs," Alan Sekula wrote, "*The Family of Man* moves from the celebration of patriarchal authority – which finds its highest embodiment in the United Nations – to the final construction of an imaginary utopia that resembles nothing so much as a protracted state of infantile, pre-Oedipal bliss."

The universal-national children of the portraits appear in circular frames. The tondo form is associated with ceremonial and decorative portraits and figure-groups often featuring women, children and angels, but it is also related to coins, on which the heads of rulers are minted.

The circular form also relates to the sphere and therefore to the symbol of the cosmos but also to a rubber ball flying through the air above a playground. Balls, bubbles, lollipops and other round, shiny, happy forms are parts of the world of toys – roller skates, Frisbees and the like – which are vehicles in adventure fantasies.

Each of the children is viewed against a background of the sky. Each sky is unique representing different times of day, different weather conditions, different seasons. The individuation of the children is expressed in the unique relation to the cosmos signified by the association of one specific child with one moment in time. Each child has unique place, a special trajectory into the future, signified in part by the mood of the sky.

The celestial void is the home of angels or putti, infant beings without family, who emanate directly from God in infinite numbers at every second of endless time. They exist briefly, before vanishing again.

OCULUS AND SPECTATOR

The oculus, as its name suggests, functions as the eye of the pavilion. The whole interior is gathered and reflected on the convex surface of the quarter-sphere of mirror glass. At the same time the transparent character of the glass allows the spectators inside the building to see the actual sky outside, and to see as well anyone looking in from the vantage point at the top of the mountain. Similarly, those

outside can view the interior. Furthermore, distorted reflections of the people looking down through the oculus from the outside, which are created by the concave form of the quarter-sphere's outer surface, may also be visible from inside and outside. The entire play of gazes and reflections generated by the architecture and the photographs is condensed onto the outer and inner surfaces of the glass.

Another typological element for the *Children's Pavilion* is the Pantheon, which is a public temple and mausoleum, dedicated to the memory of gods and heros, to patriarchs and to the state. The great Pantheon in Rome features an open oculus which permits a focused beam of direct sunlight to move around the interior in the course of the day. Depending on seasonal conditions, the light from the oculus sweeps across an arc which may coincide with particular features of the interior, such as the tome of Raphael, giving it a natural spotlight. The Pantheon has had an immense influence on the forms of modern state temples, notably Les Invalides in Paris and the United States Capitol building in Washington.

Follies and pavilions in landscaped gardens have a direct relationship with the *Children's Pavilion*, as the name indicates. These structures often replicate, on a reduced scale, ancient monuments with literary or mythological references, such as the tombs of Abelard and Heloise, which are found in English gardens in France. Patriotic and heroic memorials, as well as shelters for retreat and meditation, are also included in this type. These pavilions are places which combine the provision of temporary shelter with an inducement to participate in specific acts of memory, contemplation and philosophical speculation. They are related to the process of creating literary and philosophical works, which may take as their subjects the nature of the environment in which the pavilion is itself sited. They often suggest utopian alternatives to present civilization.

The optical dynamics are connected with the pavilion's relationship to observatories and planetaria, forms dedicated to intensive searching, gazing and observation. Science and fatherhood are implied here, and this implication is augmented by the structure's references to national temples. At the same time, the oculus is set into the form of a hill or mountain, which suggests a more maternal enclosure, a cave or grotto, but one which includes an optical ordering principle. Thus, traditional symbols of both parents are present in the architecture and organize the forms of interaction between adults and children in and around the building. All users of the *Children's Pavilion*, children, parents, and other adults, can be observers of the behaviour of others from a variety of positions. And all can be contemplated in comparison with the giant transparencies of children.

For safety, the exterior of the oculus at the summit is provided with a protective railing.

next page: Jeff Wall *Little Children (I-IX)* 1988 installation site outside the gallery

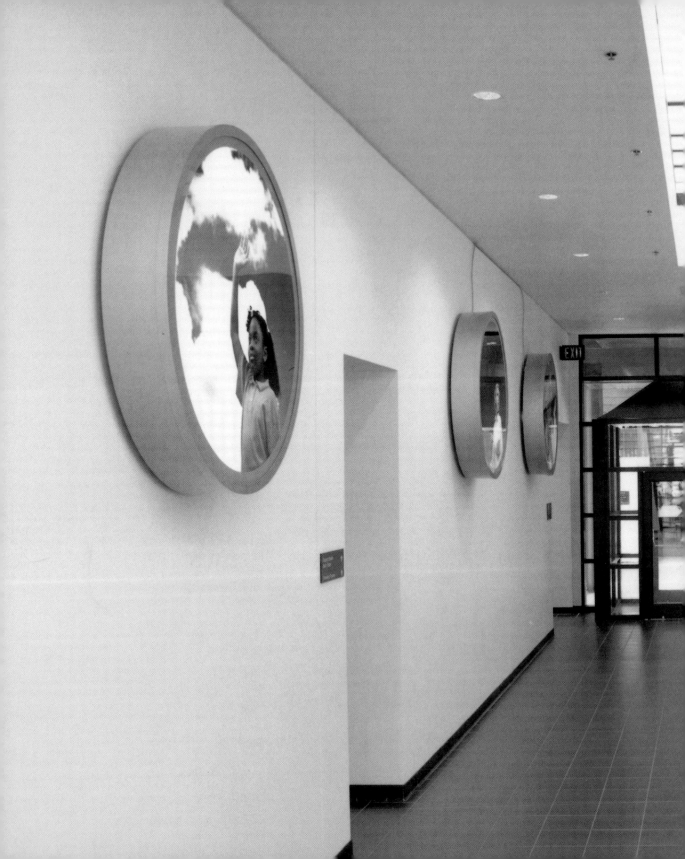

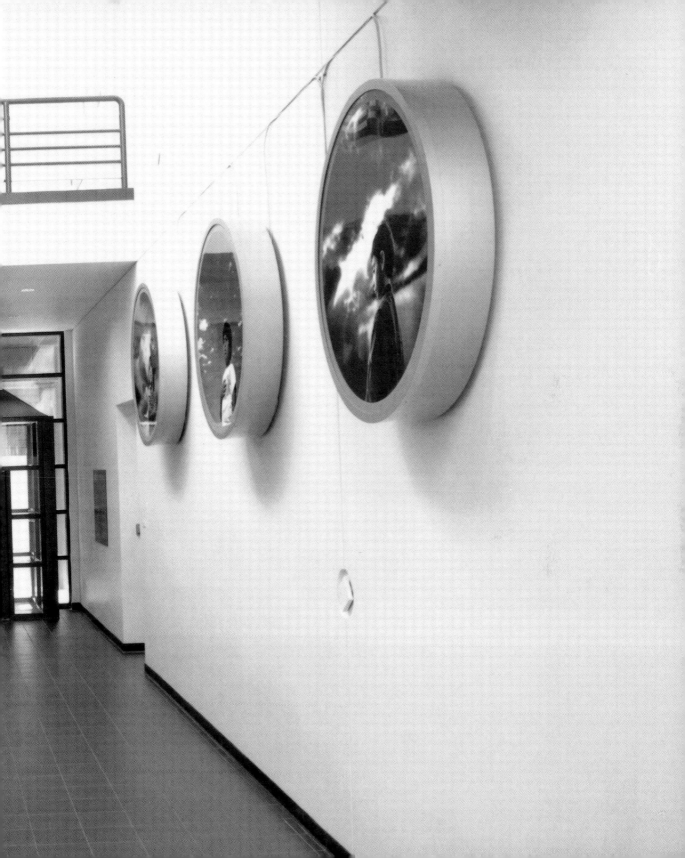

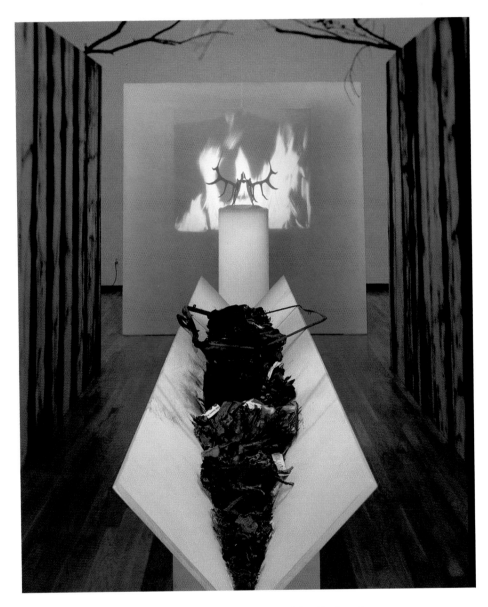

Rodolfo Machado and Jorge Silvetti *Banffire* (1992)
proposal for TransCanada PipeLines Pavilion public art commission

Marik Boudreau with Martha Fleming & Lyne Lapointe *Attention* (1992) installation view

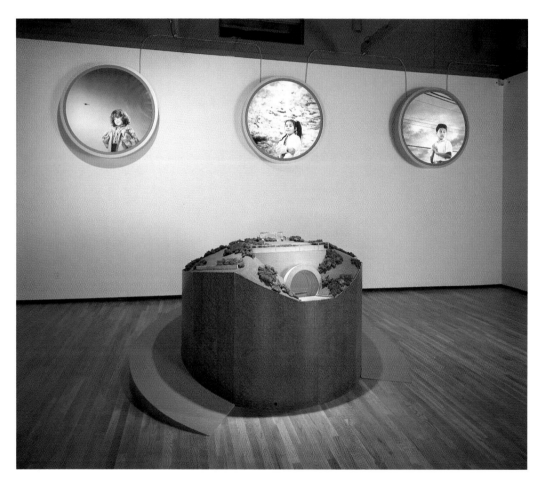

Jeff Wall and Dan Graham *The Model for the Children's Pavilion* (1989–1992) and
Jeff Wall *Little Children (I-IX)* (1988) installation view

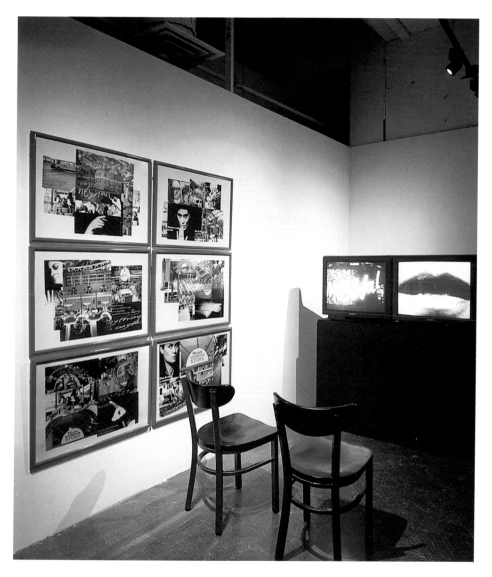

Vera Frenkel *This is Your Messiah Speaking/*
*Allo, Votre Messie Vous Parle* (1990) photo/video installation

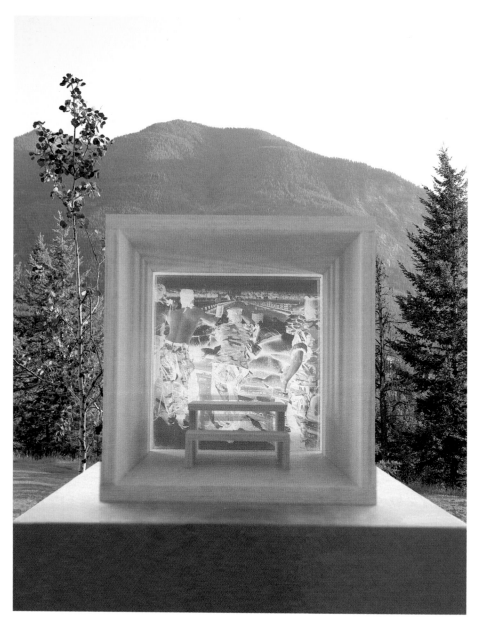

Dennis Adams *Break-Out Room* (1992) maquette
of proposal for TransCanada PipeLines Pavilion public art commission

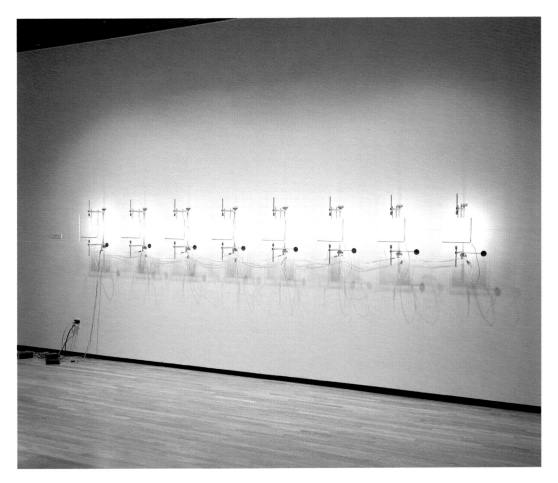

Elizabeth Diller and Ricardo Scofidio *Foto Opportunity* (1992) multimedia installation

# QUESTIONING THE PUBLIC: ADDRESSING THE RESPONSE

JOHANNE LAMOUREUX

Summer 1992. As I stood in line to board a plane to Calgary, on my way to see *Queues, Rendezvous, Riots: Questioning the Public,* I was perplexed to say the least. Surrounded by feverish vacationers, I could not help but smile at the seeming absurdity of an exhibition raising the issue of "the public" in a venue such as the gallery at the Banff Centre for the Arts, and nowhere else. At that time, I was convinced that the problematic relations between the arts and the public required very sensitive definitions of specific contexts. I did not see the problem as one concerning extra-artistic references of artworks (public art as content) or the eventual response of viewers (the public reception of art). What did it mean, then, to address questions about the public in Banff, given the conditions of insularity under which art is produced there, almost in a closed circuit, in a utopian art community that appeared to be at the time a less than perfect model of "the public." The following observations are an attempt to come to terms with that situation and to acknowledge some of the reactions the exhibition generated.

The Walter Phillips Gallery is ensconced within a set of concentric rings. It is first of all situated in the midst of a largely self-sufficient yet transitory community of artists at the Banff Centre for the Arts. Some of the participants yearn for vivid exchanges with their peers, others are devoted to the pursuit of their work in isolation, most of them are eager to be someplace where their commitment to art will be at last valued and facilitated. The Banff Centre for the Arts itself, this cultural utopia wherein everyone is an artist, in turn lies within Banff National Park, a no man's land aimed at the protection of endangered species (artists and elks united) and the preservation of wildlife. Add to these factors the geographical conspiracy: this community of artists within a national park is encircled by giant mountains that enhance, with splendid redundance, a leitmotiv of confinement. All the ingredients for a stereotypical Canadian narrative are in place: nature and culture are blurred; cultural practice is naturalized in a museified and institutionalized natural setting; reassuring and visible boundaries are invented. But how can one address "the public" in such a Russian dolls-like context?

For the outsider sojourning at the Banff Centre, the population on campus seems to consist of permanent and temporary workers, often catering to the needs and anxieties of a float of visiting artists and critics. Therefore, upon my arrival, and without having even seen the show, it was with some irony that I asked George Baird and Mark Lewis, the two curators of *Queues, Rendezvous, Riots* to describe the response to the exhibition. Lewis began by complaining about the lack of response but then acknowledged a latent but widespread hostility toward the project. Both perceptions, in fact, were accurate. Both responses were similarly motivated. Certain events, a public lecture by Dennis Adams for example, had apparently been more or less boycotted by the visual and media artists in residence at the time. A wall of the exhibition had been vandalized or at least appropriated as a kind of impromptu dazibao. As it turned out later, the entire campus had been scattered with interventions by artist-in-residence Shawna Beharry: little settings, very humble looking, almost invisible, were created in corners of buildings or on the grounds in response to the question of what art in the public domain could mean. The most successful of these, I thought, was a parody of Machado and Silvetti's proposal for the design of a communal space. Their proposal could be seen in one room of the gallery space. It astutely dealt with the possibility of using fire, not water, as the centre of attention for public art and offered a hearth-like device to attract a gathering in lieu of the traditional fountain. The design included site-specific iconography, emblematically derived from the shape of elk's antlers. Beharry took over the actual site on the grounds of the campus for which the proposal was designed and, with bones, wrecked wood, rocks and other remains, she presented an ephemeral and moving interpretation of the ambitious project highlighting its debt to a native heritage. Her intervention, an unauthorized forecast of what was to come, had nearly faded by the time I arrived on site. In its ruined state, it pointed to a further aspect of public art – its complex temporality.

When this exhibition on public art was being planned, another building on campus was under construction. A percentage of the construction budget had been set aside for art and the idea emerged to include a public art competition as part of the exhibition. Upon my arrival in Banff, I soon found out that the commission for which only artists in the exhibition had been asked to submit a proposal was a real source of grief among some resident artists then at Banff. They denounced the small number of participants enlisted and opposed the type of permanent monument likely to be produced. All this had exacerbated the reaction to the exhibition as a whole. Some had problems with having an exhibition on public art at Banff. Others thought

the selection of works was limited to a litany of too-famous names and that those who were chosen saw the issue of the public as an opportunity for monumentality. Jeff Wall and Dan Graham's *Children's Pavilion* even provoked outrage because it was seen, with its quattrocentist medallions of children of all races, as an appropriation and neutralization by dominant culture of racial and ethnic differences. Apart from the resentment that any controversial project is bound to generate (a resentment that the art world has come to expect from outside of the art milieu but not, as was the case here, interestingly enough, coming from within), this project at the Walter Phillips Gallery brought out ongoing hostility in a classic case of exclusion syndrome. The latent reproach was that *Queues, Rendezvous, Riots: Questioning the Public* had not been meant as a question after all and had left no space for interaction of any sort. Was it actually a failure or just a misleading title?

On the second evening of my stay, I was supposed to lecture on a predetermined topic. I proposed instead to comment on the exhibition and to open discussion so that some record of the dissension could be aired or debated among resident artists and the exhibition curators. If nothing else, we could agree to disagree, as the saying goes. I had no previous experience of therapeutic criticism (I am generally more committed to my own critical whining, I am afraid) so I will not presume we reached any significant degree of understanding. But those present that night, the two guests curators, the Walter Phillips Gallery curators, and the artists and critics who were in residence for part of that summer (I remember Sutapa Biswas, Richard Fung, Stephen Horne, Lani Maestro, Johanne Sloane, Cheryl Simon, Cheryl Sourkes) helped me articulate what I still deem today to be an important aspect of our fascination with "the public" and the many ways in which the ongoing critical debate fantasizes and conceptualizes the term.

During my presentation that night, I tried to bridge the gap between the title and the exhibition, or at least to read the title *with* the exhibition, for I was wondering if the dissension proceeded from a title misread or from a title mischosen. Many of the viewers, it seemed, had been shocked by the self-sufficiency of the exhibition. Given its title, they felt the exhibition should have waited for their contribution or at least the curators should have reflected upon who would actually see the show. By not doing so, they felt the concept of "the public" had been posited, in a global and abstract fashion, only to be negated. Obviously, opponents of the exhibition viewed it as an exercise that failed to achieve its intended audience. To them, the public was the recipient, hence many critical remarks commented upon the impossibility of a consensual reception and upon the urgency to think of the public in the plural form

only. But this was precisely the most crucial dimension of the question raised by the exhibition. What this show questioned was the very possibility of *the public as a notion*, not as a person, a group of persons, or a group of groups of persons.

Viewed as such, the exhibition can be read as an elaborate construct that plays with two main traditions of public intervention symptomatic of the crisis within modernity: the monument and agitprop. The first was taken up primarily by the type of artworks that had been selected (and one could sense there the determining presence of George Baird, *architect*): as a body of works, the exhibition was indeed concerned with the possible reformulation of the monumental, its rescaling, reorientation, refunctionalization. The exhibition stood as a statement on the public signifier.

Yet, I would argue, the selection and presentation of these works was only part of the curatorial activity involved. *Queues, Rendezvous, Riots: Questioning the Public* had an unusual curatorial paratext, not in the form of a catalogue or labels, but in the agitprop photomontage that greeted the visitor at the entrance of the exhibition and that indexed the first part of the exhibition's title: *Queues, Rendezvous, Riots*. In the same vein, the curators undertook to place on the grounds of the campus anonymous signs – shields of plastic orange fencing – next to the pieces of sculpture acquired over time by the Centre. The works are permanently displayed on site in such a mode of invisibility that no one could even make sense of the bright orange indexes calling attention to them. (Here, one is reminded of Lewis' own practice as an artist. These curatorial interventions reflect on the somehow necessary ephemerality of contemporary public interventions today.) This intervention seemed to denounce the conditions of insignificance and indifference whereby public markers can occupy a site and remain there only if they are both visible and inconsequential.

The curatorial decision to take action *around* the exhibition reveals the other *versant* of the project. Queues, rendezvous and riots are all modalities of action and appearance in public; they are modes of *public affect*, understood here as the permeability of space and subject in the realm of affect: the passivity of waiting (queues), the celebration of intimate, individual encounters (rendezvous), the clashing contestation of space (riots). In a sense, the curatorial paratext invited one to conceive of these figures and modalities of social encounters as contemporary public signifiers that challenged the abstraction of "questioning the public." Indeed it did activate a certain tone, a rhetoric resistant to the expected erasure of any editorial statement on the curators' part.

The curatorial gesture of indexation once again focused attention on the public

marker itself. It called attention to the message, in the sender-receiver structure of communication, or to what has been called the utterance. Now, if the curators chose, both in the exhibition's paratext and in the selection of artworks, to stress that dimension of public art, they will, at first glance, appear to be promoting a rather modernist statement. I would argue that, in so doing, they went precisely to the heart of the matter and showed how, paradoxically, this is the crucial blind spot in the postmodern debate on the public.

As I attempted to relate the core of the exhibition to its paratext, I found myself constantly shifting the grammatical status of the term *public* from noun to adjective, as if the only problem with the exhibition had been its title, and the only problem with its title, was a missing noun that, once found, would reduce the term public to some descriptive ornament and clarify the terms of the discussion. For some time, cultural discourses have urgently discussed and disputed the formulation of "the public" in the singular form, as an unsizeable, ever-elusive yet all-inclusive, monolithic entity.

In the critique of the singular form of *the* public, two *grammatical* strategies operate. The first maintains the public as a noun, either as a notion in ruin or as a kaleidoscopic all-encompassing term. It contests the global reference of public by adding an *s* and producing a virtually infinite multiplication of fragmented publics whose enumeration brings to mind a Borgesian list. The resulting figure of fragmented publics – many different groups of receivers – in the field of art practices, echoes a situation that we are familiar with in other aspects of society: the representation of the *social* as a mosaic of minorities and the demise of a (fantasized) consensus it has entailed; the parliamentary activism of specialized lobbyists at the political level; and on the communicational level (with all its economic determinations), the targeting of more narrowly defined groups of consumers by the new marketing strategies and the rhetoric of publicity. These diverse manifestations of fragmentation should not blind us to the fact that most of them are compensated and regulated by counter-motifs that function in a more systemic and totalizing fashion: for example, the ethnographic representation of the social or the interests of lobbyists can at times be overlooked due to the pressures and demagogic tyranny of a direct democracy of surveys and hot lines.

However the notion of the public has become even more complex through yet another mode: as an adjective, it has expanded the territory it claims and the poles it seeks to hold. If the plurality of the publics can be illustrated as the fragmentation of the receiver end of the sender-receiver model it can also be construed as a monopoly on the different positions of the communicational diagram. In the first case, the public

is being spelled as a plural noun *publics*. It designates a list of potential or actual receivers, susceptible to fill, concurrently or simultaneously, the role of receiver in a communicational diagram. From that single position, and through a process of feedback and dialectic interplay of reception and production, the publics have an impact on the entire structure of communication. In the second case, in its adjective form, *public* ends up qualifying almost each and every aspect of the communicational structure.

To understand this further, let us consider the distinction introduced by Mikhail Bakhtin to Roman Jakobson's communication diagram. Rosalind Krauss has already suggested, in a statement against the often reflectionist interpretations of social art historians,[1] that Bahktin's modifications open a new understanding of how the social enters the realm of art. Bakhtin breaks the univocal functioning of the sender–receiver model and presents a dialogical model, wherein meaning is constructed rather than given. Jakobson's model offered the following configuration:

|  | content |  |
| sender | message | receiver |
|  | contact |  |
|  | code |  |

Bakhtin reformulated it as follows:

|  | object |  |
| speaker | utterance | listener |
|  | intertext |  |
|  | language |  |

The two most important substitutions involve the intertext for contact, and language for code, replacing the unidirectional nature of communication flow in the earlier diagram with two-way terms.[2]

Now, to test how the public-as-adjective has come to expand on the territory mapped by these models, I propose that you keep in mind the series of controversies that have taken place around the National Gallery of Canada since the purchase of Barnett Newman's *Voice of Fire*. It includes fierce battles against the exhibition of Jana Sterbak's *Flesh Dress*, the purchase of a Mark Rothko painting and, to a lesser degree, the purchase of Guido Reni's *Jupiter and Europa*.

Initially, the issue of the public reentered artistic practices as concerns about

context/object. Even within these positions, the term has expanded its claim. The critique of modernism, it has been argued, has been supported to a large extent through a return of concerns for referentiality and extra-artistic content. The dissolution of boundaries between the private and public has entailed a dramatic and quite justified inflation in the number of private topics (largely centered around gender and sexual identity) seeking acknowledgment as part of the public realm. Dismissed is the notion that the public content of art should concern only the account of public matters (dealing with a narrow definition of the political). The expansion of what was to be considered public content was accompanied by an expanding perimeter of what constituted public space. For example, the first so-called public interventions were labelled by the fact they were presented outside of the museological institution. This is an interesting reversal since the museum along with salons, had been one of the first contexts for the public viewing of art. Both museums and salons had been influential in the very emergence of the notion of the public, as Thomas Crow has very well demonstrated.[3] The implications of that reversal were that the presentation of art in public spaces or private non-institutional settings allowed a larger public to view it.

What the recent controversies have made very clear is that there is no longer any space for art that is not public, at least in Canada. The attacks against the National Gallery stemmed from the conviction that the institution with its national mandate, was obliged to symbolically represent the taste of the Canadian public (no matter how impossible this was to achieve in reality) or at least not to offend it. We can foresee the day where every space will be public, even the private commercial galleries, as far as they are exhibiting artists who receive grants dispensed with *public funds*. For this new line of thought is now the most operative one in the discussion of art and the public, as debates around Jana Sterbak in Canada, or Robert Mapplethorpe in the United States, have made painfully clear. We then witness an adjunct consequence of the adjective "public": it serves to qualify not so much "public" space or "public" content, but the awakening of the public in the guise of the taxpayers discovering themselves as the principal aesthetic sponsor of the country's cultural production. One should not be surprised to see that the most ferocious charge against art began with this change of hats. For, as a sponsor, the taxpayer does not see him- or herself as the mere receiver of information; he or she challenges the position of the sender/speaker, a position whose function is, as Jakobson pointed out, expressive or emotional. It is from that position mainly that the issue of possible censorship is raised as a threat.

There are two remaining positions in the communications diagram. Consider the

role of language. Here again the problems of the National Gallery of Canada are revealing. Abstraction is not a shared language so although the Guido Reni purchase was more expensive, it did not provoke the outrage that was triggered by the purchase of Newman's *Voice of Fire*. (I would even argue that if the Rothko did not instigate the same furious reaction, it was not only because that scenario had already been played out around Newman, nor that the media do not like déjà vu situations, nor that the National Gallery had become more strategic in its announcement. It also differed because a geometric painting by Newman speaks less of a shared language than the more atmospheric and lyric abstraction of a work by Rothko.) As for the intertext, it goes without saying that the public has a share in it: intertext is the locus of an ambiguous rendezvous between speaker and listener, the real ground of the dialogical construction of meaning. This is the position to which the speaker formulates his or her utterance and from which the listener receives meaning from what is being uttered. Almost inescapably, what is received does not coincide exactly with what has been formulated, whence another displacement, and the cycle repeats itself throughout the communication process.

The configuration emerging from that overwhelming expansion of the public-as-adjective threatens a complete appropriation of the communication structure, a public monopoly of the artistic situation. Yet, here is a position of resistance, encircled on all sides – which is the message. The message/utterance, as a single material statement, enjoys a peculiar status in this repositioning of "the public." Not only is it the position to which the public has no claim; it is the very position from which the public tends to exclude itself. Here again, the controversies, as expressed in the doxological voice of the newspapers, are quite telling. If people refuse to see *Voice of Fire* or the *Flesh Dress* as art, it is because anybody, usually a child they know, could do the same – art is what they cannot do. The message of public outcry around art, therefore, embodies the very position the public idealizes as one it is impossible to occupy, turning its own exclusion from it as a primary condition of the public definition of art and of public tolerance and acceptance of what is being produced under that name. Precisely, at the point where it stops, the expansion of the public-as-adjective reveals the rather elitist and modernist credo to which the public still wishes to hold the artist.

This is why the insistence of *Queues, Rendezvous, Riots: Questioning the Public* to anchor its question in the materiality and the possibility of the public marker – and of the figures and affects it is likely to stimulate – seemed indeed a very relevant question, and one the curators knew could not be answered there and then, at Banff,

summer 1992. It is not merely a rhetorical question, certainly is it bound to be an open one.

## NOTES

1   Rosalind Krauss, "Reading Cubism," *Picasso and Braque: A Symposium*, New York: Museum of Modern Art, 2 November 1989.

2   For a detailed discussion of the differences, see Krauss, 275.

3   Thomas Crow, *Painters and Public Life in Eighteenth-Century Paris* (New Haven and London: Yale University Press, 1985).

# CONTRIBUTORS

**Dennis Adams** is an artist working principally in North America and Europe. Since 1978 when he produced his first public work in Manhattan, he has addressed the historical/political unconscious of the specific urban contexts in which his works are sited. Most recently, he has produced public works for Hoorn in the Netherlands, Marseille, Montréal, Munich, Saint-Denis, and Úbeda in Spain. In 1994 two separate retrospective exhibitions were held at the Museum van Hedendaagse Kunst Antwerpen and the Contemporary Arts Museum, Houston. He has lectured and taught extensively throughout North America and Europe and is currently a Visiting Artist at Massachusetts Institute of Technology.

**George Baird** is an architect and architectural theorist who has been working in Canada, the United States and Europe since 1968. He is a partner in the Toronto firm of Baird/Sampson Architects which has recently completed Toronto's award-winning Bay Adelaide Park. Baird is Professor of Architecture at Harvard University, the co-editor with Charles Jencks of *Meaning in Architecture*, 1969, and author of *Alvar Aalto*, 1970, and *The Space of Appearance*, 1994. He has taught at other major institutions in Canada, Europe and the United States and lectured extensively throughout the world. His critical and theoretical writings have appeared in many journals.

**Marik Boudreau**'s photographs have been part of Optica's art-on-the-buses events and Remue-Ménage's publication *Women of Québec in the 80s* as well as in several site-specific projects by Fleming & Lapointe. In the early 1980s she began several long-term documentation projects of urban change in Montréal – in Chinatown and along the Lachine Canal. Her book maquettes have earned several awards and her journalistic photography has appeared in dozens of newspapers and magazines around the world. Her videotape, *Série Fleuve* has been shown in festivals in New York,

Seoul and Montréal. Her work has been exhibited in group shows in Montréal, Paris, Liège, Barcelona, Seoul, São Paulo and numerous venues across Canada. She was a founding member of the Montréal production group Plessisgraphe.

**Martha Fleming** & **Lyne Lapointe** have produced a number of large-scale site-specific projects over the last twelve years, largely involving abandoned buildings and occupying their entire architectural envelope. A vaudeville theatre in Montréal, a ferry terminal in Manhattan, a library in Madrid are some of these sites. Others have taken place in London, Bath, São Paulo and Corumbá, Brazil. These ephemeral site projects are a hybrid of social theory, architectural archeology, scholarly research, popular history and metaphysical investigation. They have also exhibited in a number of museums and galleries in Canada and the United States and have produced graphic works for magazine and book publications.

**Vera Frenkel**'s video and installation works have addressed embedded assumptions as clues to the construction of consciousness, with a special focus on so-called "cargo-cult" practices as they inhabit consumer culture. *This is Your Messiah Speaking* alludes to the largest shopping mall in Europe and continues an inquiry into the relation between consumerism, messianism and popular romance, each requiring the severing of the self from the senses. Her most recent work, *Body Missing,* completed in Linz, Austria, the boyhood home of Adolf Hitler, considers the implications of the proposed public face there of the art plundered by the Third Reich, the planned Fuehrermuseum and the works destined for it that are still missing.

**Elizabeth Diller** and **Ricardo Scofidio** are New York artists/architects who have worked together since 1979. Diller + Scofidio is a collaborative team involved in cross-disciplinary work that incorporates architecture, performing and visual arts. They have published two books in 1994 – *Back to the Front: Tourisms of War* and *Flesh* – and have received numerous prizes and awards. Their buildings, installations and stage sets have been exhibited internationally. **Elizabeth Diller** has taught at Cooper Union, Harvard University, the Columbia University Graduate School of Architecture, Planning and Preservation, the Institute for Architecture and Urban Studies. She is currently Assistant Professor at Princeton University. **Ricardo Scofidio** is a New York-based architect who has been a visiting professor at

Harvard University and the University of Illinois and Professor at Cooper Union since 1979.

**Daniel Hermant** is a distinguished French scholar whose work focuses on aspects of conflict in history. The text included in this volume was originally published in French in *Annales* in 1978. Recently, he co-edited with Didier Bigo *Approches Polemologiques: Conflits et violence politique dans le monde au tournant des annees quatre-vingt-dix*.

**Johanne Lamoureux** is a writer, critic and art historian who lives in Montréal. She received her doctorate in art history in 1990 and has since been a professor in the art history department at l'Université de Montréal. A founding member of La société d'esthétique du Québec, she has served on the board of several periodicals and is a regular contributor to exhibition catalogues, books, journals and periodicals in Canada and the United States.

**Mark Lewis** is an artist whose work has been exhibited in Canada, the United States, Europe and Japan. A number of films he has directed have also been exhibited and screened internationally. In 1985 he founded with Monika Gagnon the artists' and writers' collective Public Access and is also a founding member of the art and theory journal *Public*. He is currently teaching sculpture and photography at the University of British Columbia.

**Rodolfo Machado** and **Jorge Silvetti** are Boston-based architects whose firm, Machado and Silvetti Associates Inc., has received eight Progressive Architecture awards and numerous prizes around the world. Their work has been exhibited worldwide, most notably at the Museum of Modern Art in New York, Centre Georges Pompidou in Paris and the Venice Biennale. Recently, the firm was presented a National Honor Award for Built Architecture from the American Institute of Architects. **Rodolfo Machado** has taught at the University of California at Berkeley, Carnegie-Mellon University and the Rhode Island School of Design where he was Chairman of the Department of Architecture from 1978 to 1986. He has been a lecturer, visiting critic and professor in numerous positions across the United States and is currently Professor of Practice of Architecture and Urban Design at the Harvard University Graduate School of Design. **Jorge Silvetti** has

taught at the University of California at Berkeley, the Polytechnic Institute of Zurich and the University of Palermo, Italy. Since 1975, he has taught architecture at the Graduate School of Design, Harvard University. He has received numerous international awards and citations for his work and is the first architect ever to receive Progressive Architecture awards in all categories.

**Don McGrath** is a Montréal-based translator who has worked on contemporary art essays for books and periodicals over the past six years. He holds a Bachelor of Fine Arts degree from the Nova Scotia College of Art and Design and has studied translation at Concordia University in Montréal and York University in Toronto. His own writings have been published in periodicals such as *Parachute* and a book of his poetry will be published by Wolsack and Wynn next year.

**Andrew Payne** is the author of numerous articles on art, literature and the public sphere. He is a member of the Public Access Collective and has co-edited with Mark Lewis both *Public* 6 (Violence) and *Public* 9 (Reading our Rights). He is currently completing a doctoral dissertation at the University of Toronto on problems of political incorporation in Shakespeare's tragedies.

**Régine Robin** is Professor of Sociology at the Université du Québec à Montréal. A recipient of the Governor General Award for Non-fiction in 1987 for *Le Réalisme socialiste: Une esthétique impossible* (translated by Stanford University Press in 1992 under the title *Socialist Realism: An Impossible Aesthetic)*, she has written extensively on the theory and practice of literature in the sociological field as well as on questions of identity and culture. She was honoured in 1994 by the Association canadienne française pour l'avancement des sciences (ACFAS) for her interdisciplinary body of work. She currently heads the Inter-University Centre for Discourse Analysis and Sociocriticism of Texts in Montréal.

**Jeff Wall** and **Dan Graham** have collaborated to produce the *Children's Pavilion*, a work which explores the possibilities for a utopian arena where the "not already" formed imaginations of children are able to develop according to principles of democracy and freedom. **Jeff Wall** is a Vancouver-based artist whose work has been exhibited extensively throughout North America and Europe. He completed Bachelor of Arts and Master of Arts degrees at the University of British Columbia and worked for several years on doctoral research at the University of

London, England. He has taught at the Nova Scotia College of Art and Design, the Centre for the Arts at Simon Fraser University and has been Associate Professor in Fine Art at the University of British Columbia since 1987. **Dan Graham** is a New York–based artist whose work has been exhibited across North America and Europe for almost thirty years. Since 1981, he has developed public projects for municipalities, schools, gardens and private collections in Europe and the United States.

# ACKNOWLEDGMENTS

Analyzing notions of "the public" is an enticing and necessary investigation, yet art's audiences remain slippery and unpredictable, subject to changing social and political values. Through artworks and essays, *Queues, Rendezvous, Riots* – the exhibition and the book – contributes to the existing body of knowledge on this debated subject. The book provides important accounts and analyses and, in its undertones, points to difficult questions of "the public" especially those around conflicted notions of identity, power, social and aesthetic values. George Baird and Mark Lewis, the curators/editors of the overall project, must be congratulated for creating a framework which has yielded discussion and debate.

It is important to acknowledge the work that has gone into this project, from the planning stages of the exhibition to the final stages of book design. Much of the work in this publication was exhibited as part of *Queues, Rendezvous, Riots: Questioning the Public* from June 12 to July 19, 1992, at the Walter Phillips Gallery and we are grateful to the artists for the rich array of perspectives. Generous loan of work came from the artists and Galerie Chantal Boulanger. Sylvie Gilbert undertook the important role of coordinating the exhibition while she was Associate Curator, with support from Deborah Cameron, Sally Garen, Marilyn Love, Mimmo Maiolo, Pauline Martin, Mary Anne Moser, Wendy Robinson and Mary Squario. The exhibition was made possible with the assistance from many people including Petúnia Alves, Stephen Atkinson, Jeff Brandt, Michael Cameron, Colin Griffiths, Christopher Kirwan, Bob Knowlden, Joel Robson, Phil Smith, Tim Westbury and Calvert Wright.

This publication has taken shape over many months and, during that time, has taken on a life beyond the exhibition from which it emerged. First and foremost, all the artists and writers must be thanked for their important ideas that contribute to the discourse on "the public." The commitment of Publications Editor Mary Anne Moser stands out as she took this book through its many phases to completion especially in her role as coordinating editor and designer. She was ably assisted by Mary Squario through all stages of production and design. Translations of two essays in this volume

were provided by Don McGrath. Cathy McGinnis and Eswina Ngai provided much appreciated input during the preliminary stages of the book's design, while Doug Smith and Marilyn Love offered important computer support. Many thanks to Tim Westbury and Petra Watson for proofreading and to the Visual Arts staff for offering valuable insights.

The Walter Phillips Gallery is grateful for financial support for this project from the Canada Council Exhibition Assistance Program and the Alberta Foundation for the Arts, a beneficiary of Alberta Lotteries.

Daina Augaitis
Director/Chief Curator, Walter Phillips Gallery

## LIST OF WORKS

**Dennis Adams**
*Break-Out Room* 1992
maquette of proposal for TransCanada PipeLines
Pavilion public art commission
(wood, photograph, wooden base)
68.5 x 30.5 x 75 cm

**Vera Frenkel**
*This is Your Messiah Speaking / Allo, Votre Messie
Vous Parle* 1990
photo/video installation
(2-channel video, 9:40 minutes, colour and black
and white; 6 colour photo collages)
installation area 5.3 x 3.5 m

**Jeff Wall and Dan Graham**
*The Model for the Children's Pavilion* 1989–1992
model (mirror, colour photographs,
9 colour cibachromes, aluminum, wood, cork,
concrete)
courtesy Galerie Chantal Boulanger
1.25 x 1.85 x 1.37 m

**Jeff Wall**
*Little Children (I–IX)* 1988
9 cibachromes
each 135 cm diameter

**Marik Boudreau with
Martha Fleming & Lyne Lapointe**
*Attention* 1992
installation (30 photographs)
57 x 750 cm

**Elizabeth Diller and Ricardo Scofidio**
*Foto Opportunity* 1992
multimedia installation
(liquid crystal panels, steel, electronic
components)
46 x 445 x 26 cm

**Rodolfo Machado and Jorge Silvetti**
*Banffire* 1992
proposal for TransCanada PipeLines Pavilion
public art commission
(plaster sculpture, 20:40 minute video,
wood construction, text)
installation area 10.7 x 7.4 m

## PHOTO CREDITS

page iii: Curator's intervention during the
exhibition *Queues, Rendezvous, Riots* in 1992
showing fence in front of Hugh Leroy's
*Papillon* (1979). Photo Monte Greenshields

page iv–v: Mark Lewis, *Let Everything be
Temporary* (1991). Courtesy the artist

page 10, 14, 38, 167: Cheryl Bellows

pages 18, 25, 134–35: Monte Greenshields

pages 19, 20, 22, 27: Courtesy the artists

page 29: Ludwig Mies van der Rohe, *Glass House
on a Hillside* (1934) Elevation. Ink on paper
10.7 x 20.3 cm. Courtesy the Mies van der
Rohe Archive, Museum of Modern Art, New
York. Gift of the architect

page 30: Ludwig Mies van der Rohe, *Resor House*
(1937–38) Jackson Hole, Wyoming. Unbuilt.
Interior perspective of living room, view
through north glass wall. Pencil, photograph
on illustration board (76.2 x 101.6 cm).
Courtesy the Mies van der Rohe Archive,
Museum of Modern Art, New York. Gift of
the architect.

page 31: Ludwig Mies van der Rohe, *Resor House*
(1937–38) Jackson Hole, Wyoming. Unbuilt.
Interior perspective of living room, looking
south. Pencil, wood veneer, cut-out colour
reproduction (Paul Klee, *Bunte Mahlzeit* 1928),
and photograph on illustration board (76.2 x
101.6 cm). Courtesy the Mies van der Rohe
Archive, Museum of Modern Art, New York.
Gift of the architect.

page 36: Robert Galbraith

pages 41, 50–55, 141: Isaac Applebaum

pages 44, 46, 99, 102, 103, 129, 138–40, 142–43:
Judy Cheung

pages 74, 76, 78: Courtesy the artists

page 167: Curator's intervention during the
exhibition *Queues, Rendezvous, Riots* in 1992
showing fence in front of John McEwen's
*Stelco's Cabin* (1984). Photo Cheryl Bellows

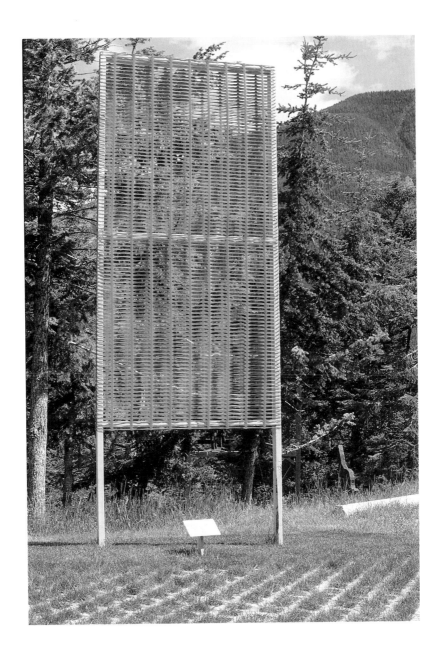